ROLLERGIRLS
THE STORY OF
FLAT TRACK DERBY

FL
TRACK

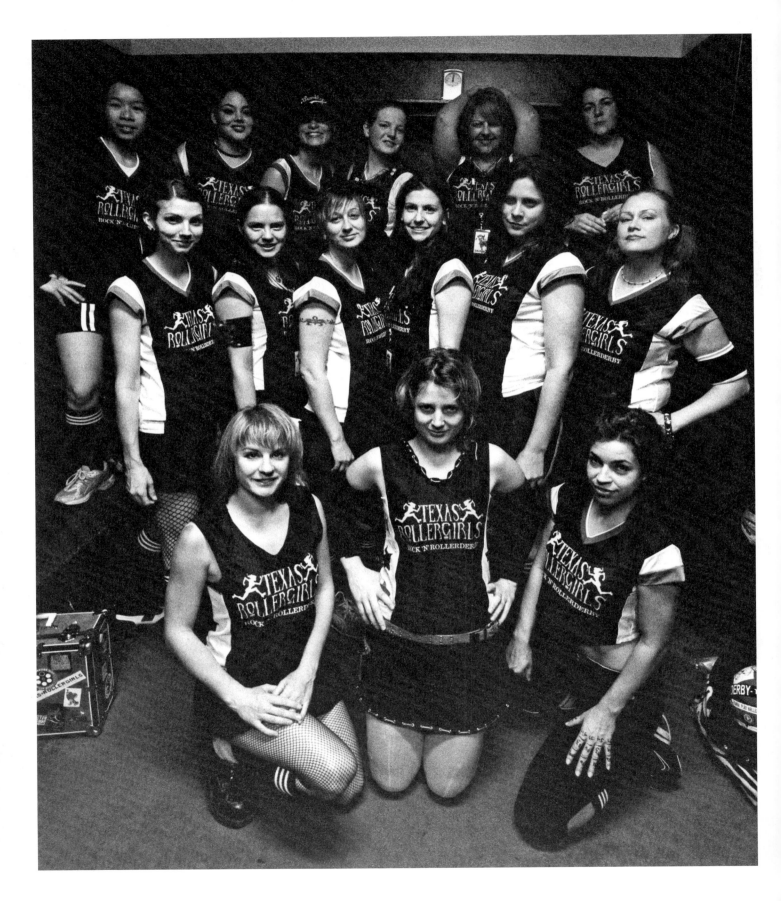

ROLLERGIRLS
THE STORY OF FLAT TRACK DERBY

Photographs by FELICIA GRAHAM
Foreword by MELISSA JOULWAN
Afterword by DENNIS DARLING

Trinity University Press
San Antonio, Texas

Published by Trinity University Press
San Antonio, Texas 78212

All photography by Felicia Graham, with the exception of pages 14 and 17
courtesy Chicago Tribune Archives, and page 13 courtesy kathyathy.com

Book design by Julie Savasky and Jeffrey Wolverton
Pentagram Design, Austin, Texas

Design modification by BookMatters, Berkeley

Printed in Canada

ISBN 978-1-59534-882-1 hardcover
ISBN 978-1-59534-883-8 ebook

Trinity University Press strives to produce its books using methods and
materials in an environmentally sensitive manner. We favor working with
manufacturers that practice sustainable management of all natural
resources, produce paper using recycled stock, and manage forests with the
best possible practices for people, biodiversity, and sustainability. The press
is a member of the Green Press Initiative, a nonprofit program dedicated to
supporting publishers in their efforts to reduce their impacts on endangered
forests, climate change, and forest-dependent communities.

The paper used in this publication meets the minimum requirements of the
American National Standard for Information Sciences—Permanence of Paper
for Printed Library Materials, ANSI 39.48–1992.

CIP data on file at the Library of Congress

22 21 20 19 18 | 5 4 3 2 1

THIS BOOK IS FOR ALL
THE TEXAS ROLLERGIRLS,
PAST AND PRESENT. YOU LET AN
OUTSIDER IN AND MADE ME ONE
OF YOUR OWN. I WILL ALWAYS
BE EXTREMELY GRATEFUL.
THIS ESPECIALLY GOES OUT TO THE
BEAUTIFUL SKATERS WE'VE LOST: SIC
SHOOTER AND PIXIE TOURETTE. Y'ALL
WILL ALWAYS BE WITH US.

TO MY FAMILY AND FRIENDS, THANK YOU
FOR ALL THE SUPPORT OVER THE YEARS.
YOU KNOW WHO YOU ARE AND WHAT
YOU'VE MEANT TO ME.

I ALSO DEDICATE THIS WORK TO MY
NIECES, EMILY, SIENA, AND PORTIA. I
HOPE THIS BOOK SHOWS YOU JUST HOW
STRONG A GIRL CAN BE IN THIS WORLD.

THE TEXAS ROLLERGIRLS LEAGUE,
WHICH BEGAN IN AUSTIN, STARTED THE
FLAT TRACK ROLLER DERBY MOVEMENT.
AS SEEN INTERNATIONALLY IN FILMS
AND OTHER MEDIA, THE LEAGUE
WAS THE FIRST OF WHAT IS NOW
HUNDREDS WORLDWIDE. THE ATHLETES'
EXPERIENCES EMBODY AND EMBOLDEN
THIS COMPETITIVE SPORT FOR WOMEN. IT
HAS BEEN AN HONOR TO TELL THE STORY
OF THE TEXAS ROLLERGIRLS THROUGH MY
PHOTOGRAPHY, AND IT IS MY HOPE THAT
EVERY ROLLER GIRL AROUND THE WORLD
CAN SEE HERSELF AND HER EXPERIENCE
IN THESE PAGES.

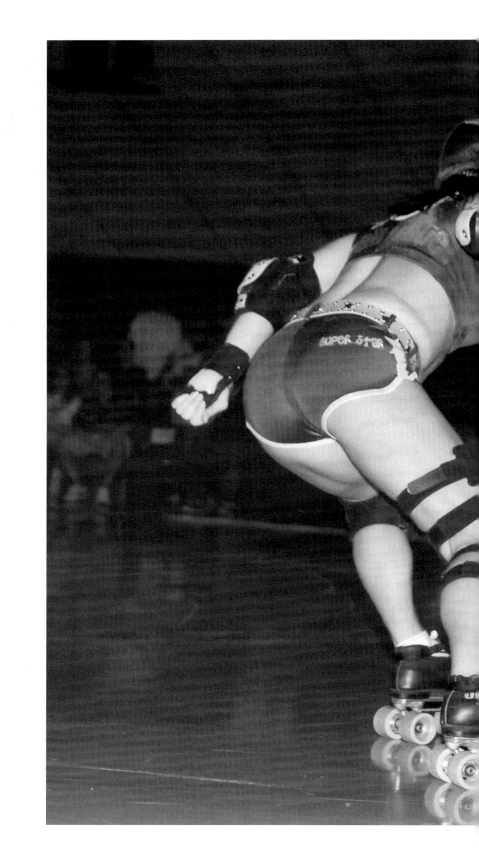

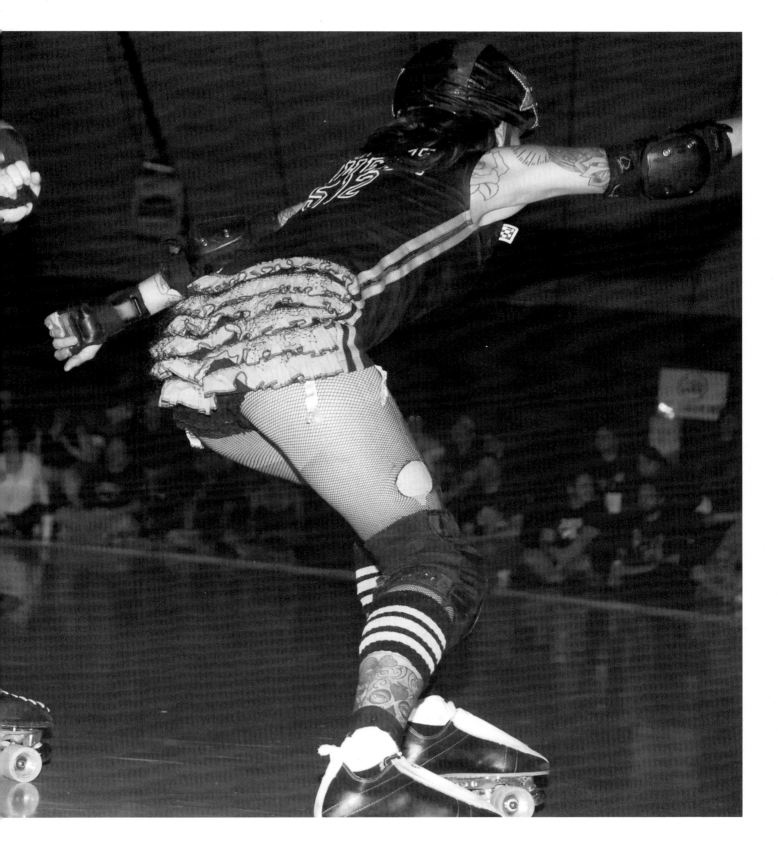

ABOVE: **Dinah-Mite & Rollin Sweet** Austin, 2007; FOLLOWING SPREAD: **Texas Spirit** Austin, 2012

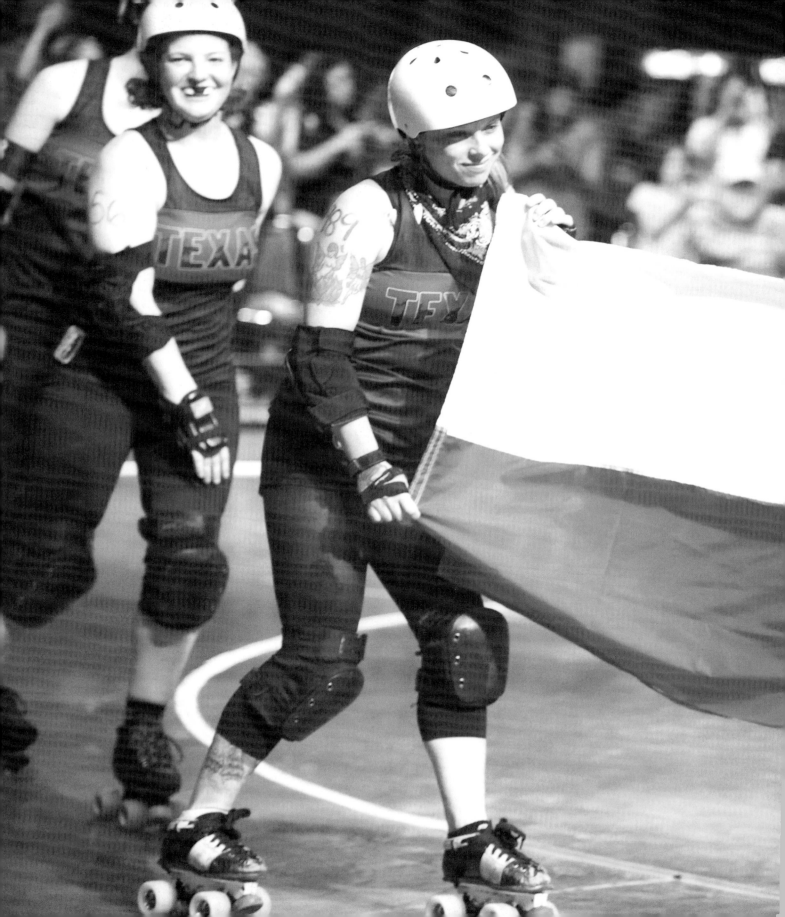

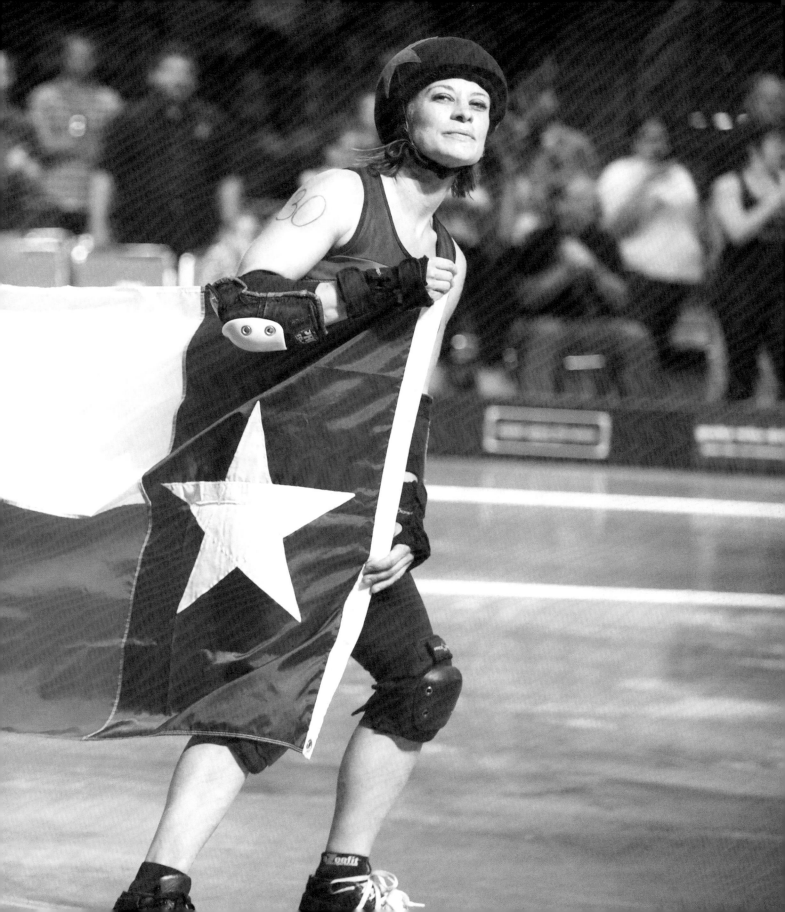

WARRIOR WOMEN ON WHEELS
BY MELISSA JOULWAN

I've done a lot of things in my life that I think are interesting: completed an Olympic distance triathlon, written and published five books, undergone shoulder and thyroid surgery, traveled to a dozen foreign countries, met Muhammad Ali and the members of Duran Duran..., but the thing people always want to talk to me about is my time as a rollergirl. And I get it! There's something irresistible about the singular combination of feminity and fierceness embodied in a warrior woman on wheels.

When we, the members of the Texas Rollergirls laced up our skates in Austin, Texas in 2003, we were a rag-tag bunch of bartenders, waitresses, teachers, dancers, artists, musicians, office workers, feminists, introverts, extroverts, athletes, and klutzes. But our uniforms, the freedom of flying around the track, and the adoption of our playful and powerful rollergirl names transformed us into the versions of ourselves we always wanted to be. Felicia Graham was there with us, silently capturing the moments when regular girls became rollergirls. Her photographs showed us what we couldn't always see through our own eyes, but was apparent to the cheering spectators. We were our personas. Determined. Sexy. Athletic. Powerful. And maybe even a little bit intimidating.

To understand today's flat track rollergirls, it helps to understand where the skating phenomenon started. In post-Depression America, the entertainment world was dominated by legendary Hollywood stars and crazy fads like dance marathons and walkathons, anything that would help Americans forget their dire financial situation was a welcome distraction, and the cheaper the ticket, the better. An impresario named Leo Seltzer enhanced the fads and made "stars" of regular people with novelties like ice-sitting contests, gimmicky weddings, and a new endeavor called the Transcontinental Derby.

It was like a dance marathon on wheels: twenty-five fresh-faced teenage couples skated laps on an oval track with steeply-banked sides. Eighteen laps of the track equaled one mile, and the teams skated the approximate distance from New York City to San Diego, tracking their progress with tiny lights on an oversized map of Route 66. Every day, for seven weeks, from noon until 2:00 a.m., the skaters went round and round and round. Unbelievably, 20,000 spectators watched. That's more than the modern Madison Square Garden capacity for a basketball game.

Even though the teams were made of male/female pairs, the sexes skated separately, and any kind of hanky-panky was verboten—until pulp writer, Damon Runyon, entered the picture in 1937. He was the popular master of stories about thieves, winos, pimps, gamblers, and swindlers. He advised Seltzer he could spice things up by adding a little sex and violence to the mix.

Runyon and Seltzer put their heads together to devise updated rules and a new points system. Feuds and fistfights became part of the action. Audiences and sportswriters were thrilled by the competition and bloodlust. The derby moved from the entertainment section to the sports page.

By 1949, the five-day world series of the National Roller Derby League was played at Madison Square Garden before an audience of 55,000. But Derby had reached its peak and, by the mid-1950s, the craze was

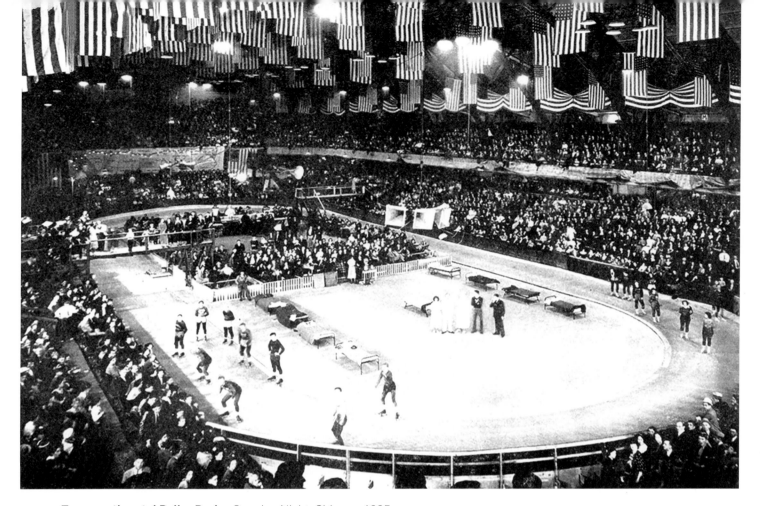

Transcontinental Roller Derby Opening Night, Chicago, 1935

mostly over, replaced by new fads: drive-in movies, the hula hoop, and television. Throughout the seventies and eighties, roller derby could be found on late-night TV, but the once-popular sport was pushed to the fringes of pop culture where it stayed until the late 1990s.

In the flush of the popularity of inline skating, Rollerjam premiered on The Nashville Network in 1998. The skaters were athletes recruited from roller hockey and speed skating. They were good looking, super fit, and encased in spandex. They skated in a slick studio tricked out with rock show lighting and a sexy banked track, and the storylines were straight out of professional wrestling. After an early burst of popularity, the ratings dropped and it looked as though roller derby had taken its final lap until the turn of the millennium in Austin, Texas.

I suppose Devil Dan, as he came to be known, was a 1990s version of Leo Seltzer, a n'er-do-well who took up residence on bar stools along Red River Street in Austin, running his mouth with big ideas. Forget the wholesome vibe of roller derby's golden years. Dan had a brainstorm about a roller derby revival for the new century: hot girls with attitude and a rock-n-roll soundtrack, like a sexy sideshow on wheels. It didn't take long for a few strong-willed women to get on board with that idea and, when Devil Dan blew out of town as mysteriously as he'd arrived, those girls took matters into their own well-manicured hands.

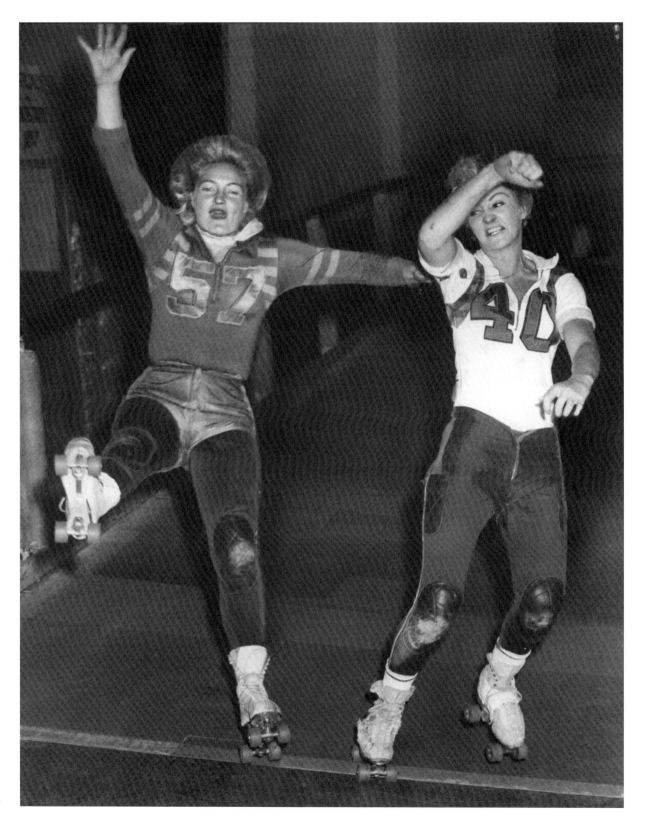

Joan Weston, left, and Cathy Reed collided in a practice on
Oct. 17, 1963, to prepare for an upcoming series at the Coliseum.

A group of three women, collectively known as the SheEOs, formed Bad Girl Good Woman Productions and began aggressively recruiting daring girls to join them. Teams were sorted, personas developed, and once they all had Rollergirl names, they were officially in the business of becoming a sports league. The Wrench, an experienced personal trainer, set up a training program to start preparing skaters' bodies for the demands of their new avocation. Strawberry, a soccer player, and Hydra, a ranked amateur handball player, helped with tricky team dynamics. Sparkle Plenty and other skaters formed a Rules Committee and drafted the first-ever rules for Flat-Track Roller Derby. Electra Blu used a CAD program to translate the old dimensions of the banked track into a new, fast flat track that meant roller derby could be played just about anywhere. Meanwhile, girls with no sports experience—and who hadn't been on skates in decades—skated endless laps around the track, perfecting their cross-over turns and building their stamina, slowly transforming themselves into Rollergirls.

The fledgling league held its first public bout in June 2002, and it took all forty-five of the skaters to make it happen. Despite the pride we all took in our success, the wild popularity of the spectacle, and the major media coverage it garnered, there was growing disharmony in the ranks. As the new derby's reputation grew, the SheEOs became increasingly greedier about the business while simultaneously stepping back from participating in the sport. There was talk that they'd walked away with money that wasn't theirs, and they failed to acquire insurance for the bouts, and then lied about it. They made decisions about the skaters' fates with regard only for the bottom line. The

skaters, in contrast, became more committed to their sport and less comfortable risking injury in the pursuit of cash. Eventually, there was a fiery showdown and the league split in two. When the smoked cleared, eighty percent of the skaters, including me, decided to from a new league: The Texas Rollergirls.

Our upstart league, completely owned and managed by the entire group of skaters, held elections for management positions and adopted the mantra "By the skaters, for the skaters." The league's structured mirrored a corporate org chart with one major difference: There was no CEO. Along with the captains of the four teams (Hell Marys, Hotrod Honeys, Honky Tonk Heartbreakers, and Hustlers) the elected managers formed the governing body and were bound by bylaws to negotiate with each other to run the league.

The formation of the Texas Rollergirls was one of the most extraordinary experiences of my life. To watch a large group of disparate, passionate women unite around the sport they love—and to see them treat themselves and each other with such profound respect—changed me forever.

On April 27, 2003, the Texas Rollergirls held its first bout and the flat-track roller derby revolution that's swept the globe officially began.

That night in April was a turning point for several reasons, although I'm not sure we knew it at the time. We played our premiere games in front of a sell-out crowd. The line to get into the skating rink stretched around the building in a queue that was half a football field long. It seemed our potentially crazy roller derby dream could come true. And, perhaps more significantly, we all got a glimpse of where our sport could go. Dyna-Mite made

her debut as a jammer for the Hustlers with speed and power that astonished all of us. She would ultimately be the catalyst for the rest of us to improve and for the sport to evolve.

When flat-track roller derby started, it was more "sexy circus" than sport. Leo Seltzer and Damon Runyan had set the course, and Devil Dan and the SheEOs evolved the concept. The lure of glam-girl makeup and sexy uniforms was a huge part of the appeal for a lot of the early members of the league. Live music and larger than life personas were all part of the fun. Who doesn't want to feel like a rock star once in a while?! In those early days of derby, we were entertainers, first and foremost. I remember cooking up schemes with the Wrench before each bout, coordinating when I'd take her down to the floor in a bear hug and whather oversized reaction would be. The outcome of the bouts was never planned in advance. We all played to win—but the shenanigans between players were part of the show. Until they weren't.

By the time Dyna-Mite helped the Hustlers smoke the Honky Tonk Heartbreakers in that first bout, we were starting to evolve from showgirls to legitimate athletes. Suddenly, tussling on the floor in a crowd-pleasing cat fight was less appealing than actually out-skating our opponents. We worked to educate the crowd about the mechanics and rules of the game so that they'd know when to go crazy for legit reasons. Eventually, when fights broke out on the track, they were the result of real animosity between the players, and the participants earned the penalties they deserved.

Nowhere is this transition more evident than in Felicia's photos. We were no longer content to merely preen in posed glamour shots (although that didn't stop us from doing it before and after the bouts). What we really clamored for, and Felicia delivered, were action shots that commemorated our accomplishments on the track. Why just be pretty or hot when you can be powerful?

Powerful is not a word I would have used to describe myself before becoming a Rollergirl. Sure, I'd been successful in the corporate world but, in my personal life, I had a tendency to be a people-pleaser. It was desperately important to me that other people like me even if I didn't like them, and I thought that being embarrassed was one of the worst things that could happen to me.

I don't have sisters and was never part of a large group of girlfriends but, all at once, I had forty sisters in the Texas Rollergirls and I learned that we could love each other without always liking each other. I learned that fear can be channeled into determination, and that laughing in the face of embarrassment is the only reasonable response.

A big part of my transformation was my derby persona. When I wasn't in uniform, I was Melissa, the nerdy writer and classical pianist. But when I laced up my skates and wiggled into my push-up bra, I became Melicious: bratty, glamorous, light-hearted, honest, tough, and way more rock-n-roll than Melissa could ever be. The more I played at being those things in the game, the more they spilled over into my real life. I've never gone so far as to knock someone annoying to the floor, but I have learned to defend my territory with a sweet smile and the verbal equivalent of a hip check.

Roller Derby participant Harriette "Babe" Topel at the Coliseum in 1953.

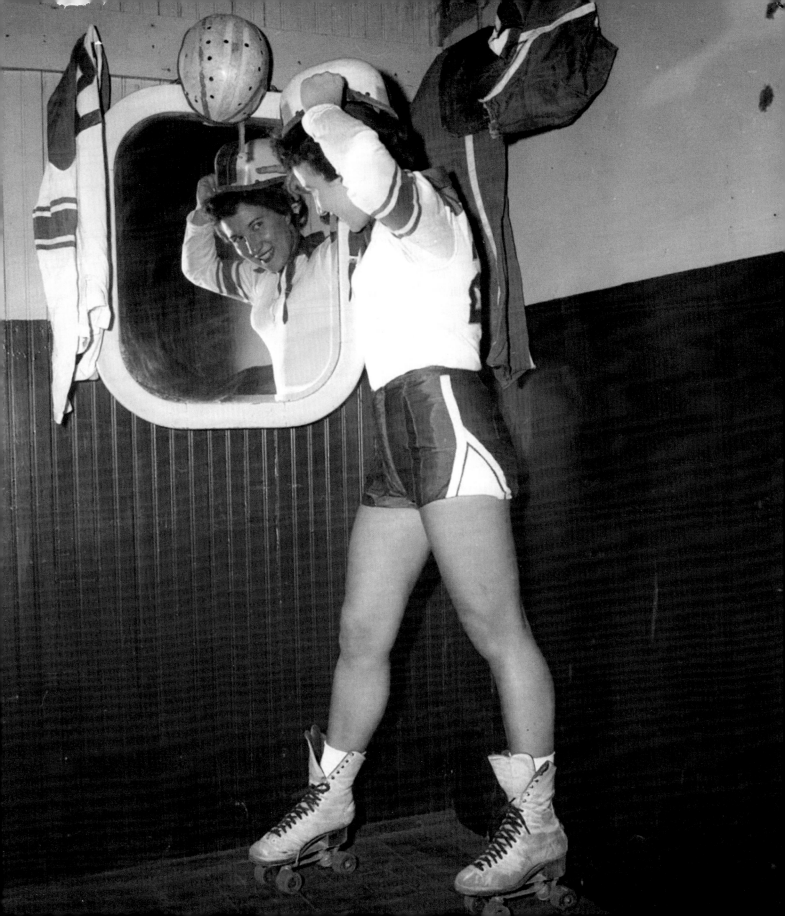

I JOINED BECAUSE I WANTED TO HIT PEOPLE HARD.

Tinkerhell Tuscon, 2006

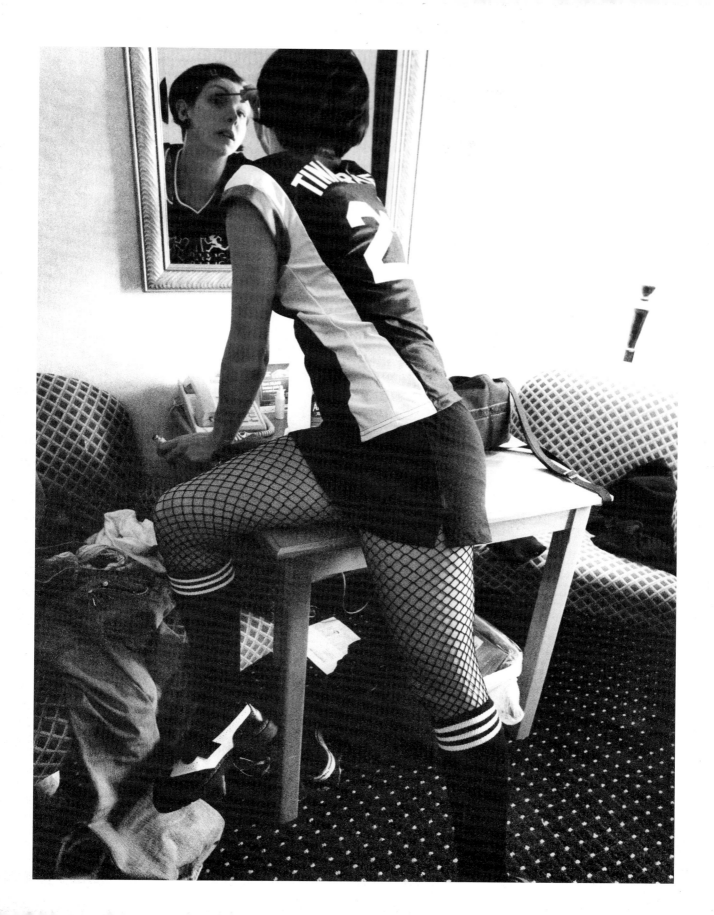

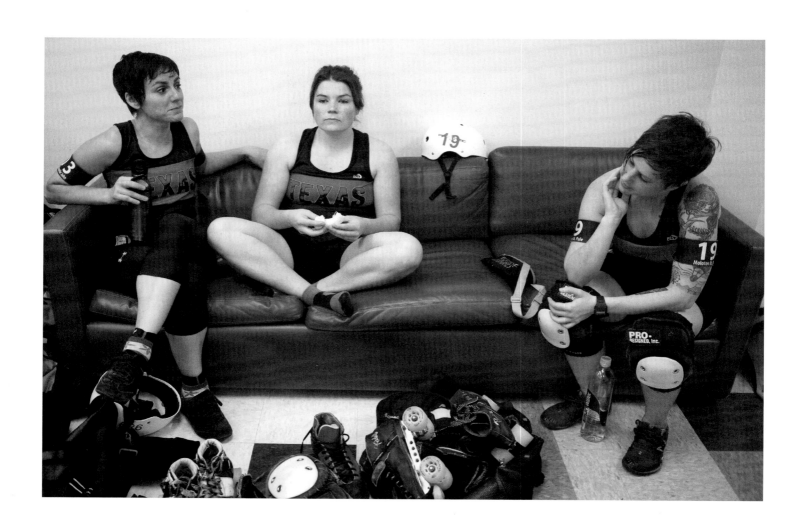

Olivia Shootin' John, Pollygone & Molotov M. Pale Austin, 2012

Q-Ball Craze & Fender Bender Austin, 2014

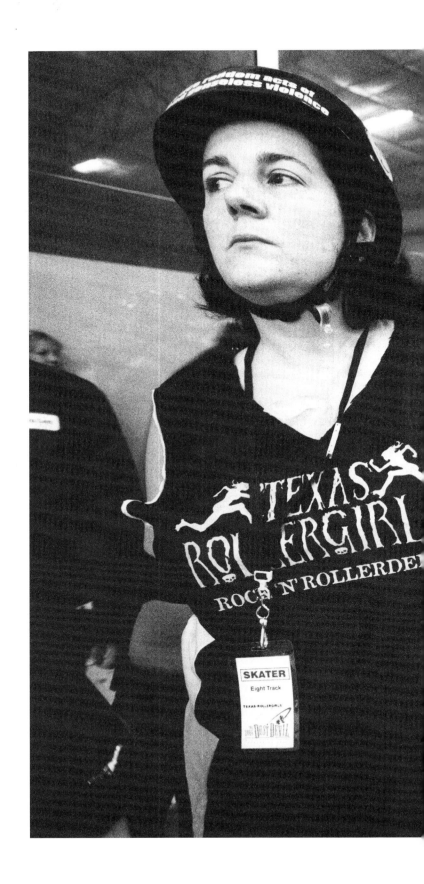

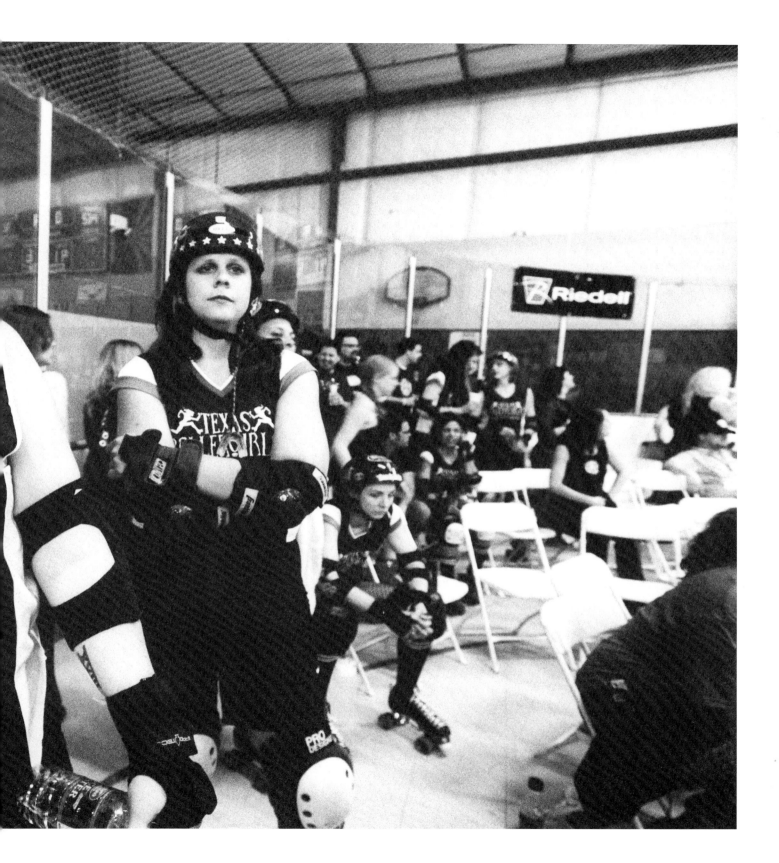

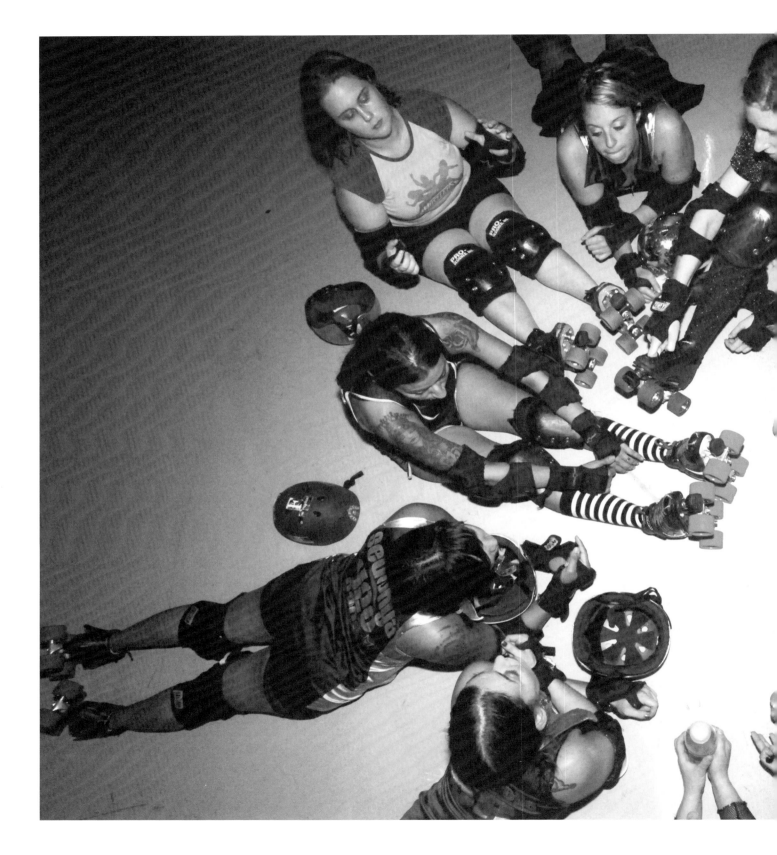

Hustlers Austin, 2006

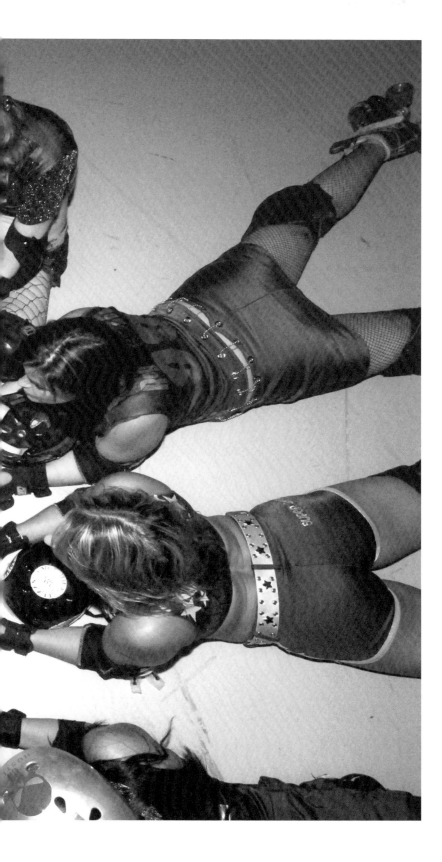

OPPOSITE: **Slim Kickins** Austin, 2007;
FOLLOWING SPREAD: **Kansas City Roller Warriors Supporting Texas** Seattle, 2006

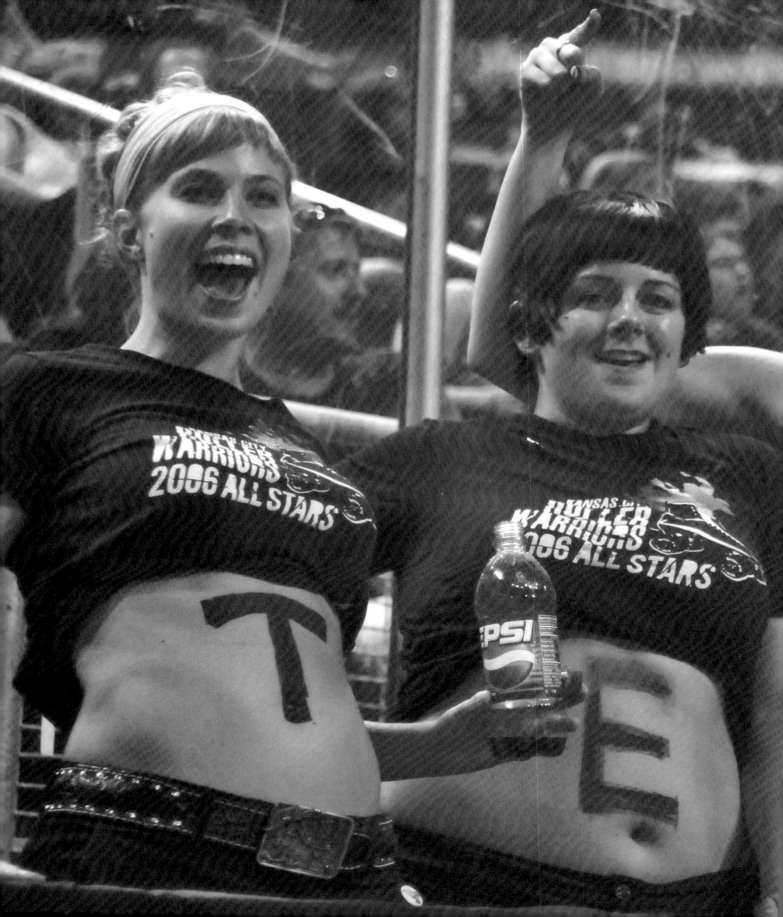

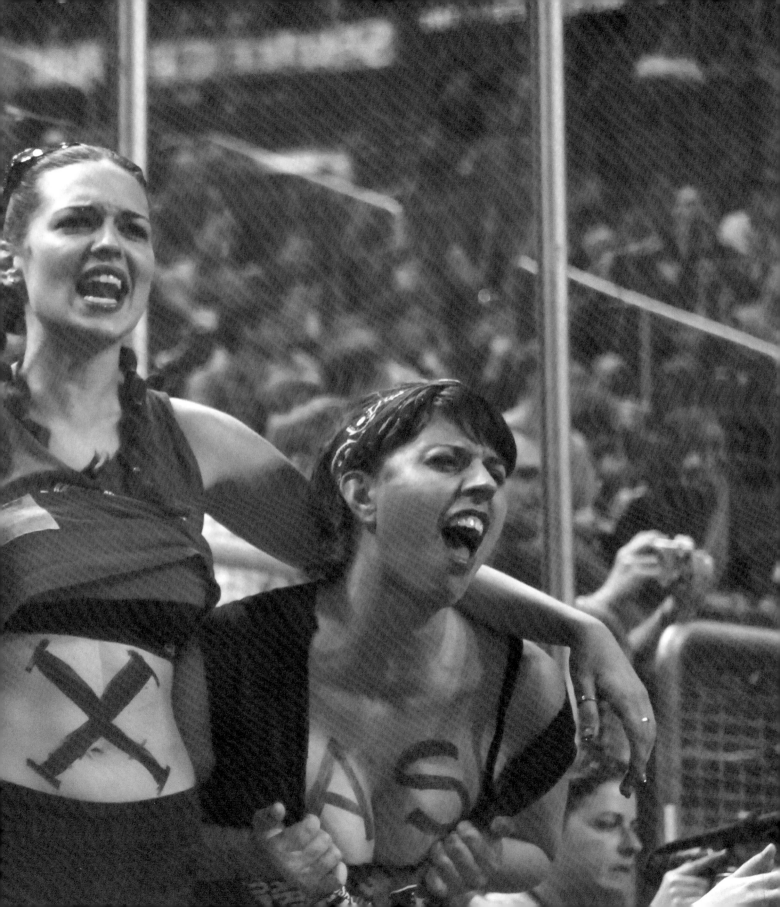

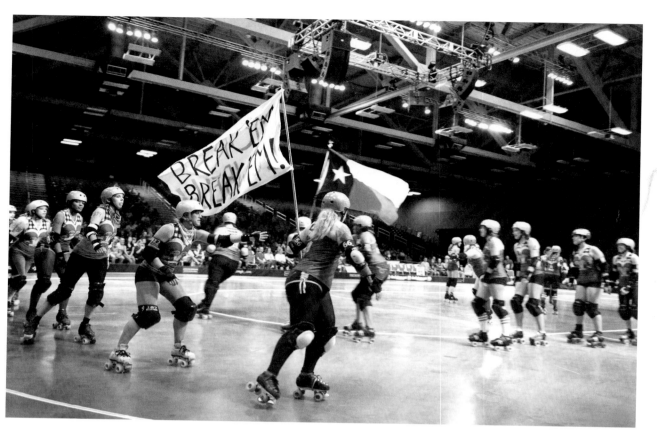

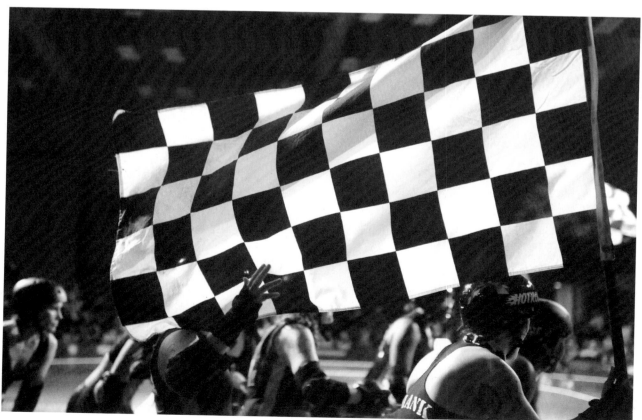

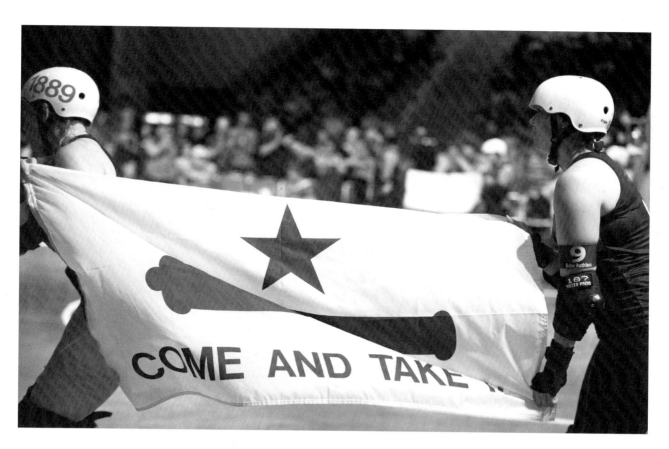

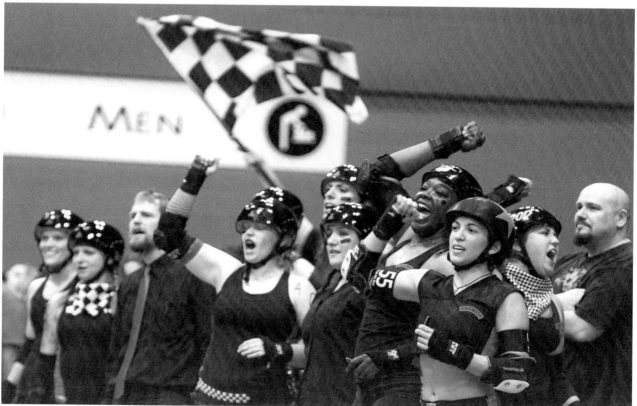

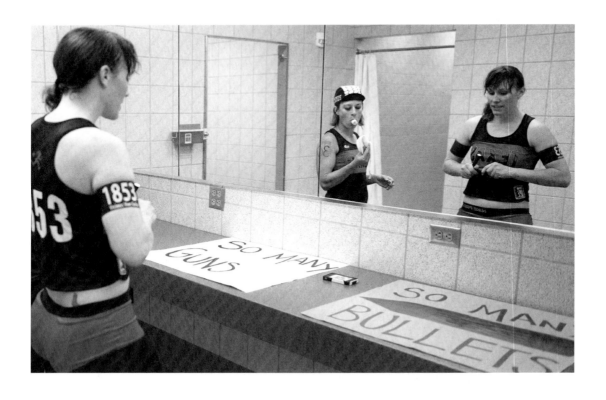

PREVIOUS SPREAD: **Flags** Austin, 2011–2012; ABOVE: **Bloody Mary & Vicious Van GoGo** Austin, 2012

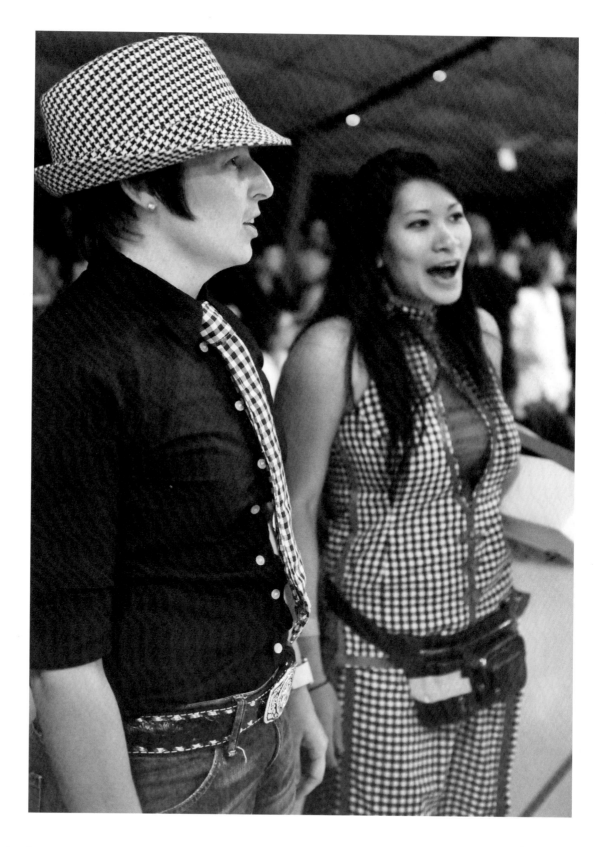

Coach Kelly & Yellow Die Austin, 2010

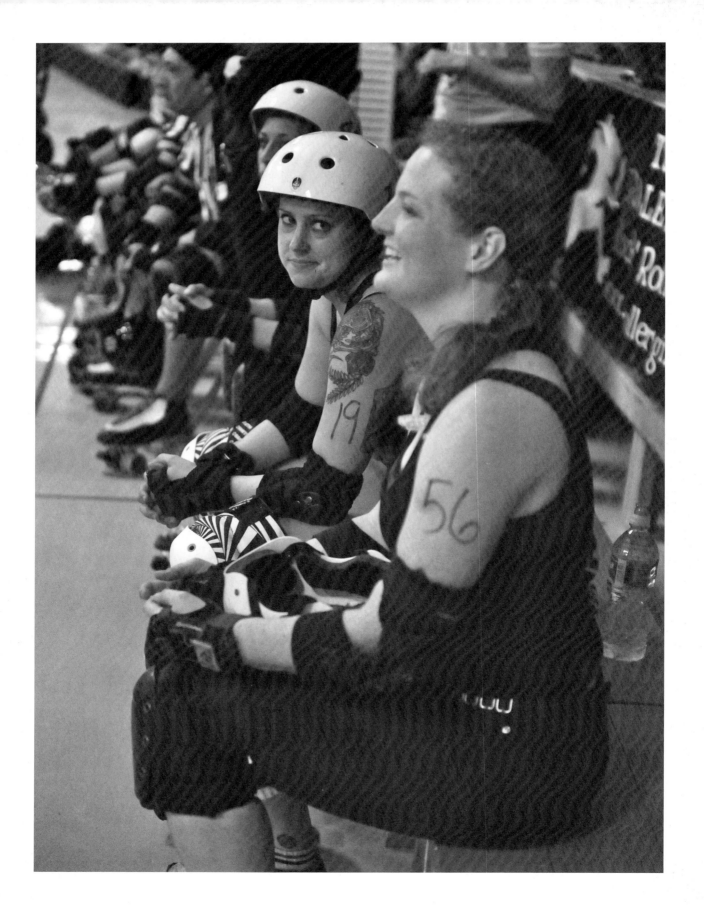

WE HAVE NOTHING IN COMMON AND EVERYTHING IN COMMON AT THE SAME TIME.

Molotov M. Pale & Lucille Brawl Austin, 2010

Barbarella Austin, 2007

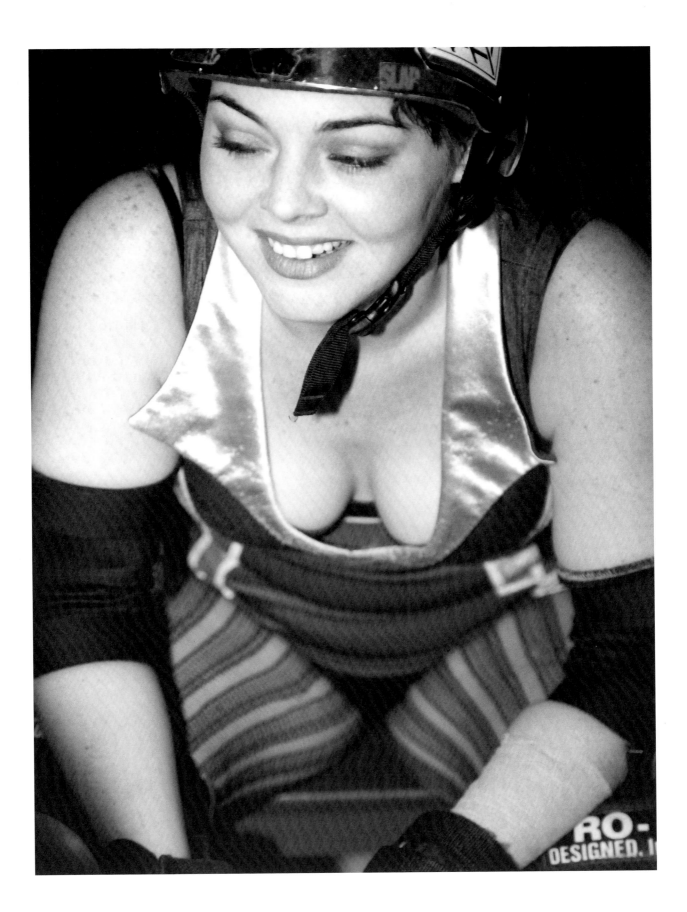

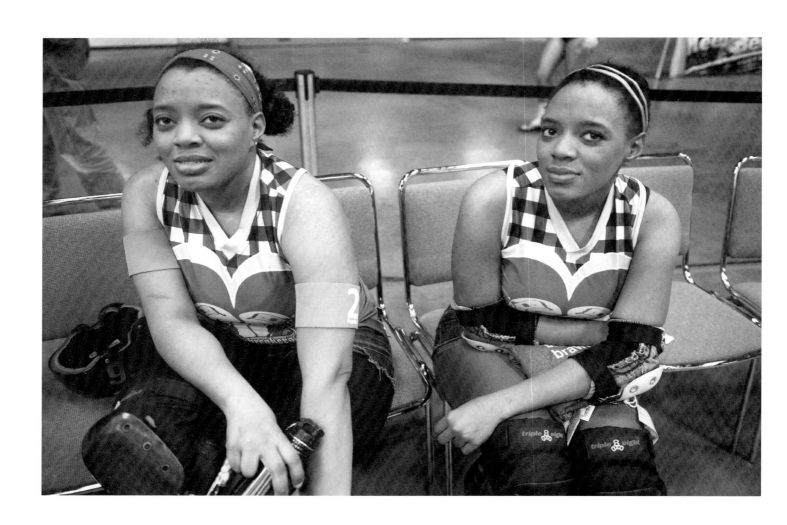

Derby Twins — Fender Bender & Ruby Wring Austin, 2014

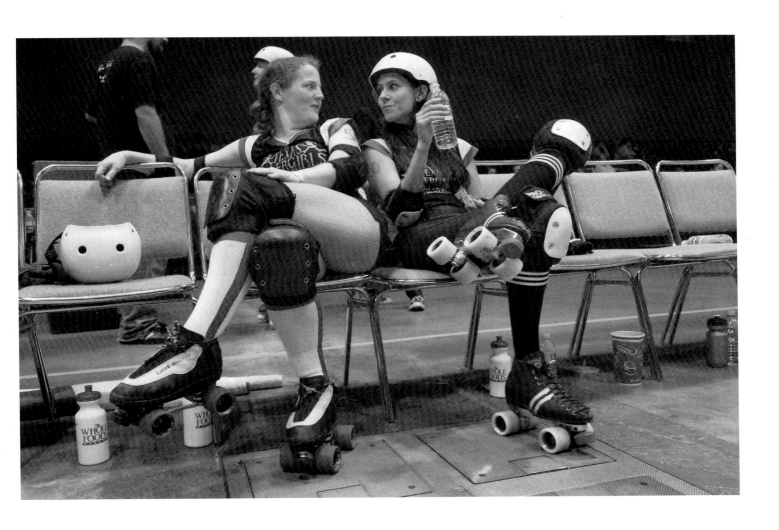

Lucille Brawl & Sparkle Plenty Nationals, Austin, 2007

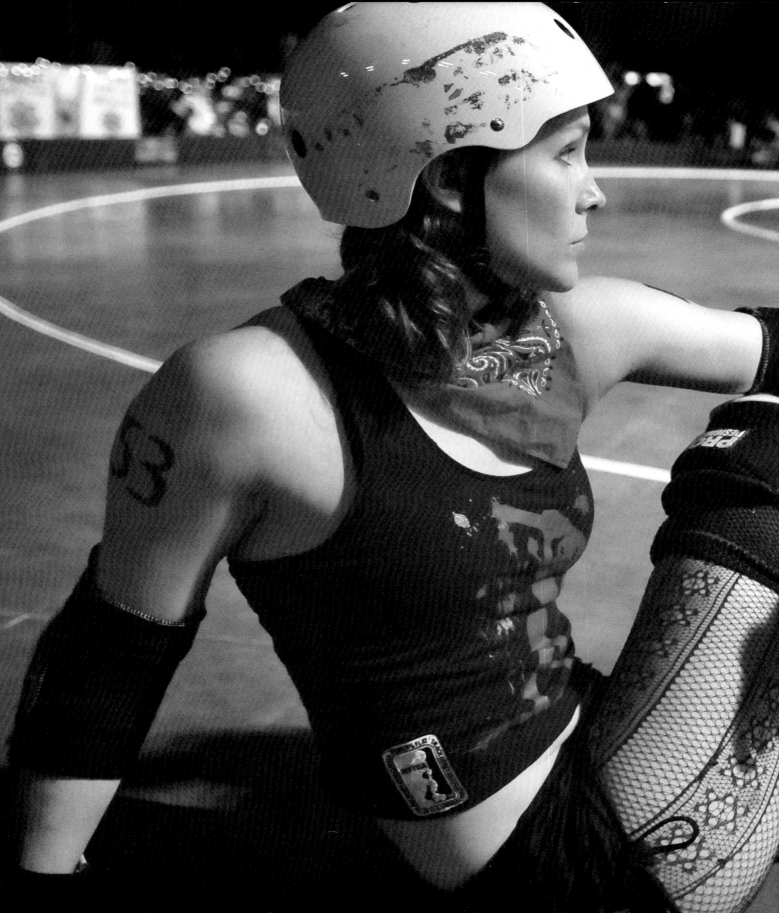

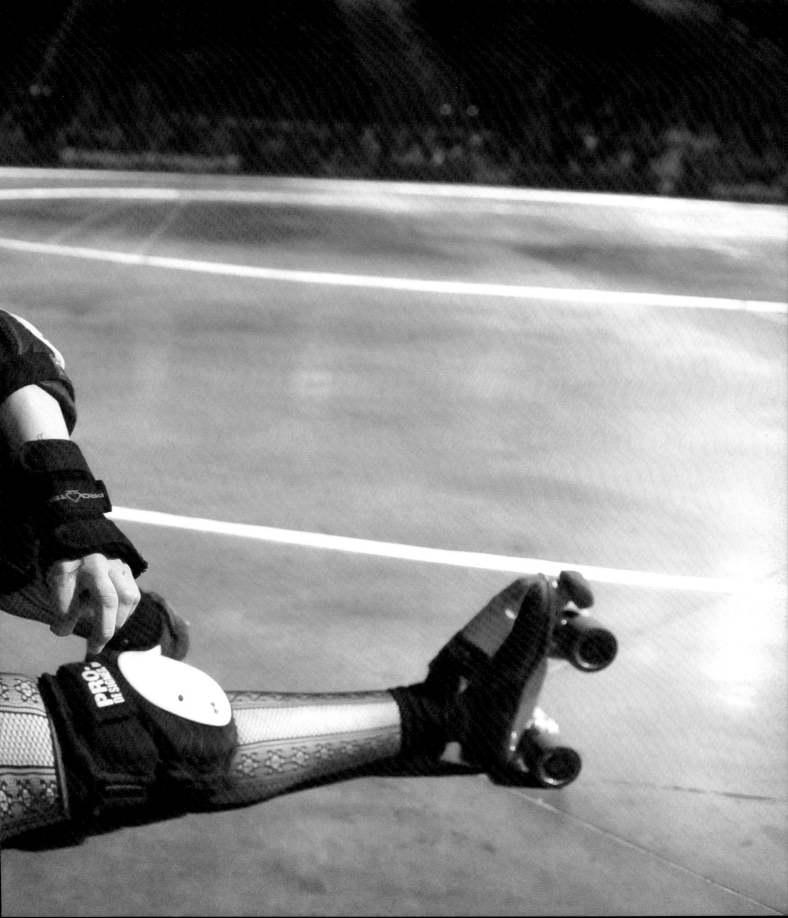

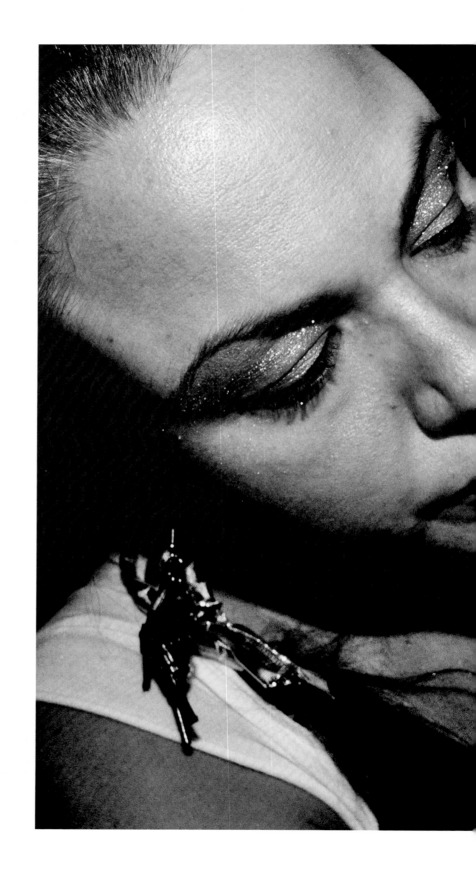

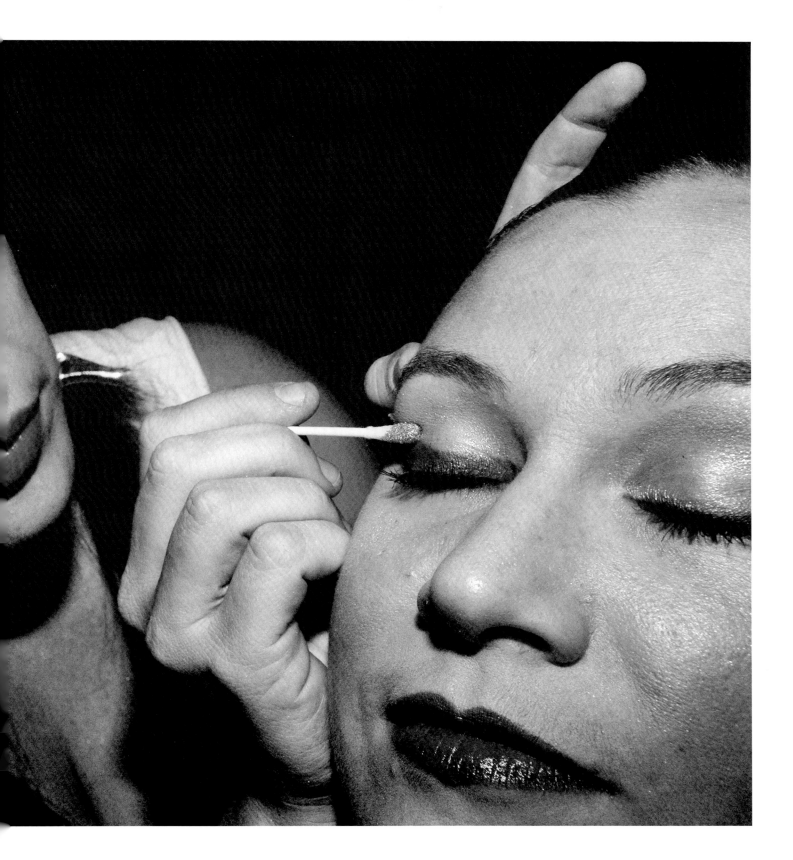

PREVIOUS SPREAD: **Vicious Van GoGo** Austin, 2011; ABOVE: **Bettie Page & Jen-N-Tonic** Austin, 2005

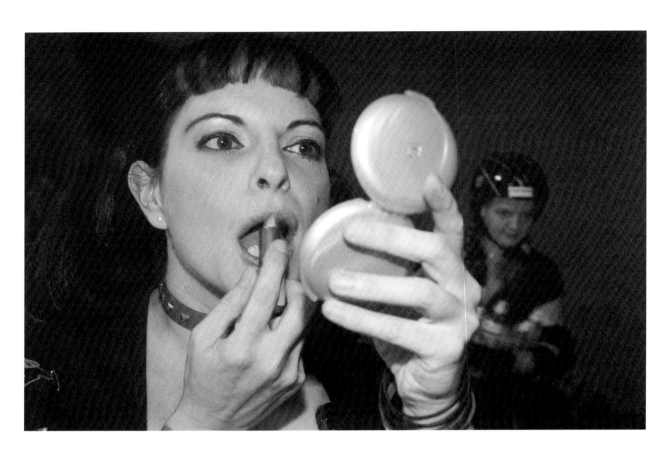

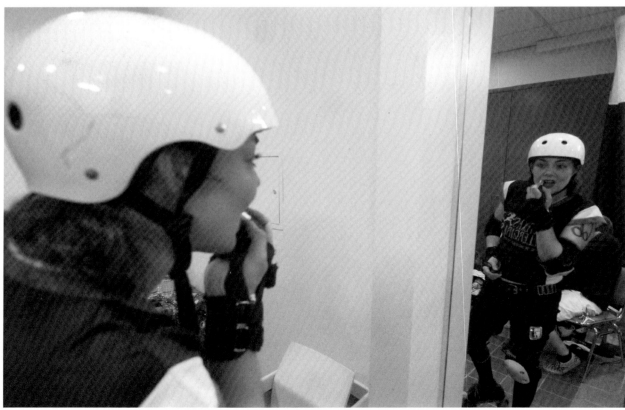

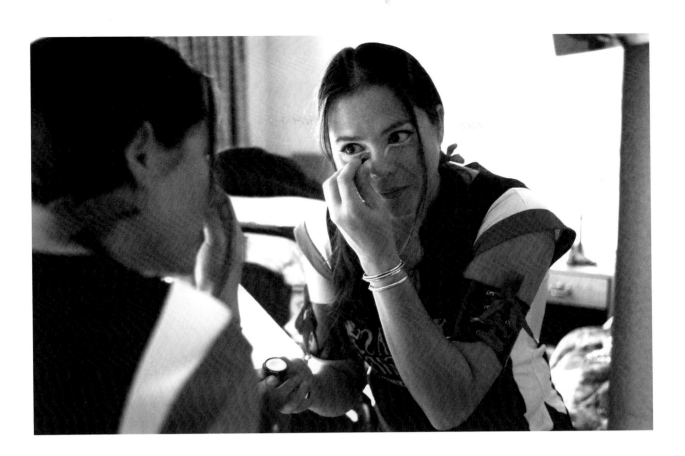
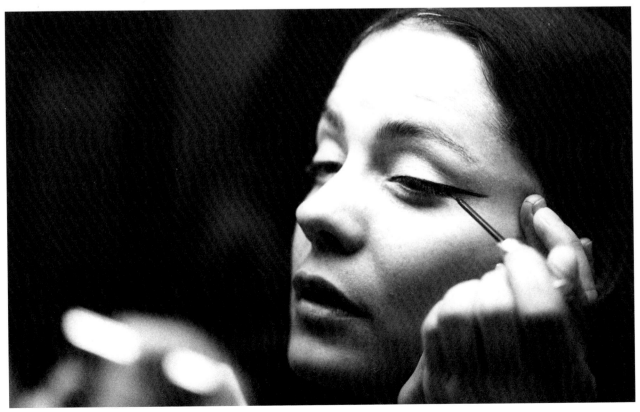

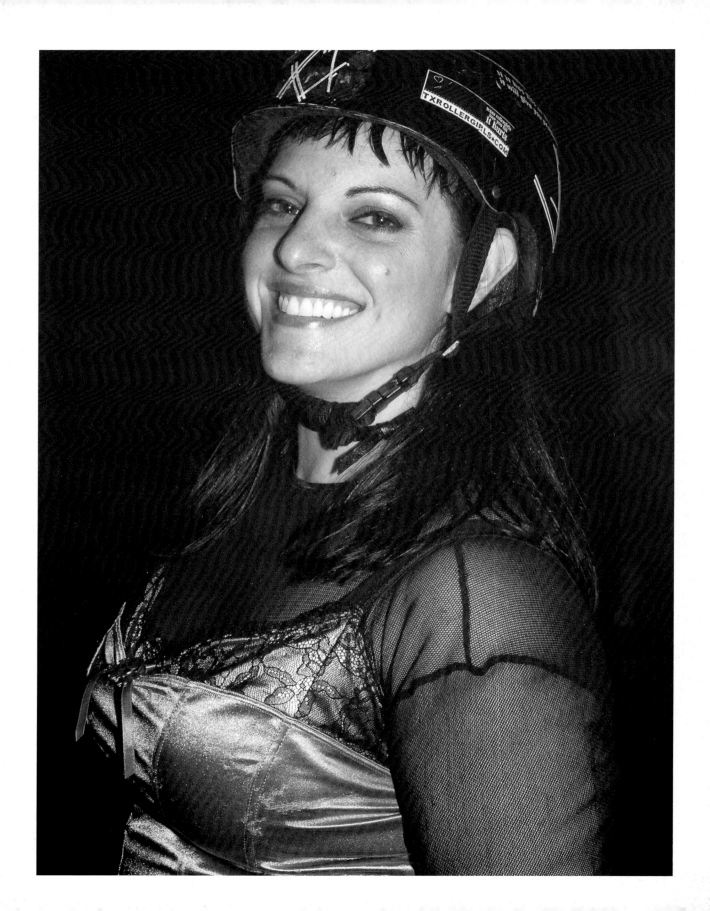

I HAVE GOTTEN TO KNOW MYSELF AND WHO I TRULY AM.

Pussy Velour Austin, 2006

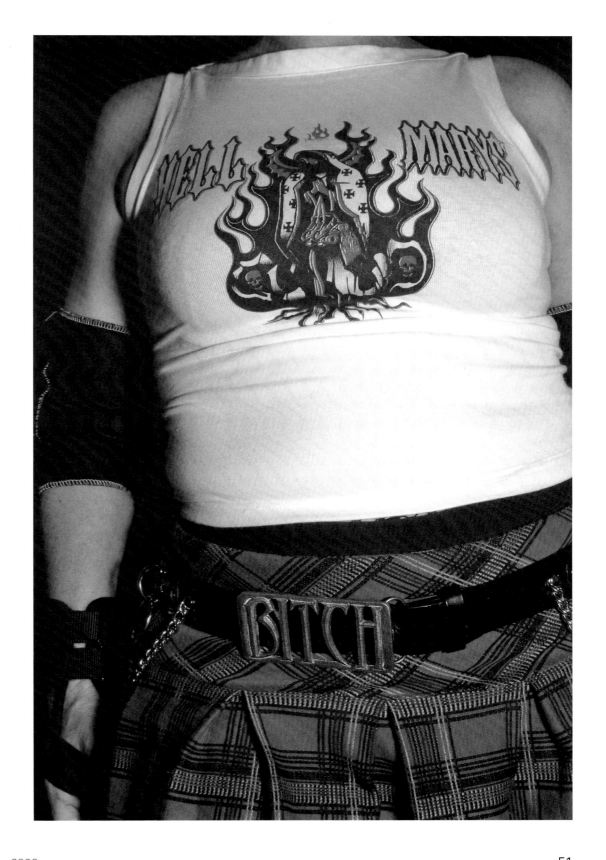

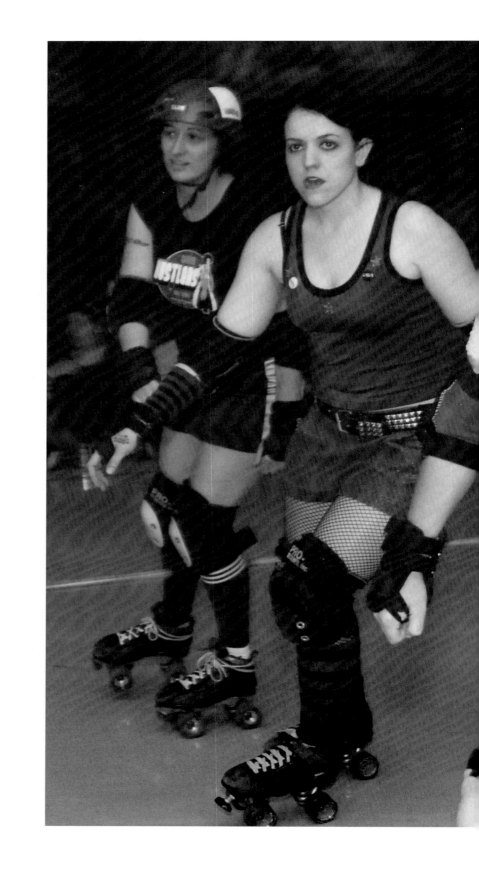

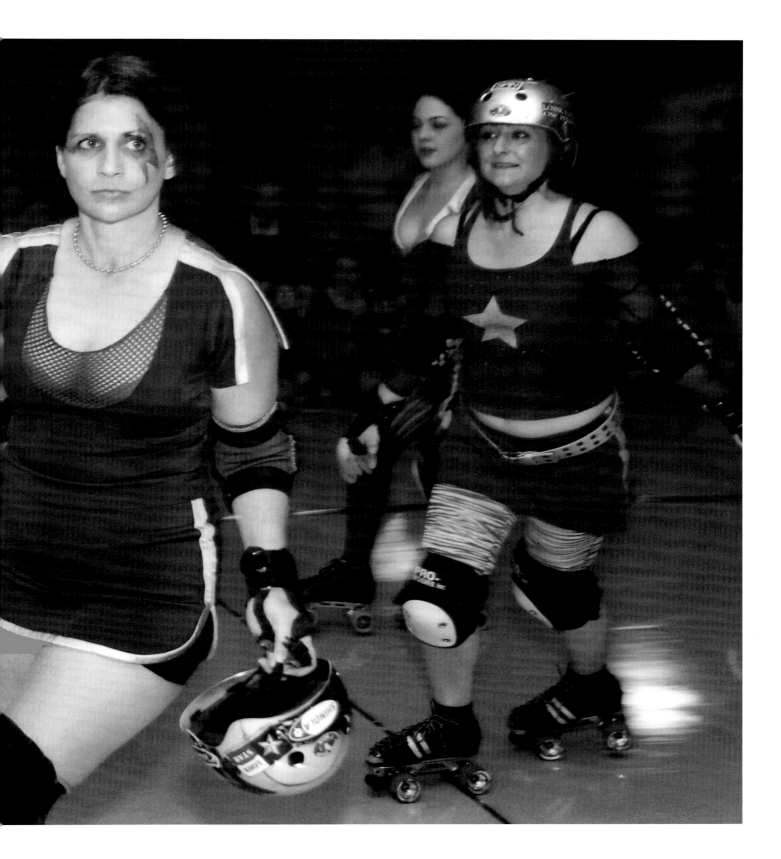

Slim Kickins, Cheap Trixie, Electra Blu, Barbarella & Pussy Velour of The Hustlers Austin, 2007

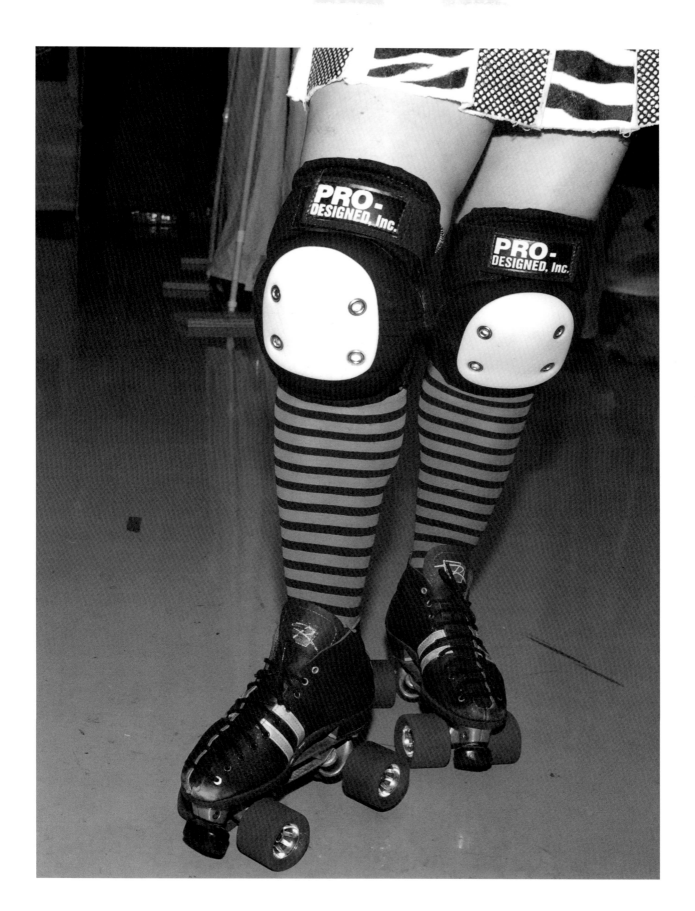

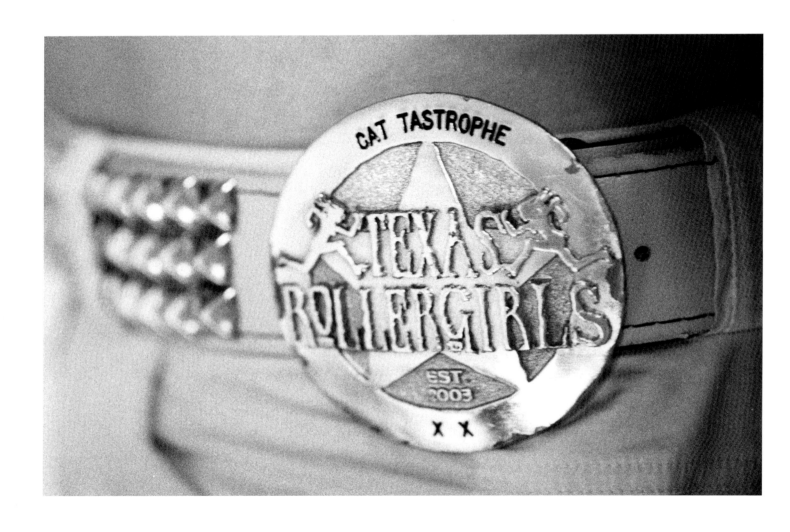

PREVIOUS SPREAD: (Left to Right) **Boots** Austin, 2005; **Skates** Austin, 2006; ABOVE: **Belt Buckle** Tuscon, 2006

Chainsaw Austin, 2010

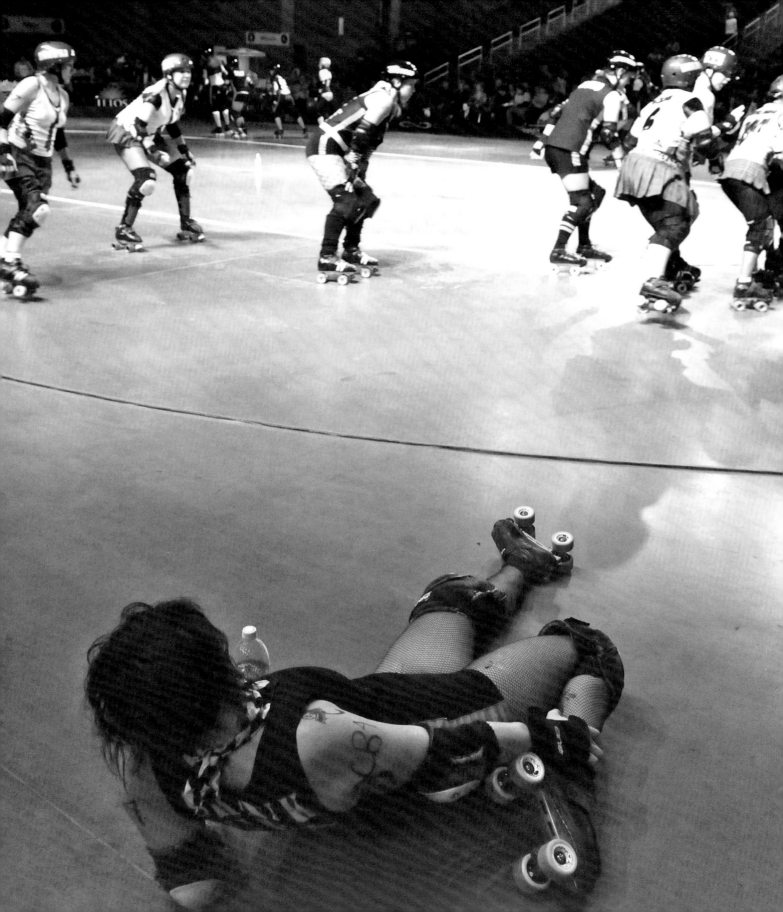

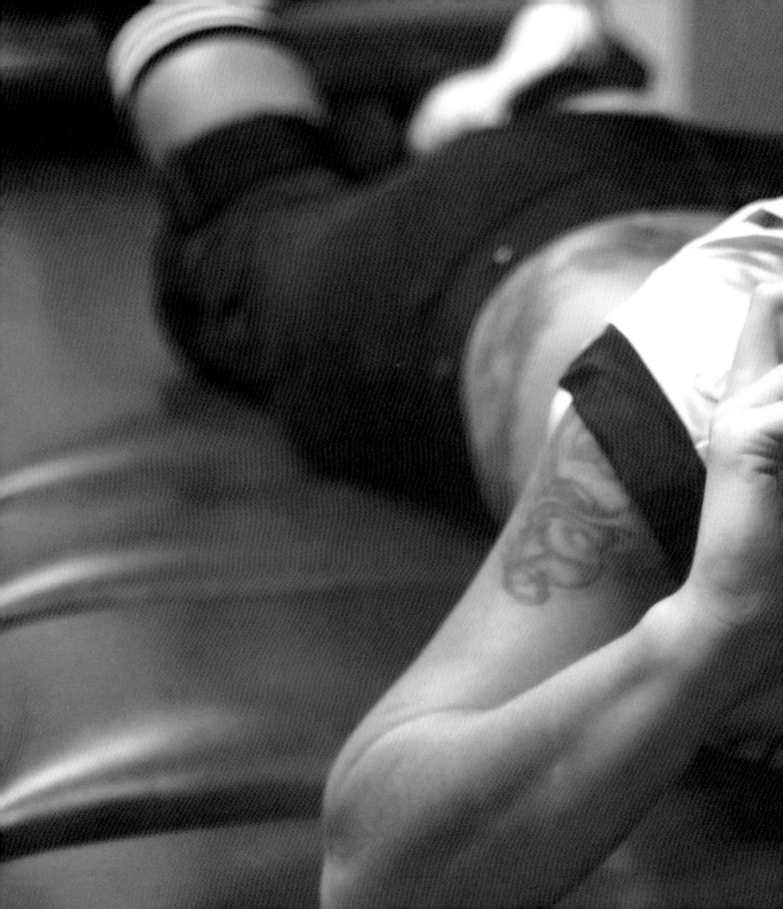

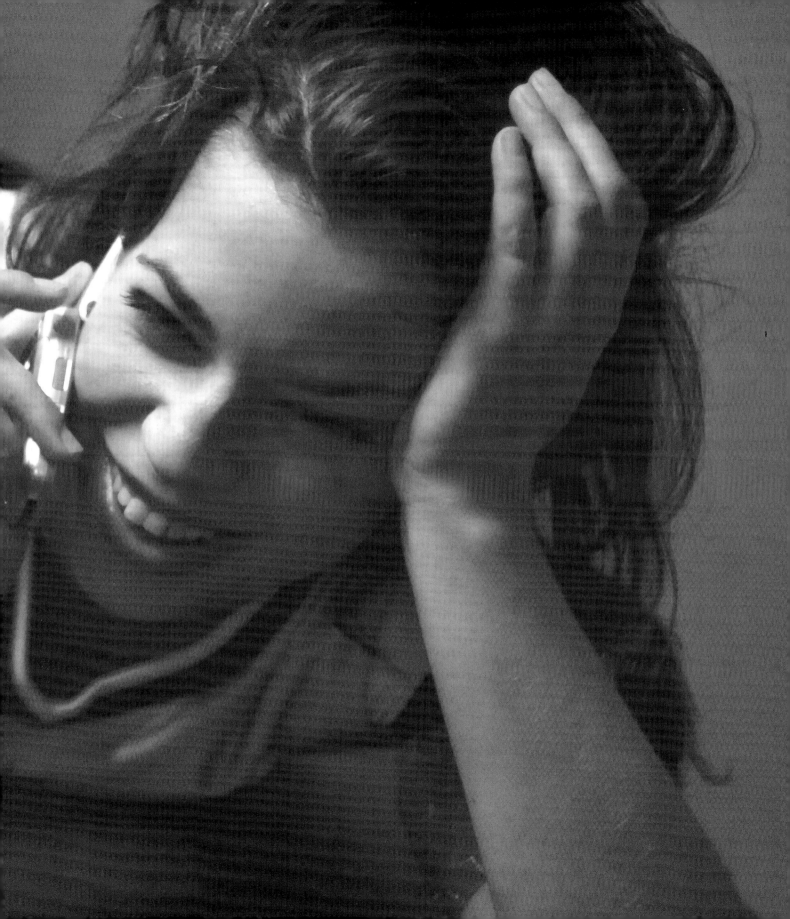

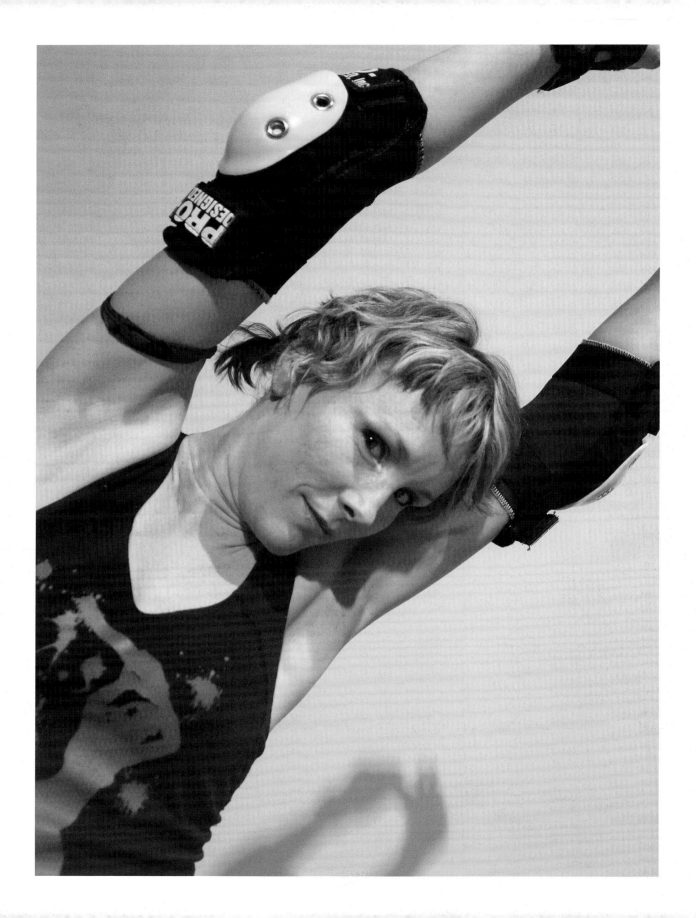

IT IS A WAY TO PLAY A PHYSICAL SPORT, HAVE FUN, AND STILL BE A GIRL.

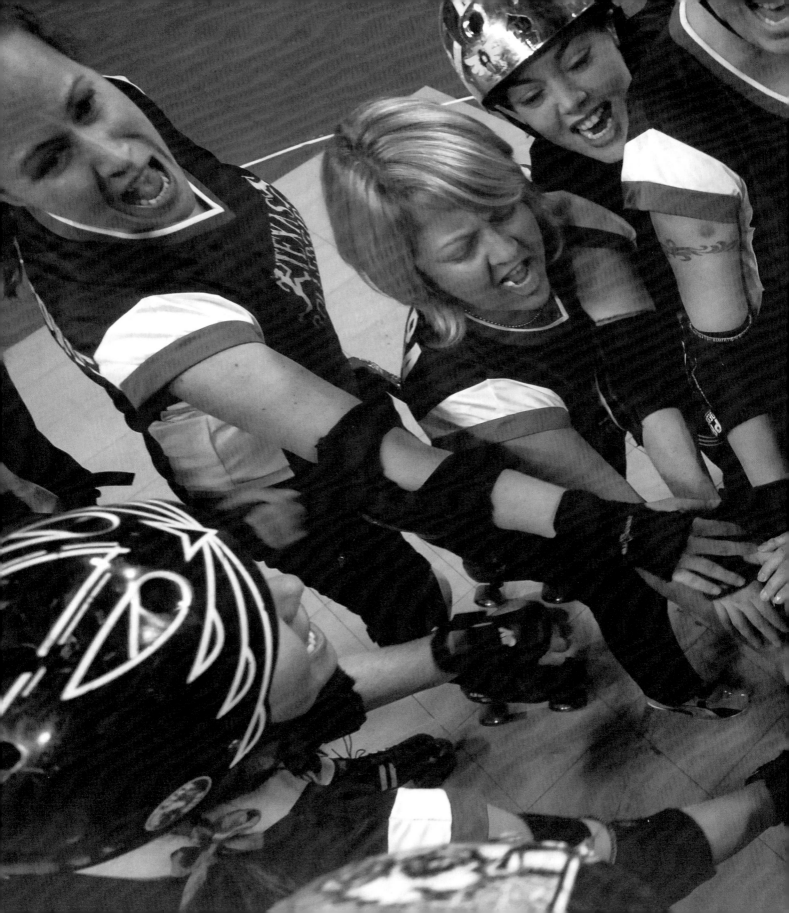

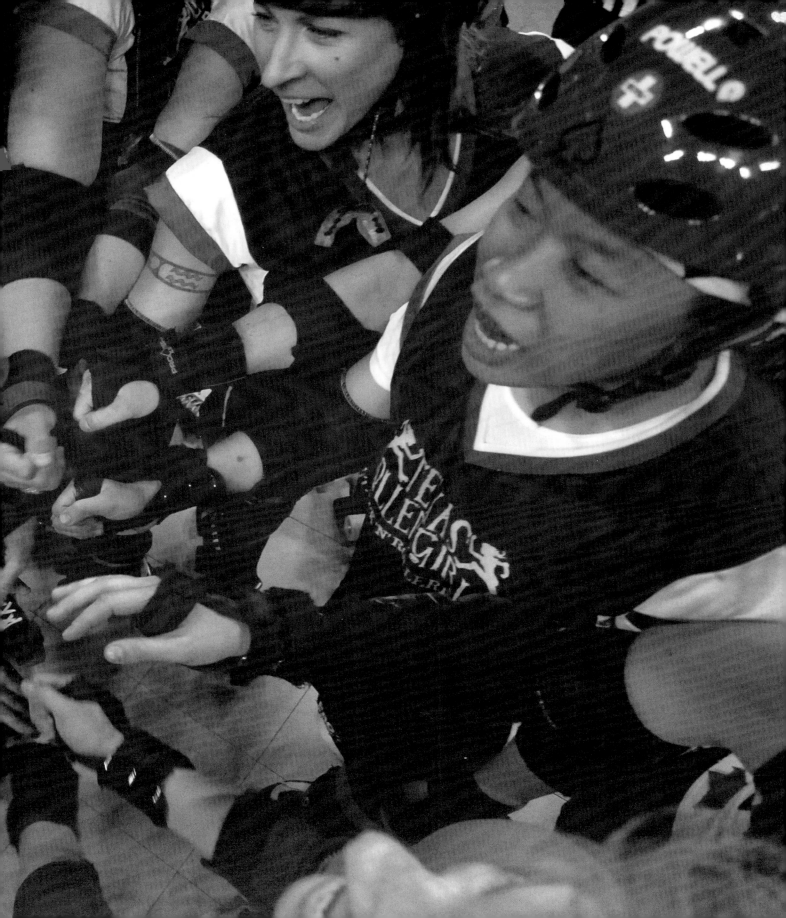

Derby Tattoo Nationals, Austin, 2007

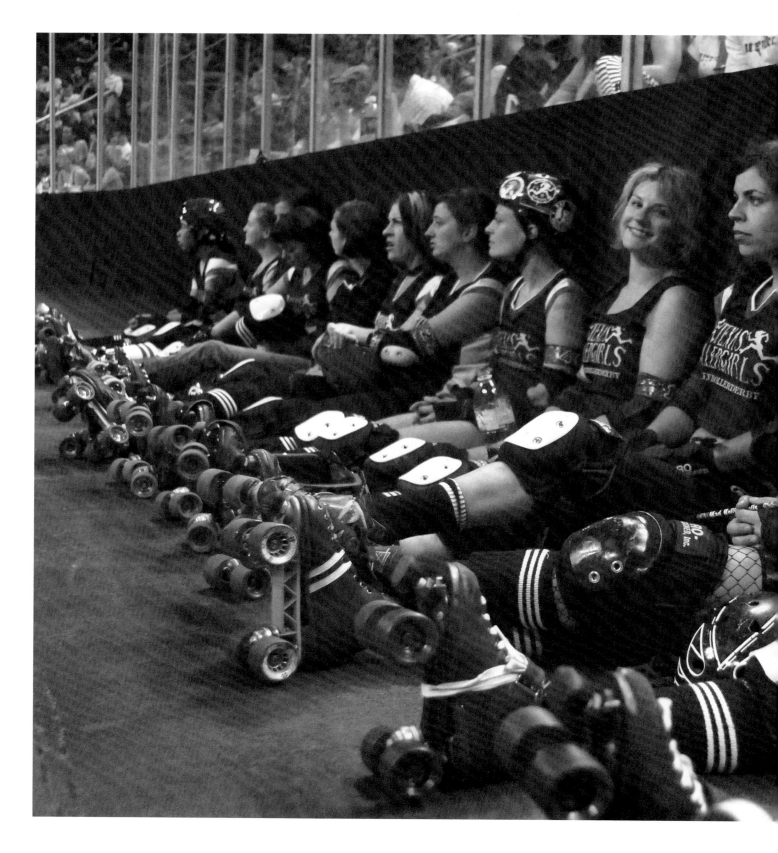

Texecutioners Seattle, 2006

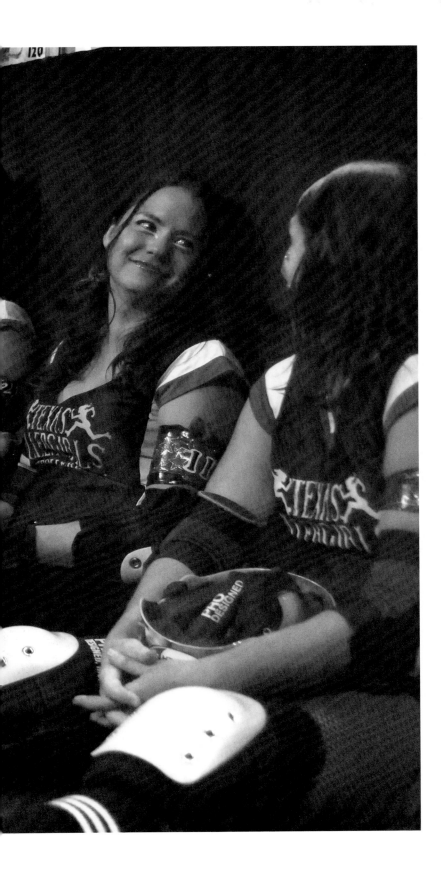

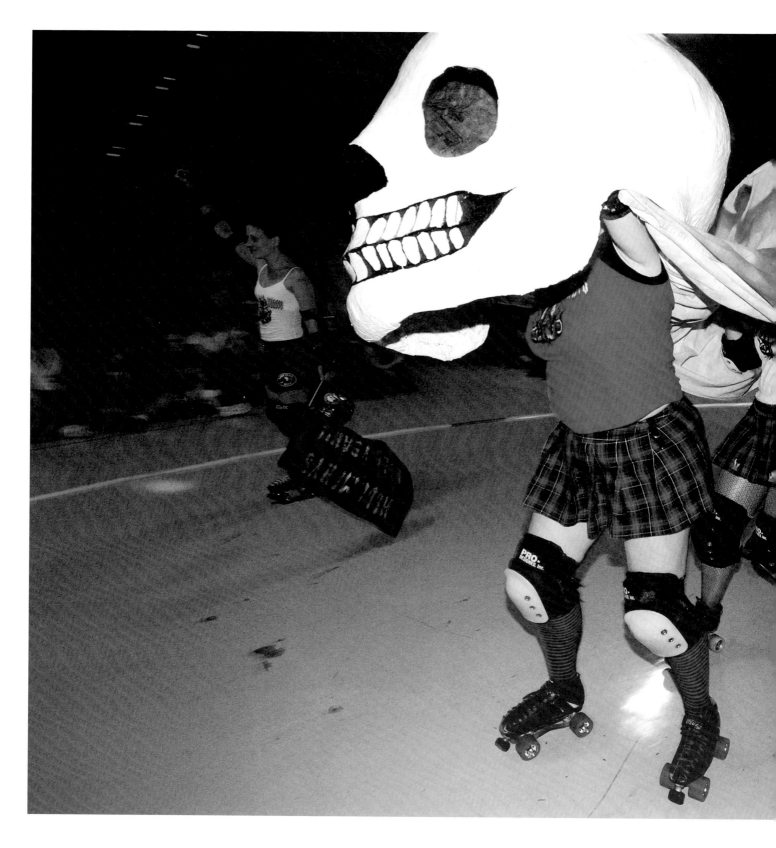

Intro for Hell Marys Austin, 2005

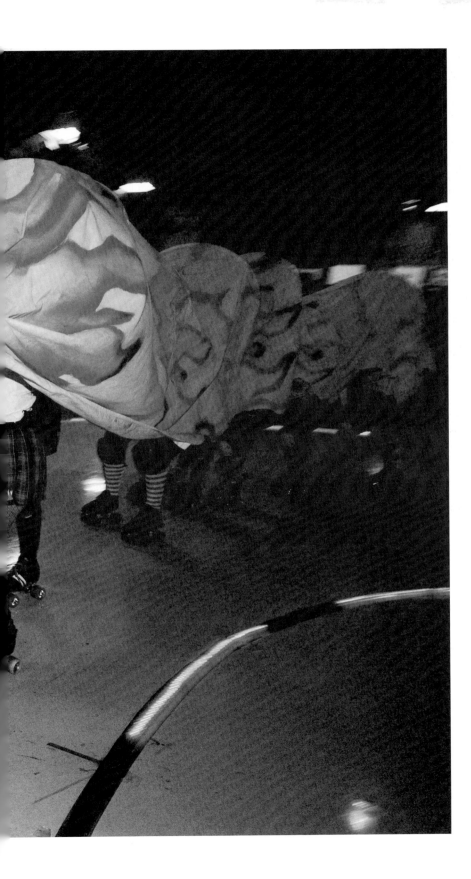

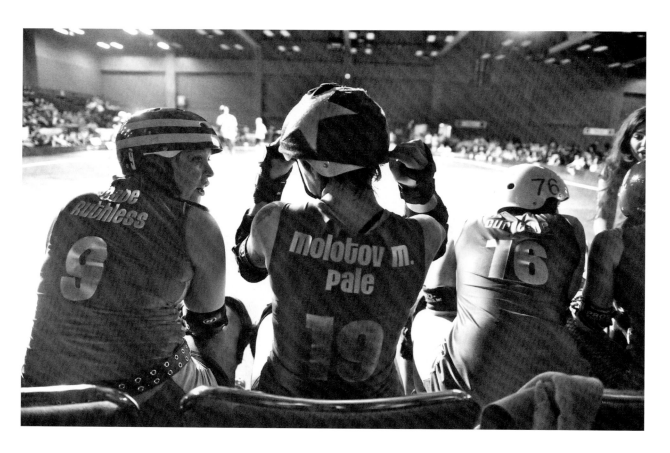

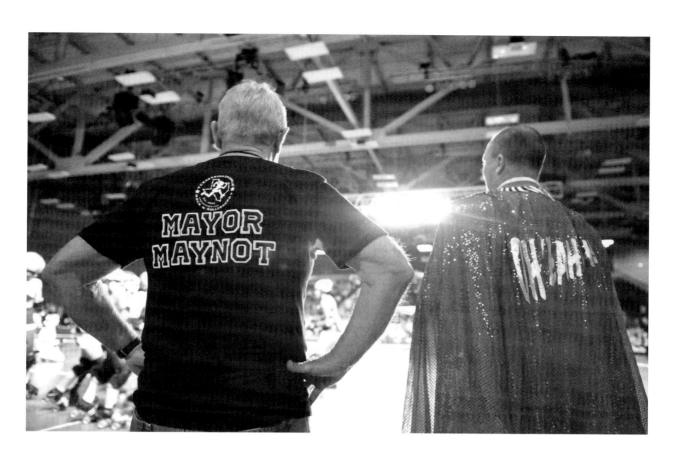

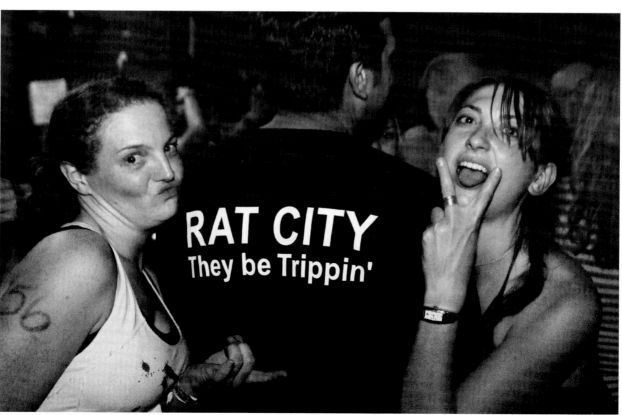

ROLLER DERBY MADE ME FACE MY FEAR OF BEING IN THE SPOTLIGHT, OR BEING THE CENTER OF ATTENTION.

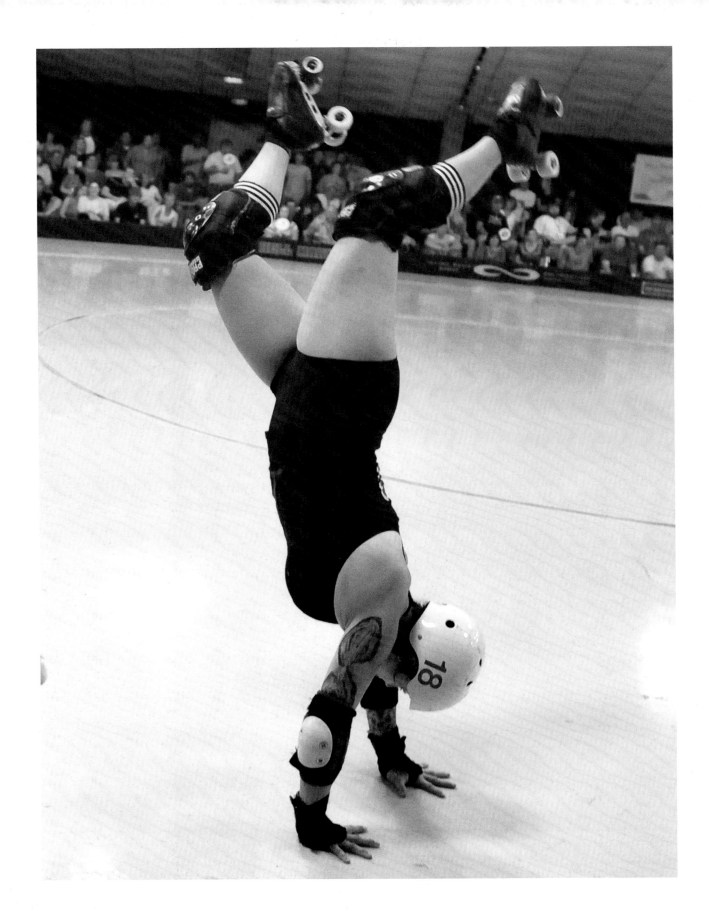

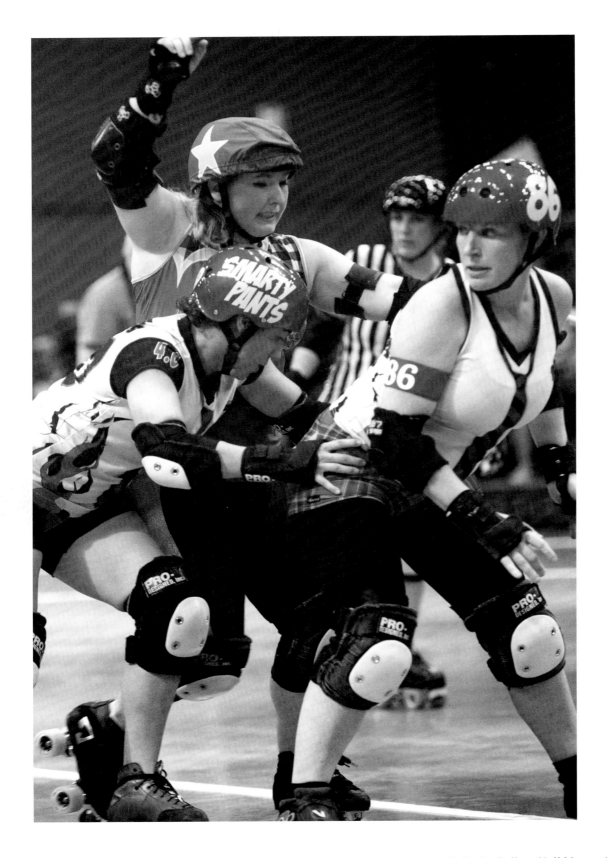

Bella De Ball vs. Hell Marys Austin, 2013

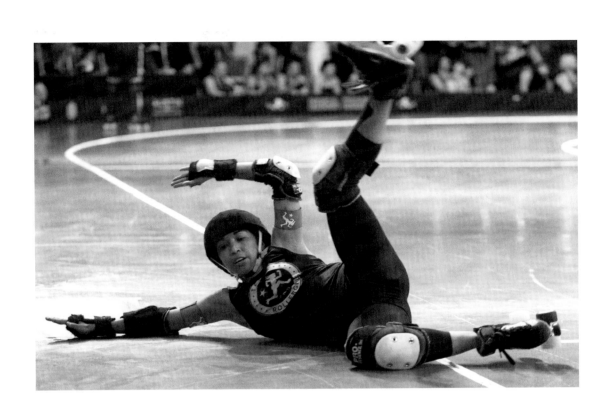

ABOVE: **Baby Face Assassin** Austin, 2012; FOLLOWING SPREAD: (Left to Right)
LuAnne Splatter Austin, 2011; **Haas Da Boss vs. The Killa Sal Monella** Austin, 2011

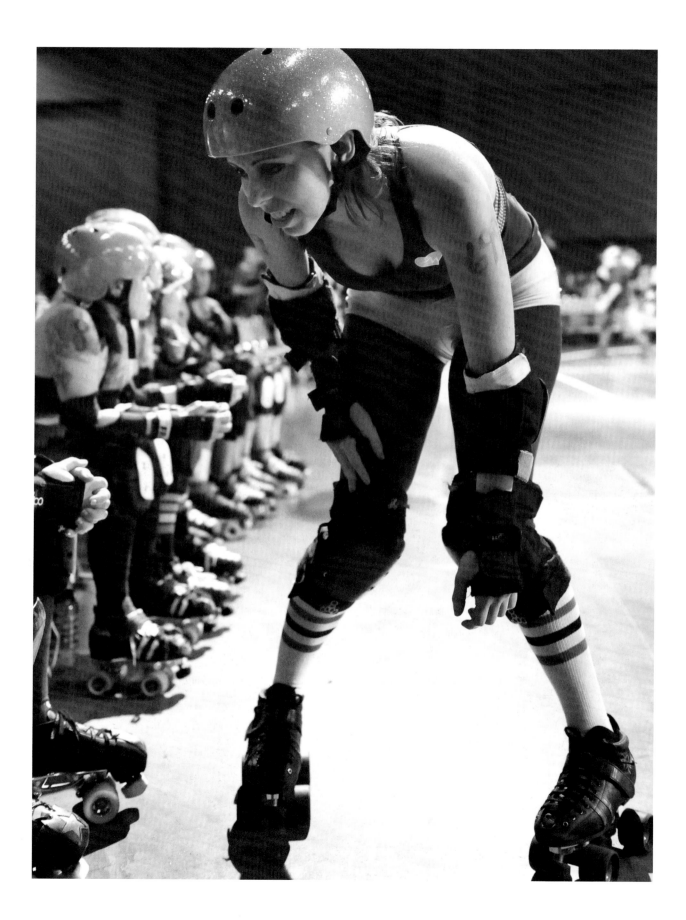

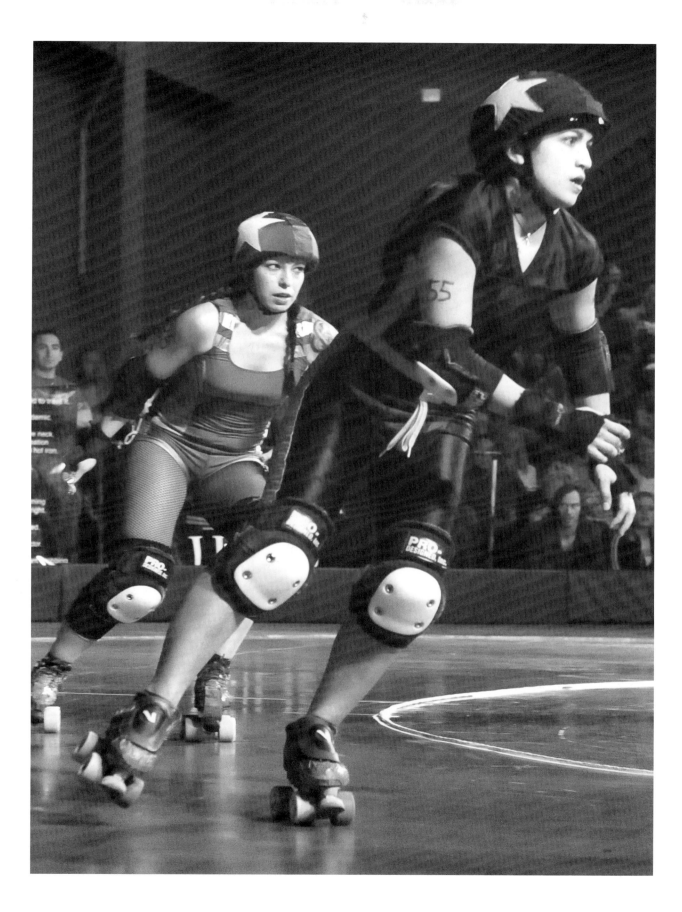

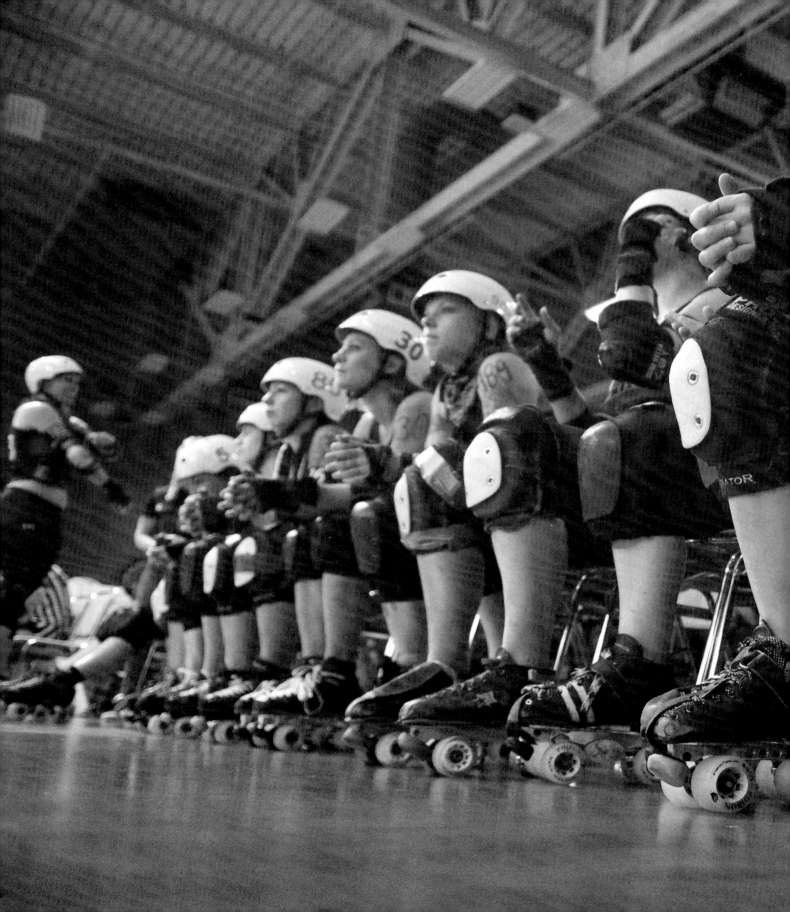

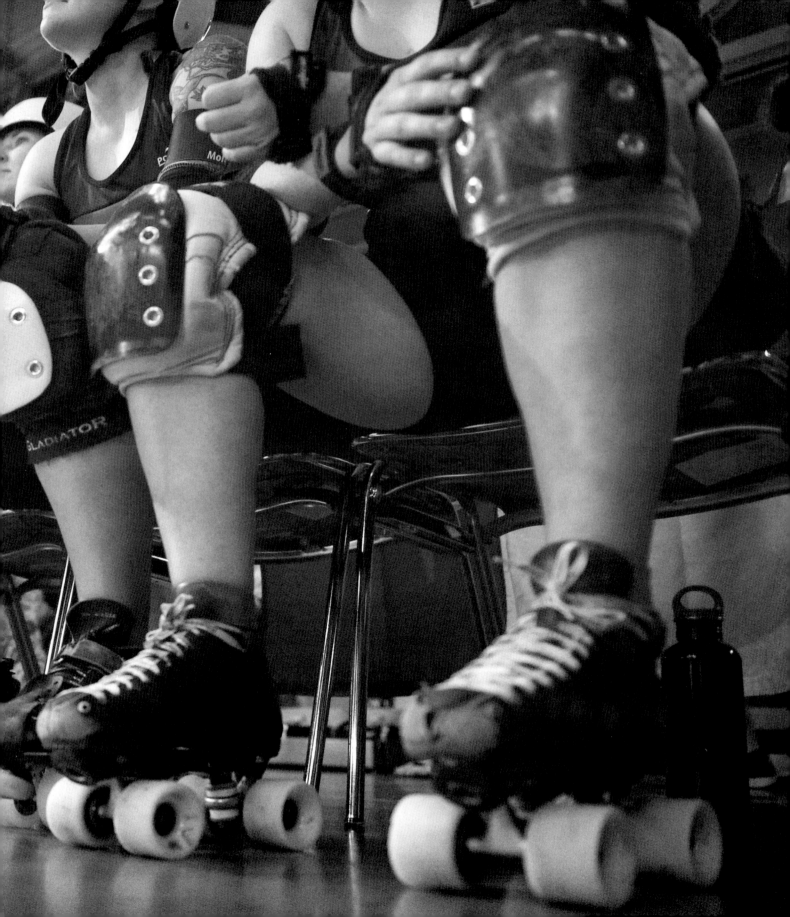

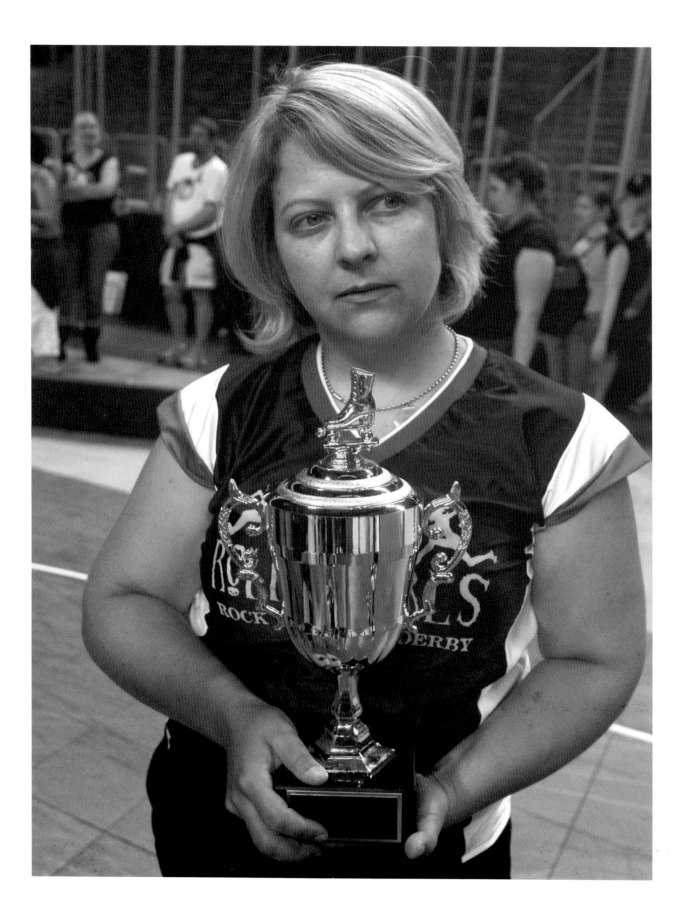

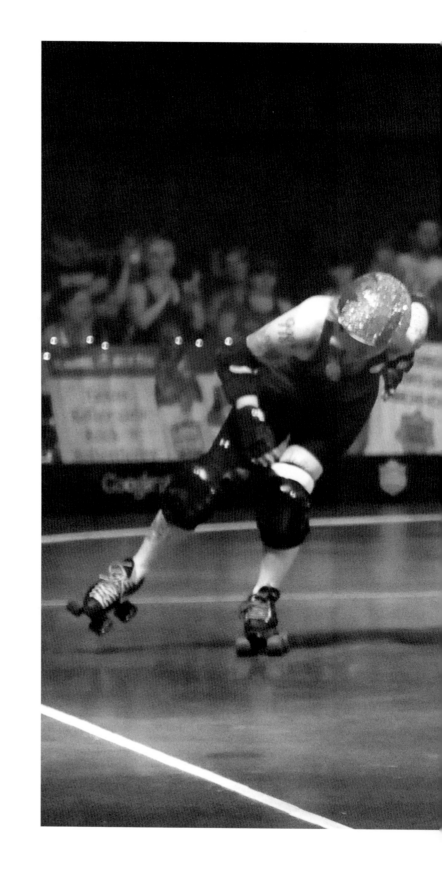

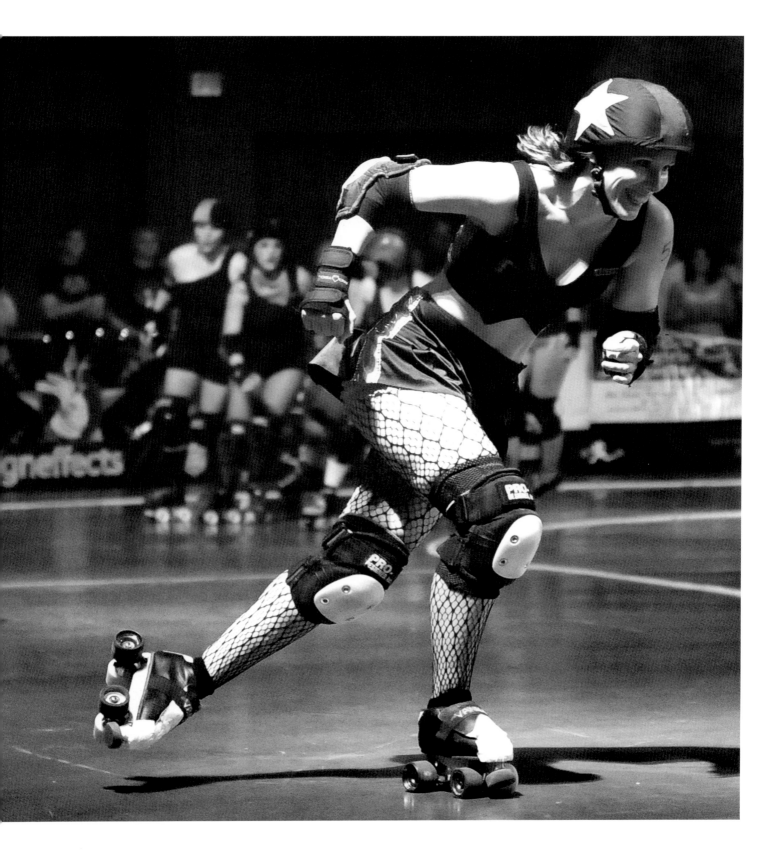

Vicious Van GoGo Austin, 2011

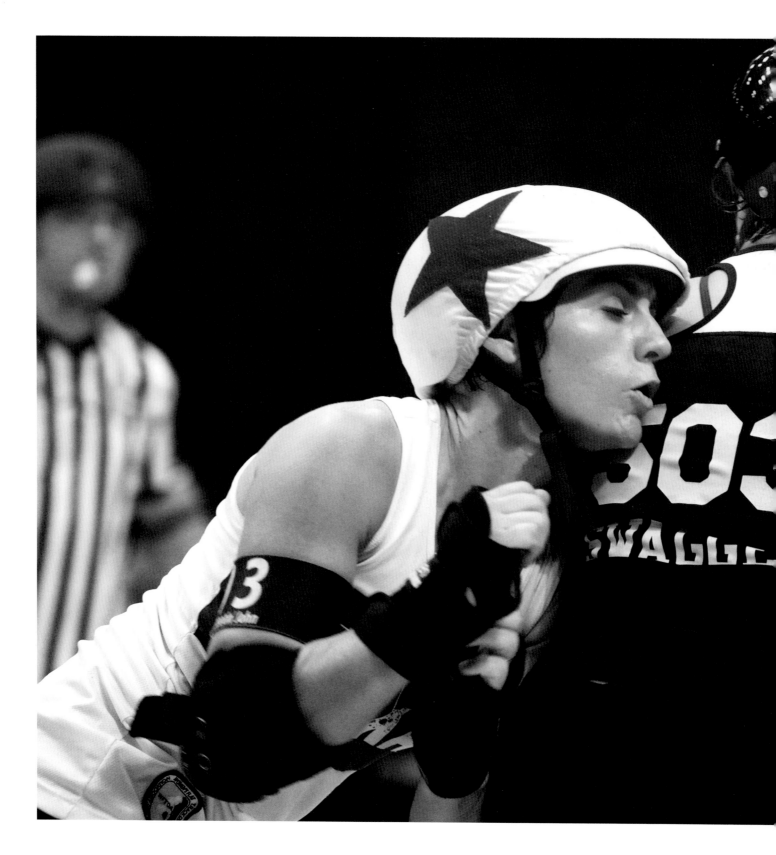

Olivia Shootin' John Austin, 2012

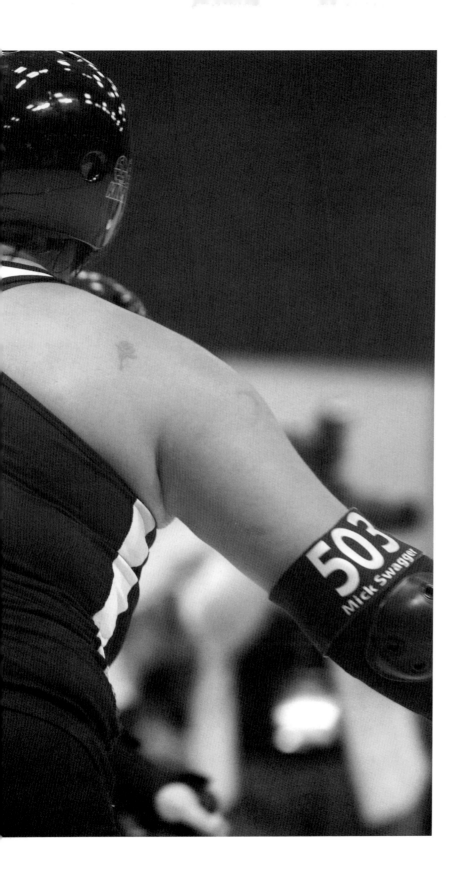

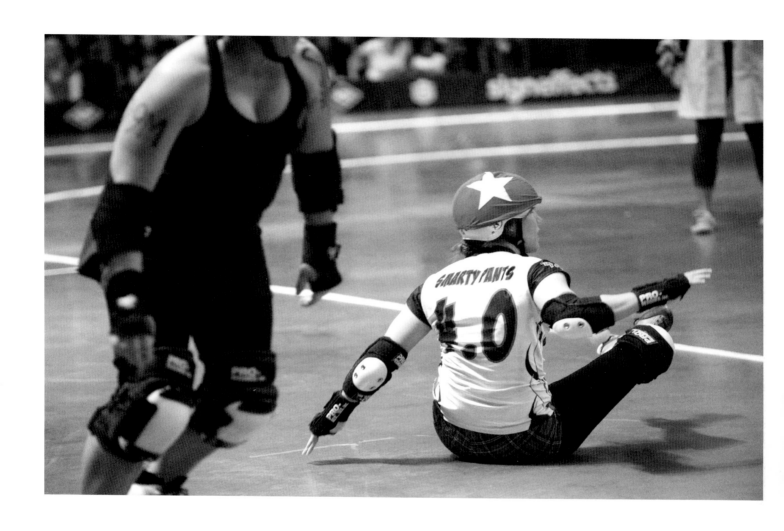

Smarty Pants Austin, 2012

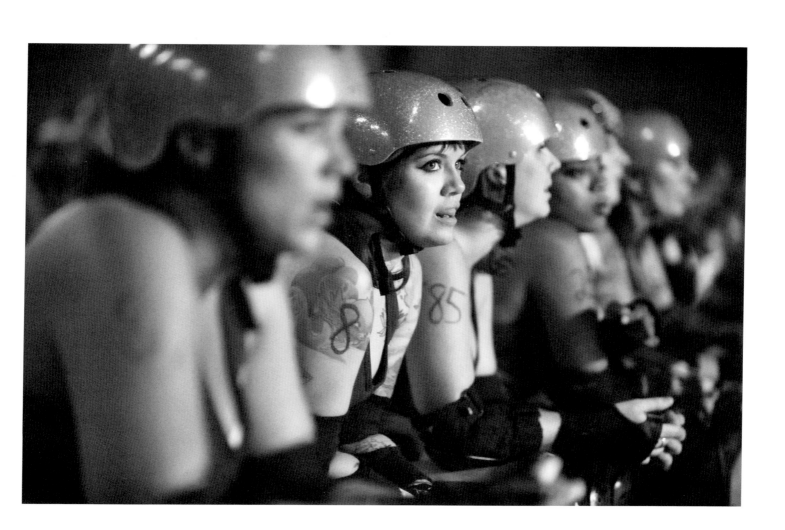

Big Nasty Austin, 2011

Dagger Deb & Buckshot Betsy Nationals, Austin, 2007

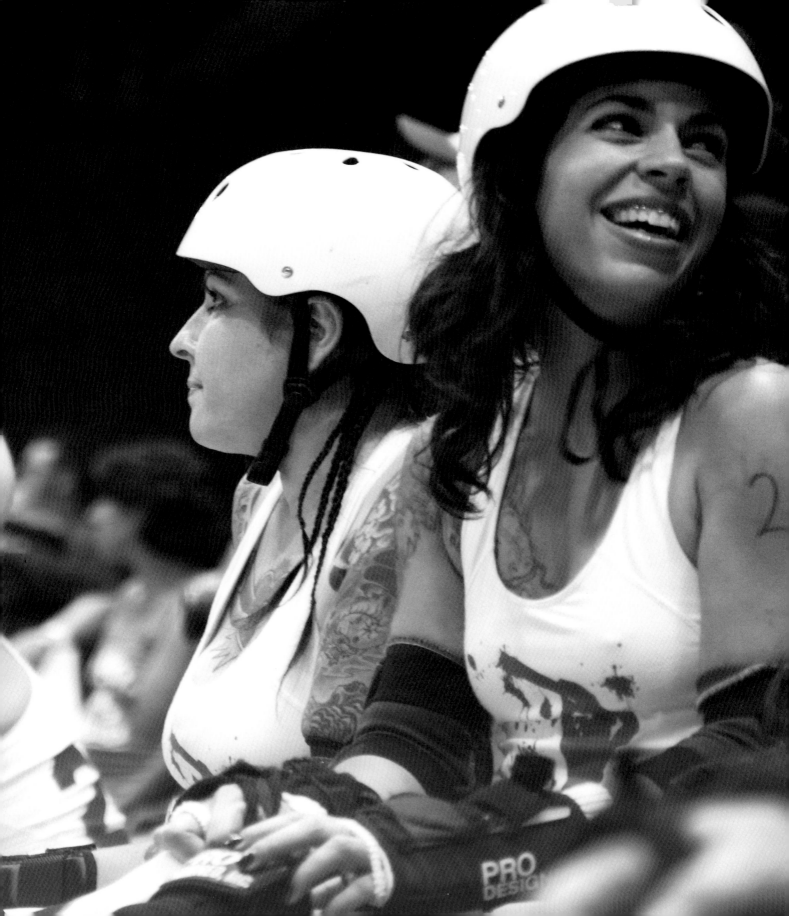

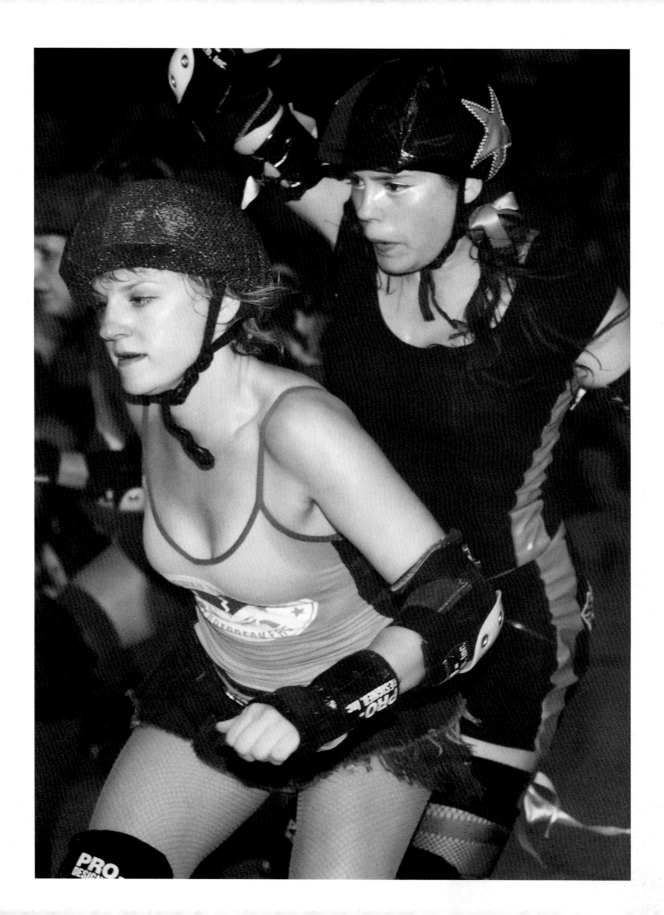

ROLLER DERBY IS LIKE BALLET EXCEPT THE DANCERS HIT EACH OTHER!

Trouble vs. Cat Tastrophe Austin, 2006

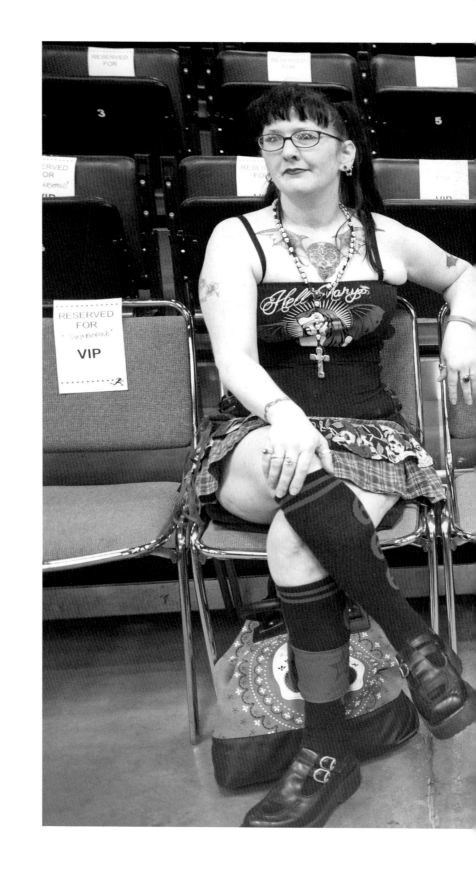

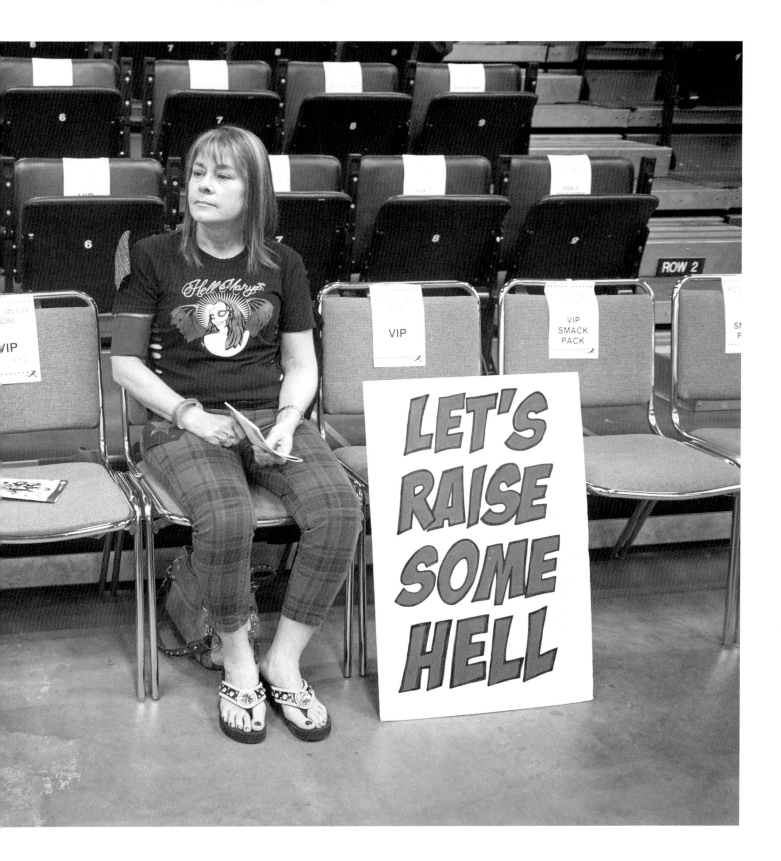

Hell Mary Fans Austin, 2012

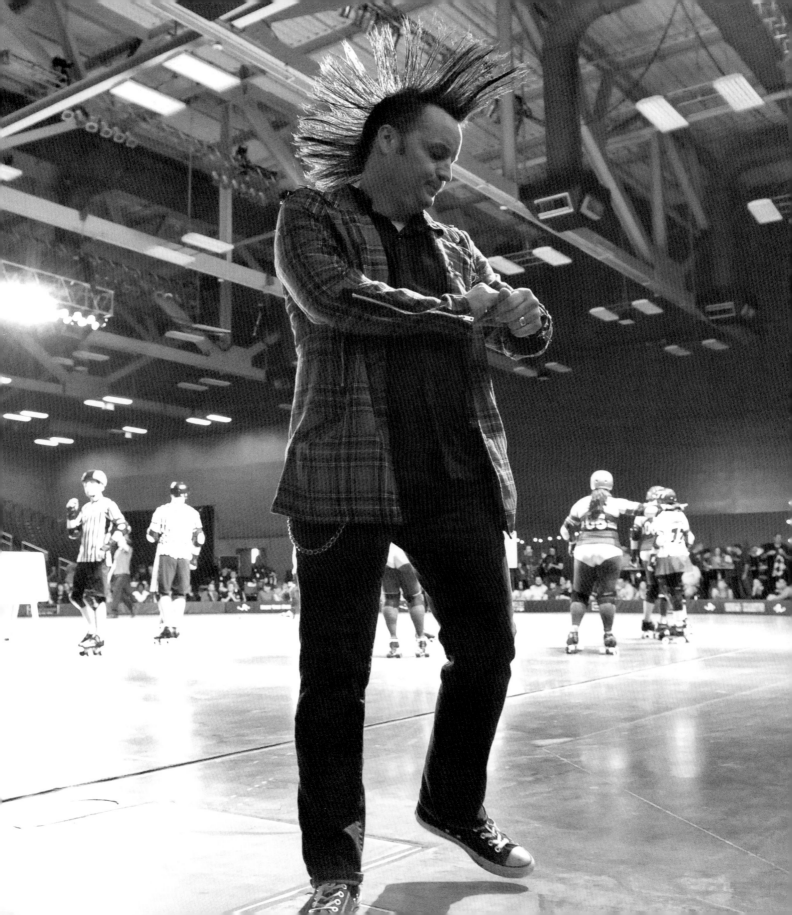

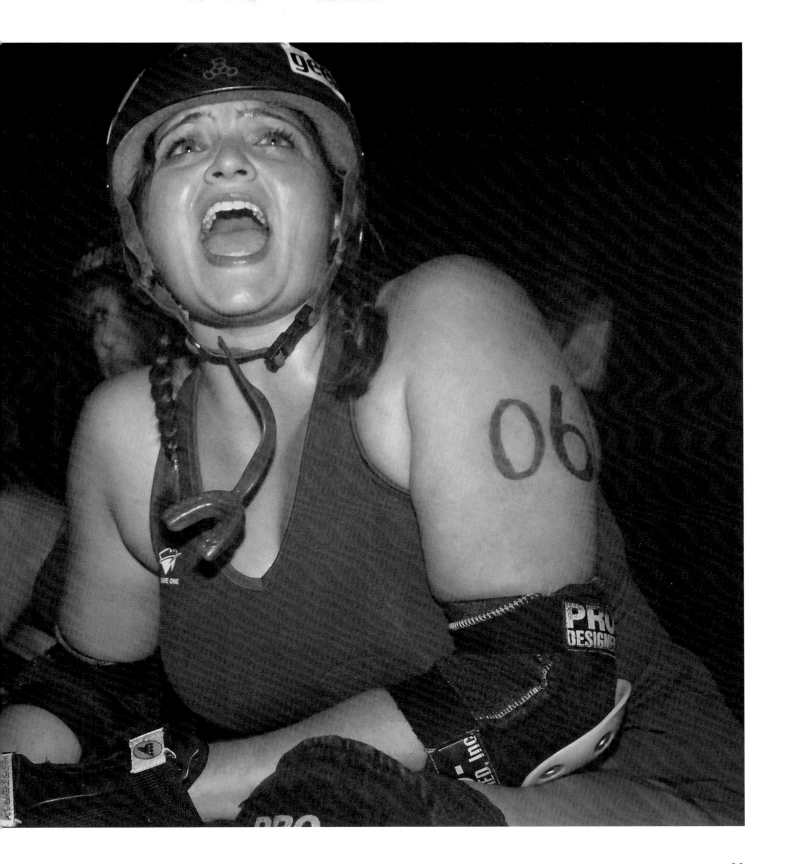

Sic Shooter & Honkytonk Heartbreakers Houston, 2007

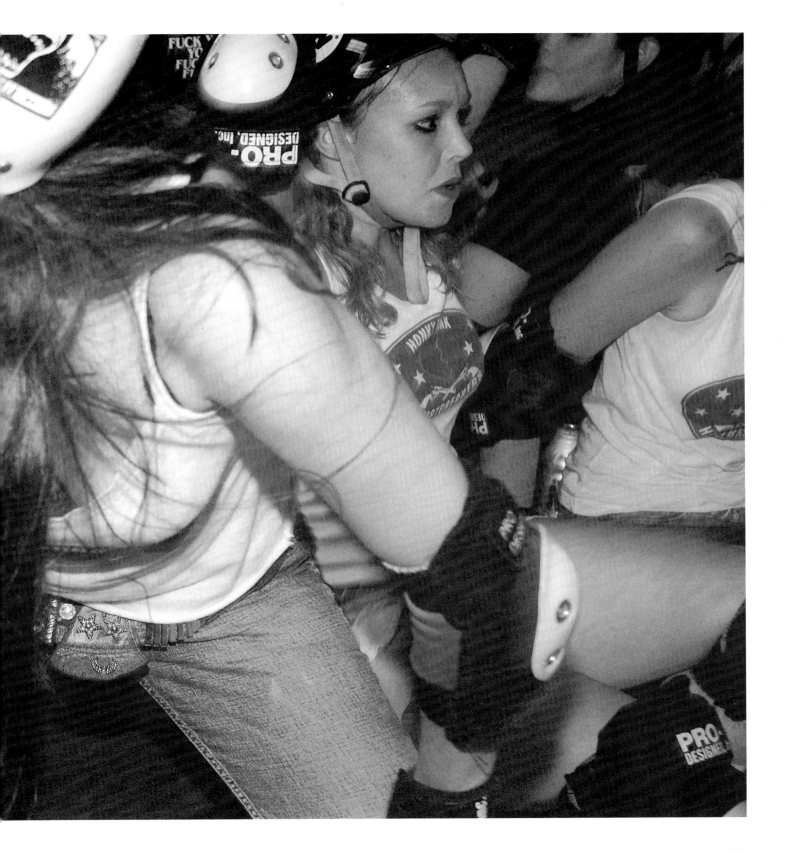

ABOVE: **Sparkle Plenty** Austin, 2005; FOLLOWING SPREAD: **Sedonya Face** Austin, 2007

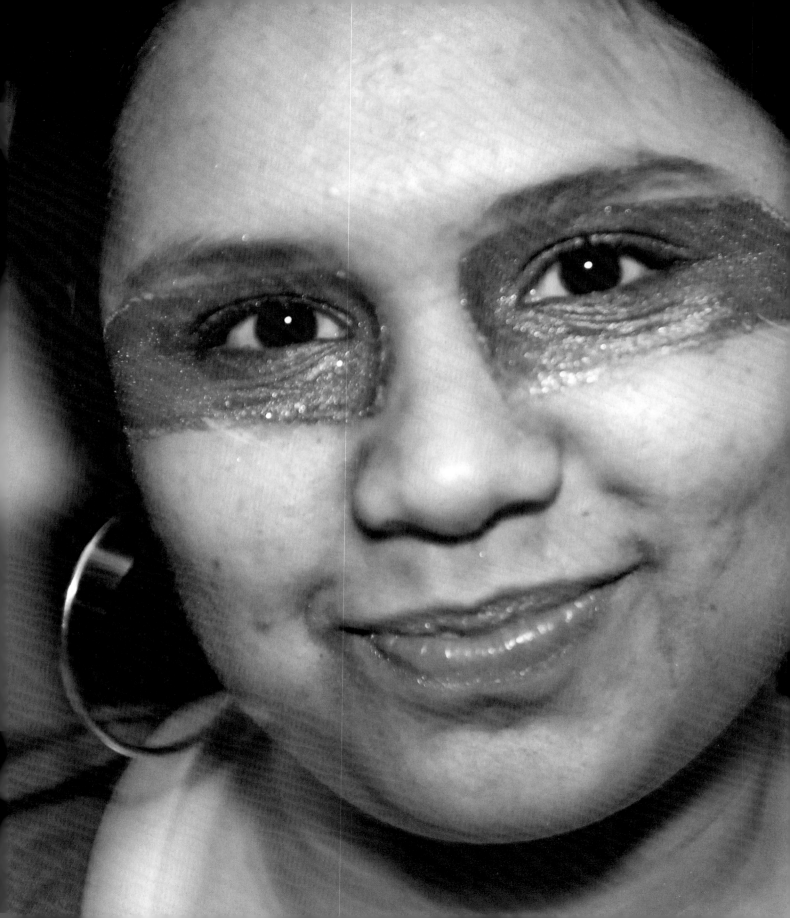

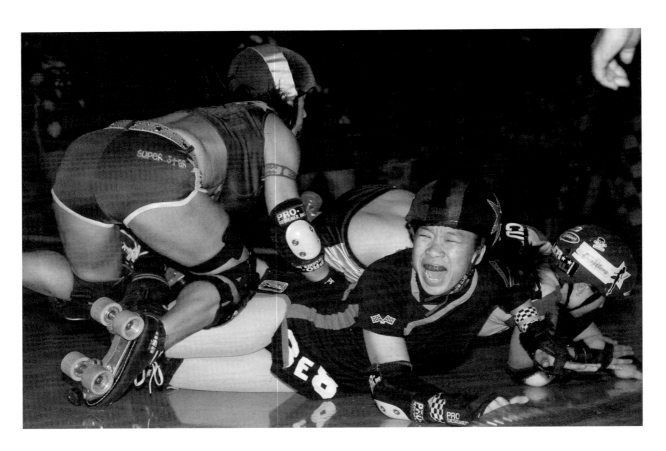

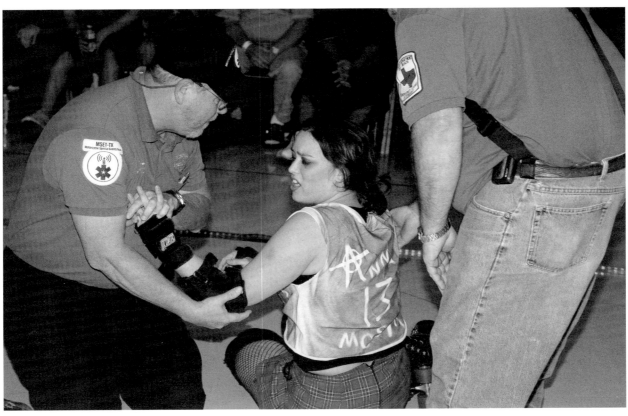

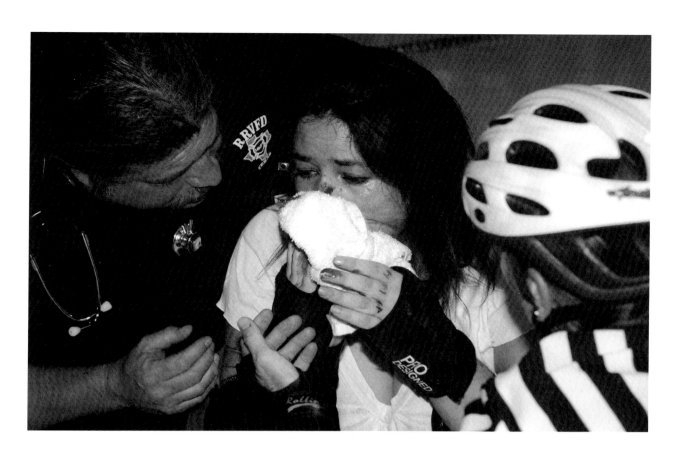

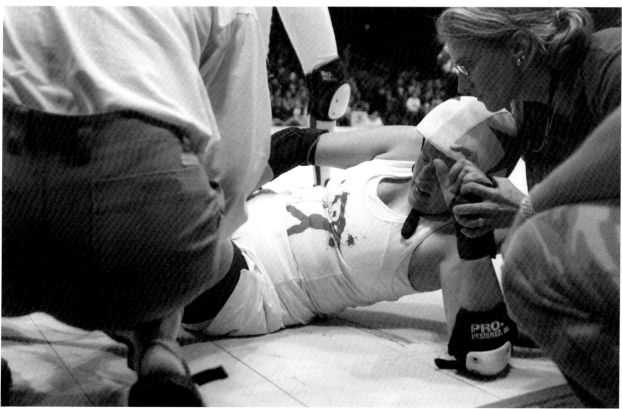

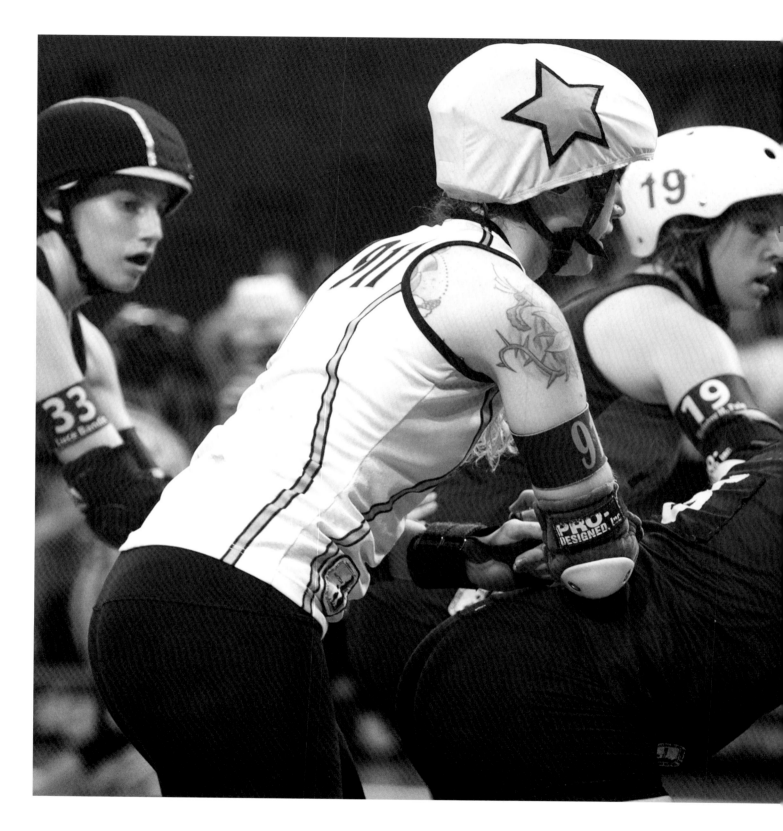

PREVIOUS SPREAD: (Clockwise from Top Left)
Rice Rocket Austin, 2007; **Crusher** Austin, 2005; **Lady X** Nationals, Austin, 2007;
Anna Mosity Austin, 2005; ABOVE: **Luce Bandit & Molotov M. Pale vs. Houston** Austin, 2011

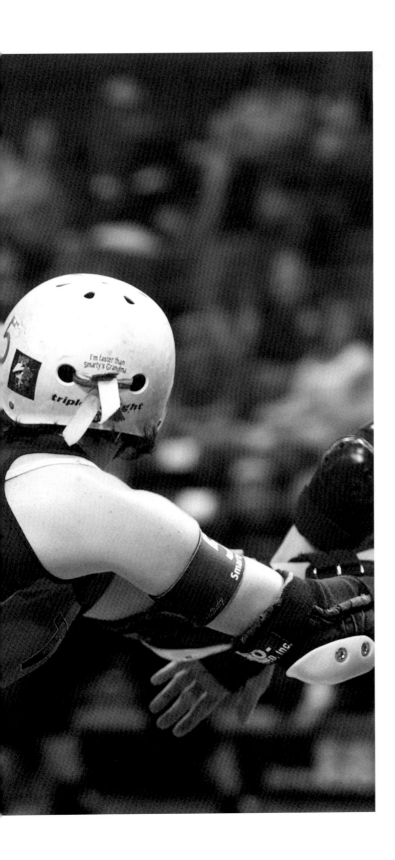

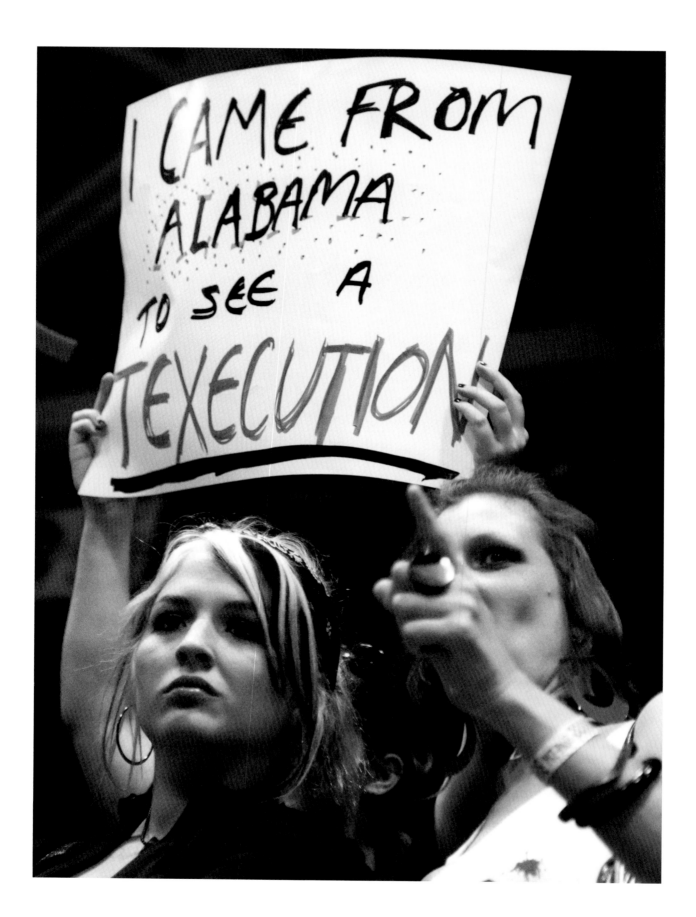

OPPOSITE: **Texas Fans** Nationals, Austin, 2007; FOLLOWING SPREAD: (Left to Right)
Curvette Nationals, Austin, 2007; **Scarlot Harlot & The Hell Marys** Austin, 2005

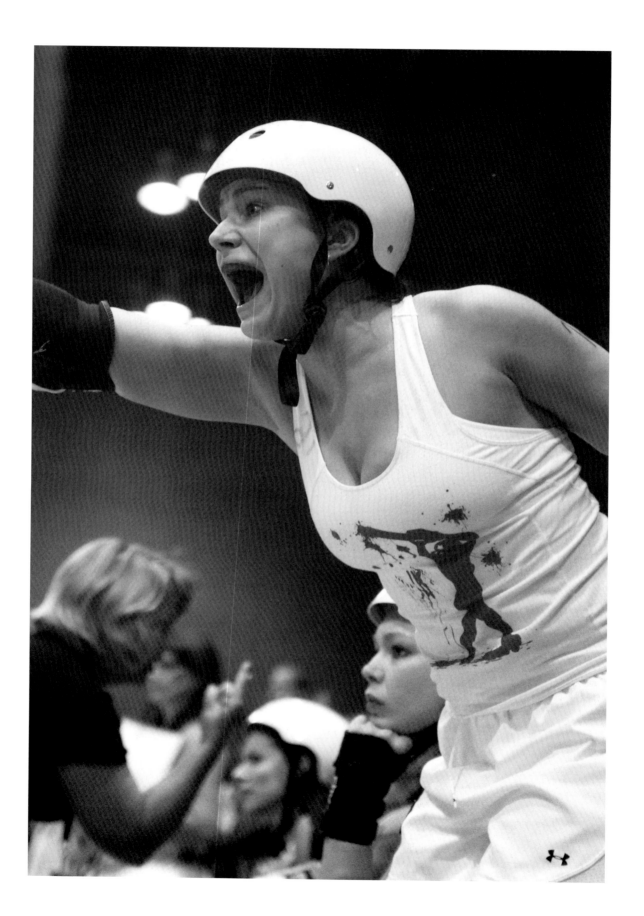

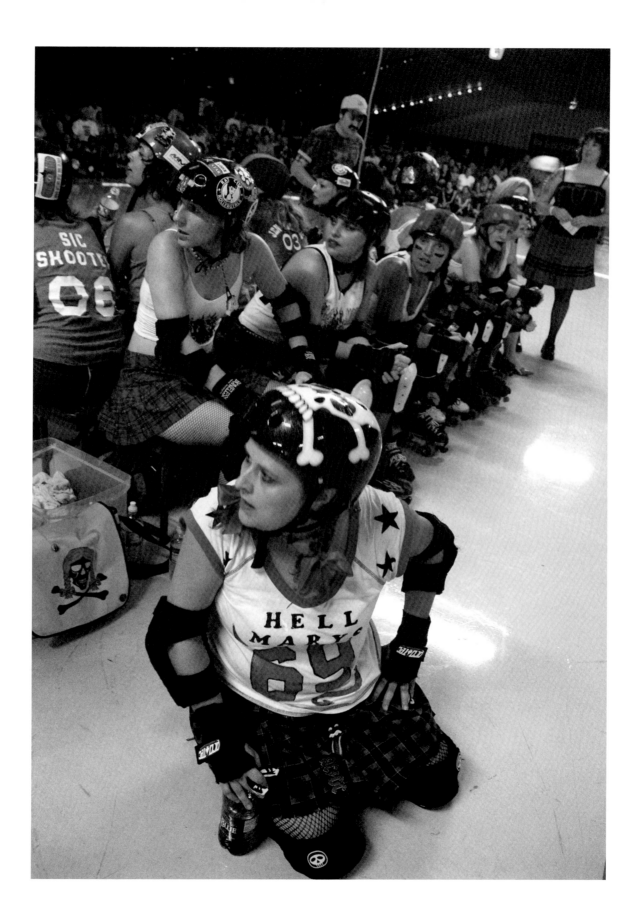

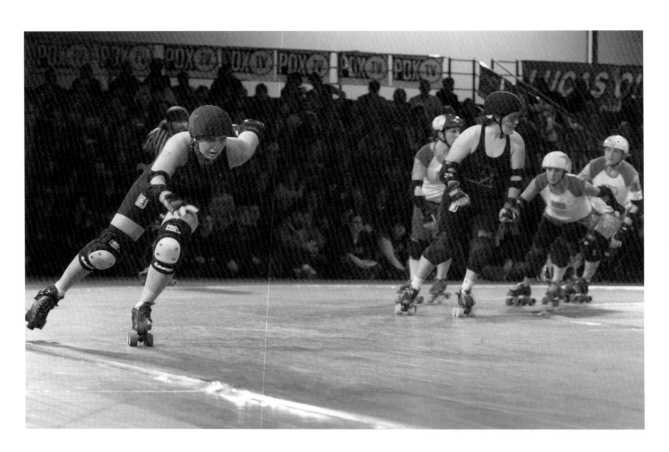

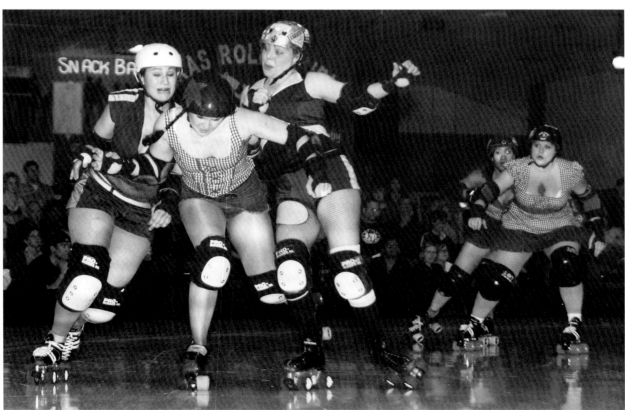

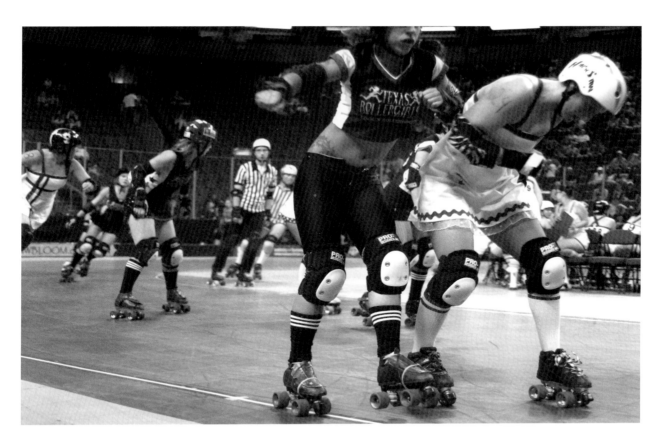

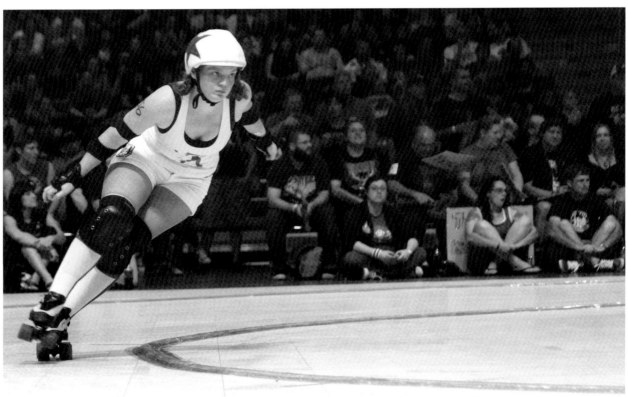

PREVIOUS SPREAD: (Clockwise From Top Left) **Texecutioners** Nationals, Portland, 2008; **Texecutioners vs. Mad Rollin Dolls** Seattle, 2006; **Lucille Brawl** Nationals, Austin, 2007; **Hustlers vs. Honky Tonk Heartbreakers** Austin, 2008; ABOVE: **Derby Style** Austin, 2012

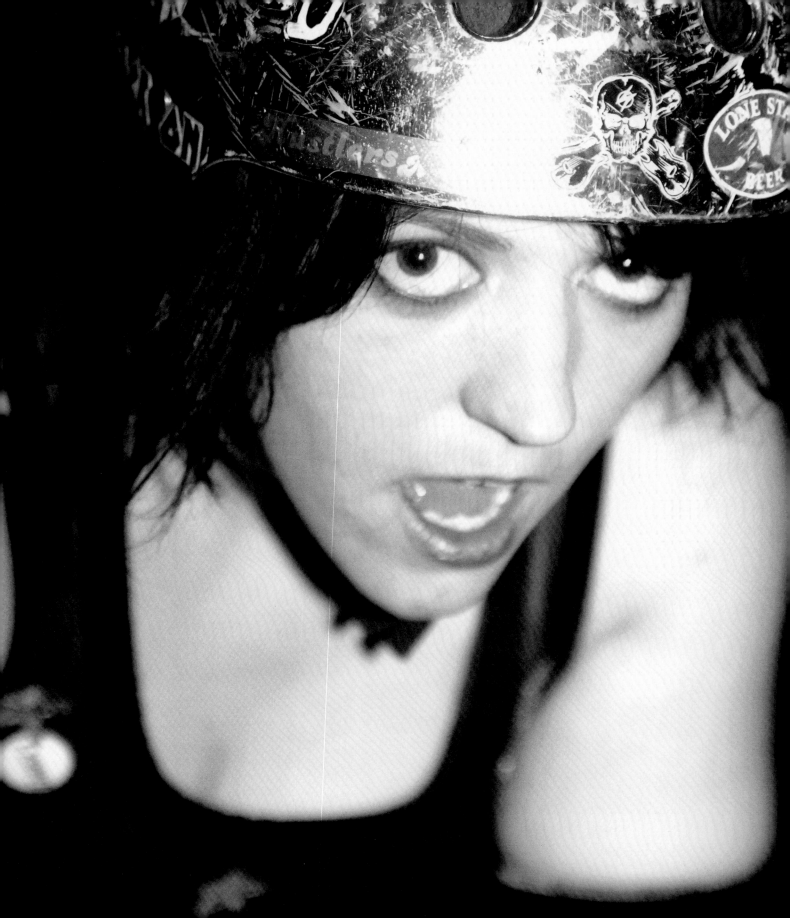

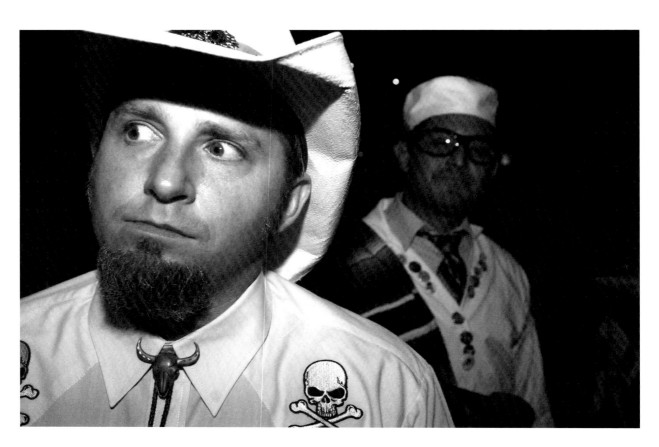

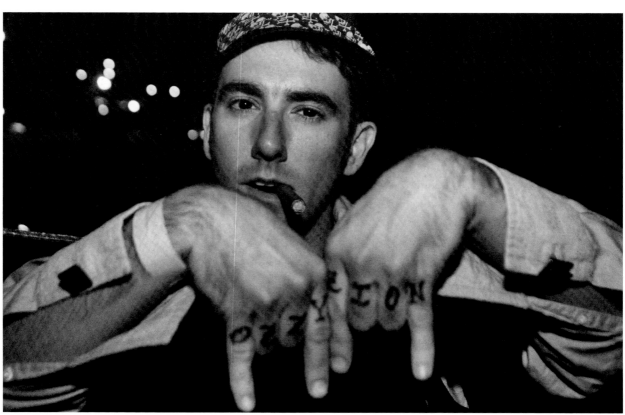

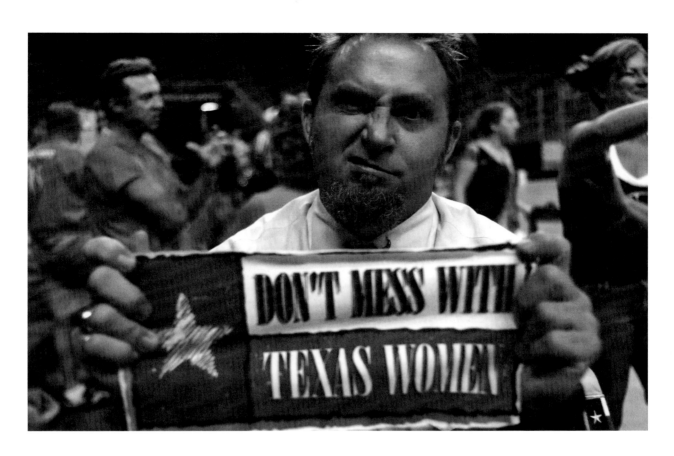

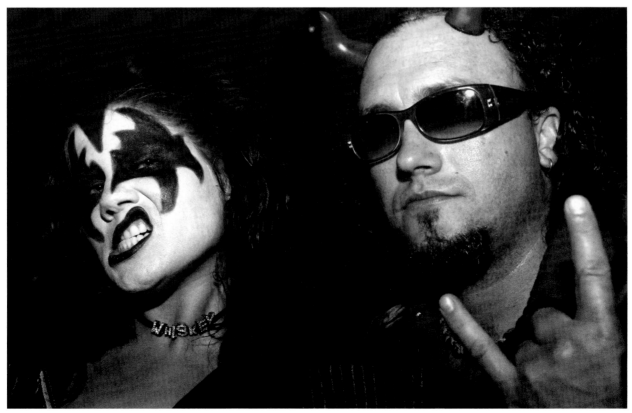

SOME DO IT FOR THE SISTERHOOD. SOME DO IT FOR THE COMPETITION. A FEW DO IT JUST TO BE A ROLLERGIRL.

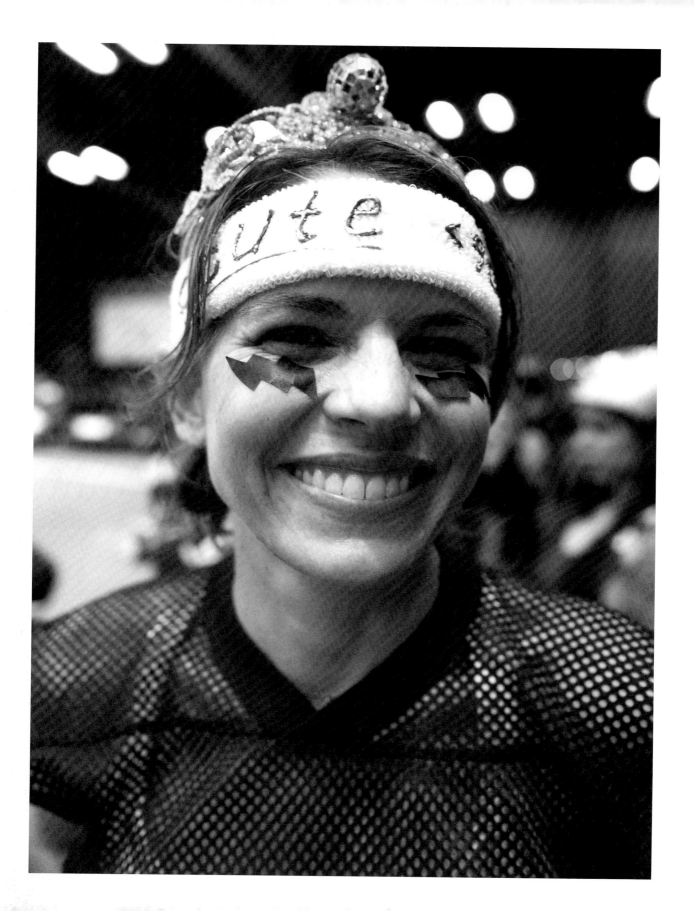

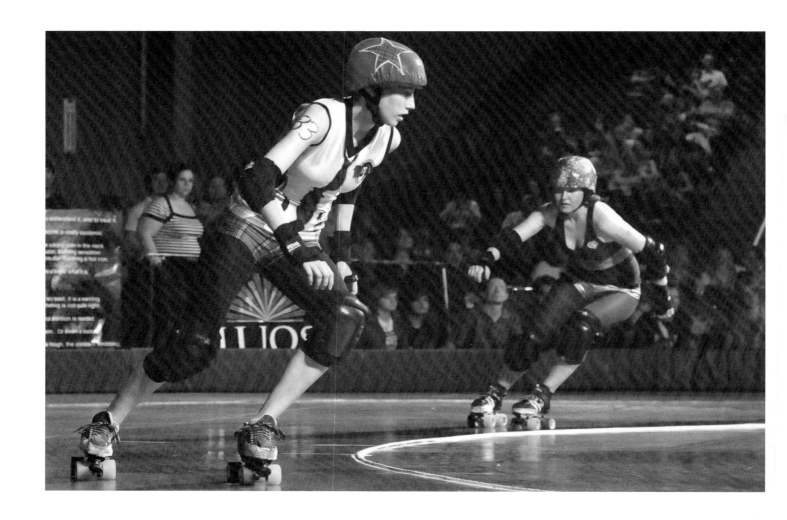

Luce Bandit & Shortcut Austin, 2011

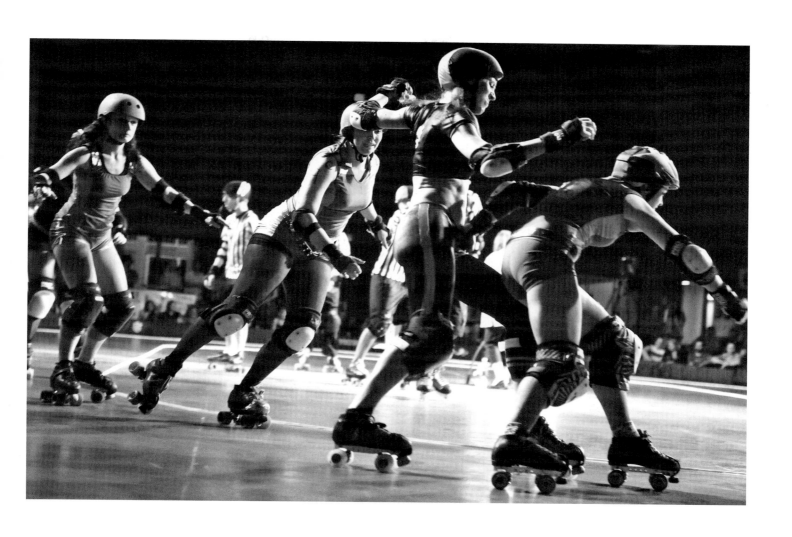

ABOVE: **Chasing Amy, Babe Ruthless, Voodoo Doll & Molotov M. Pale** Austin, 2011;
FOLLOWING SPREAD: **Hot Box vs Notorious D.I.E.** Austin, 2011

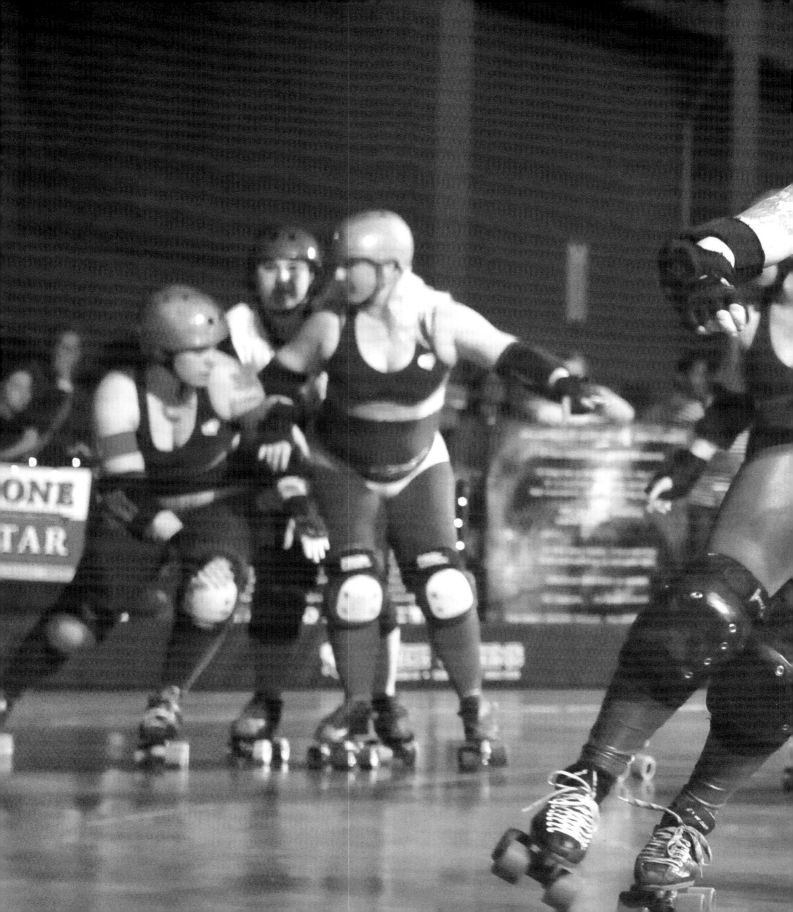

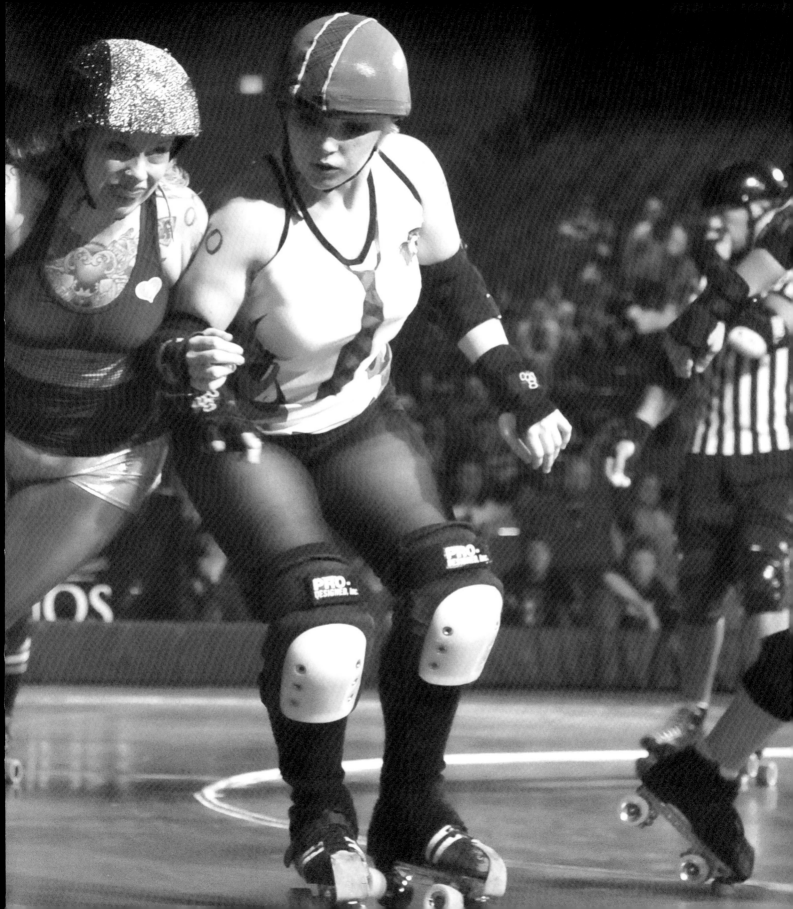

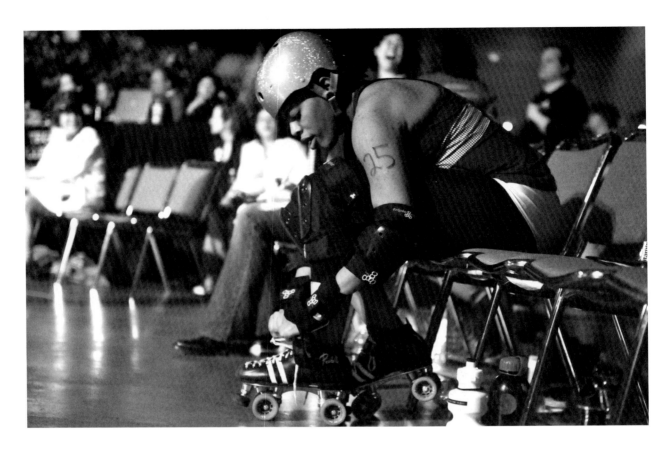

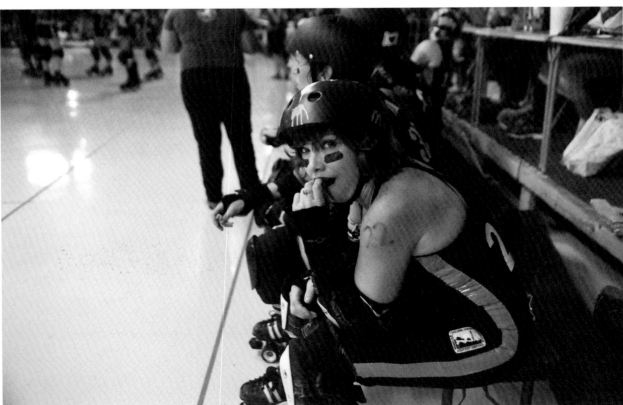

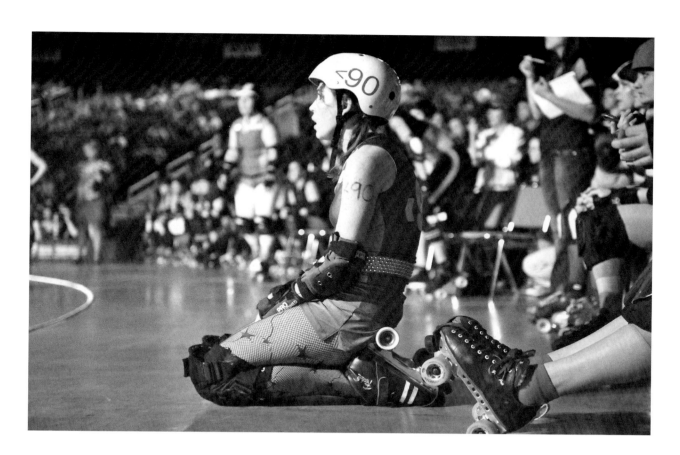

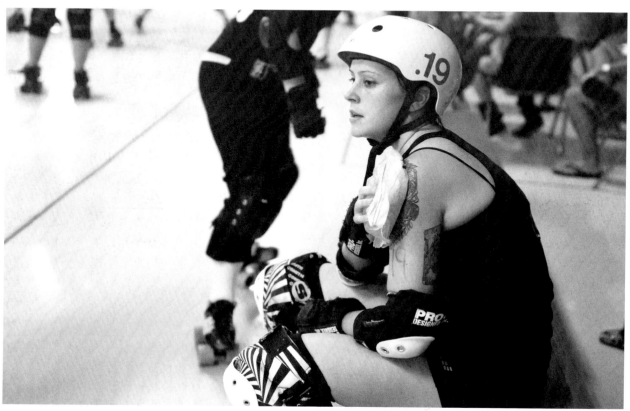

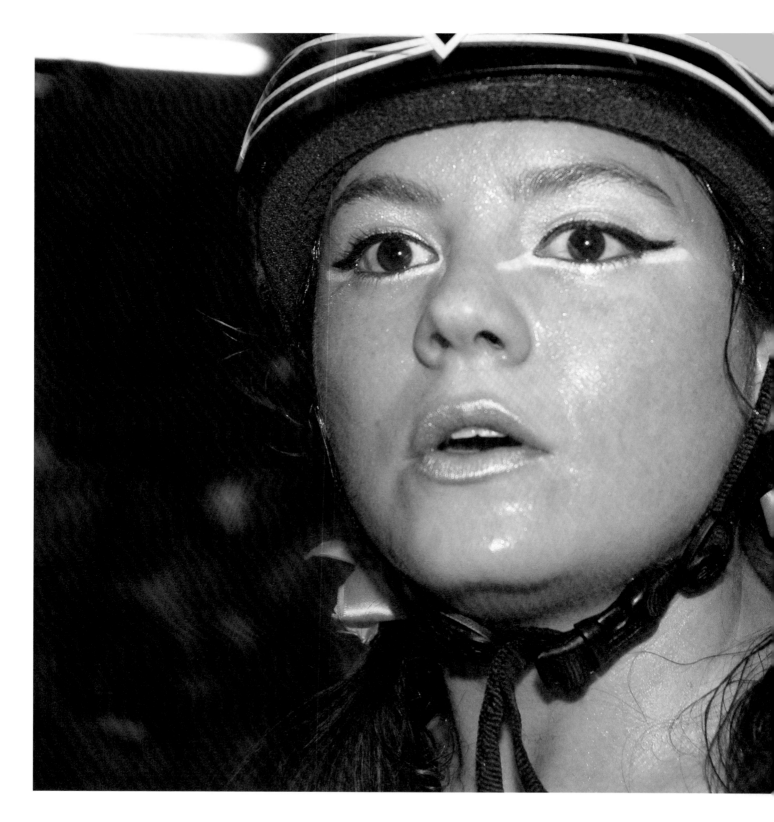

PREVIOUS SPREAD: (Clockwise From Top Left) **Fender Bender** Austin, 2011; **Acute Angel** Austin, 2011; **Molotov M. Pale** Austin, 2012; **Morphine** Austin, 2009; ABOVE: **Cat Tastrophe** Austin, 2005

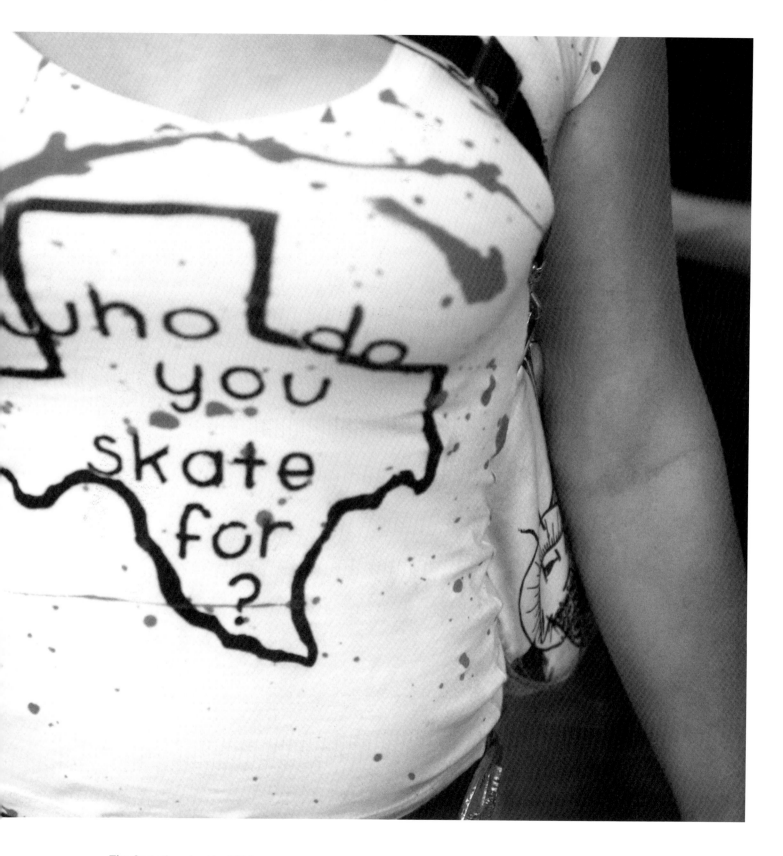

The Question Austin, 2012

OPPOSITE: **Tinkerhell** Tuscon, 2006;
FOLLOWING SPREAD: (Clockwise From Top Left) **Bloody Mary** Seattle, 2006;
Lady Stardust Austin, 2005; **Tinkerhell** Austin, 2005; **Pixie Tourette** Austin, 2005

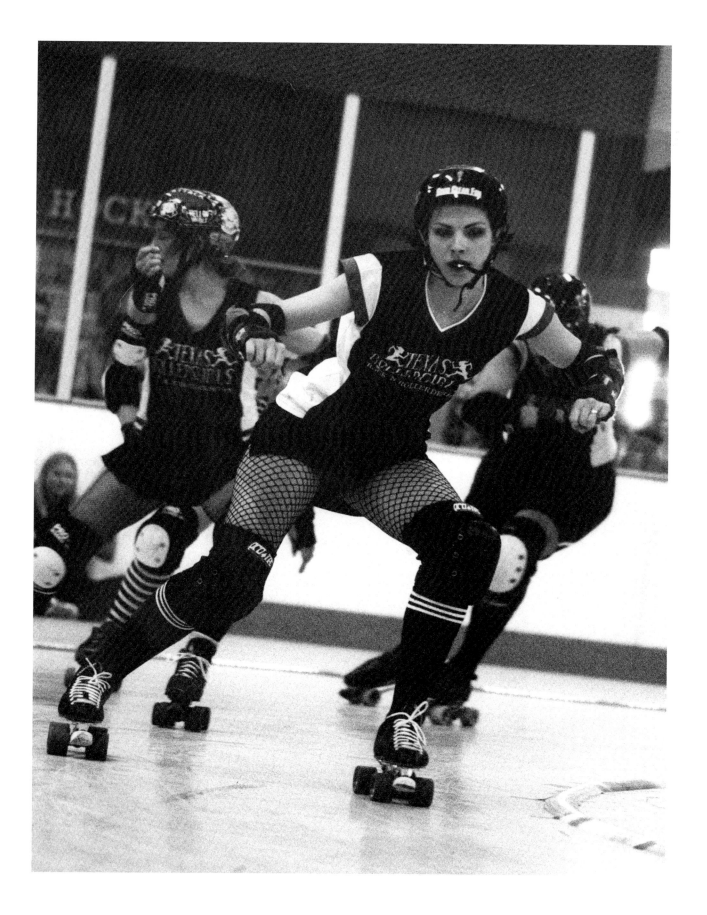

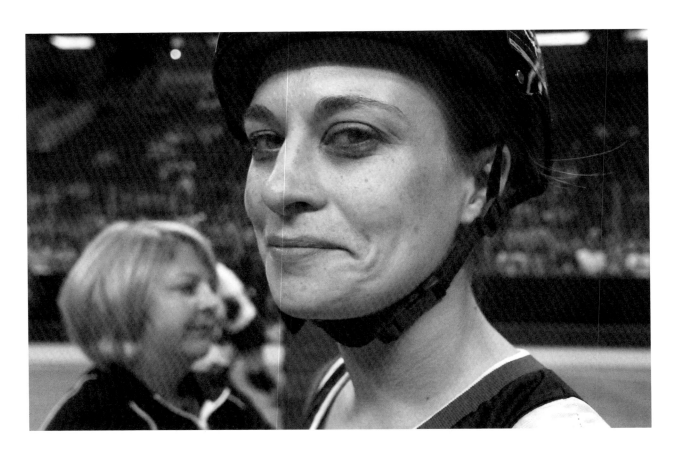

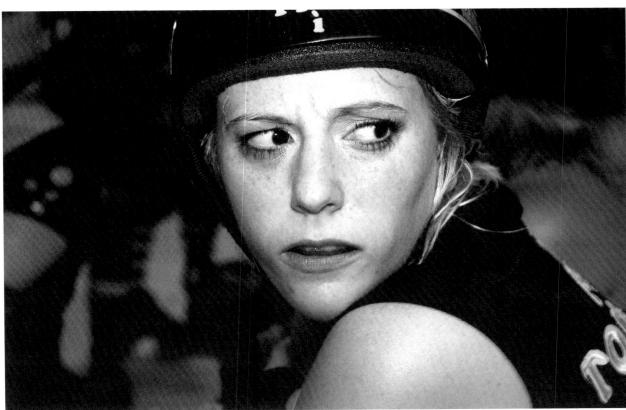

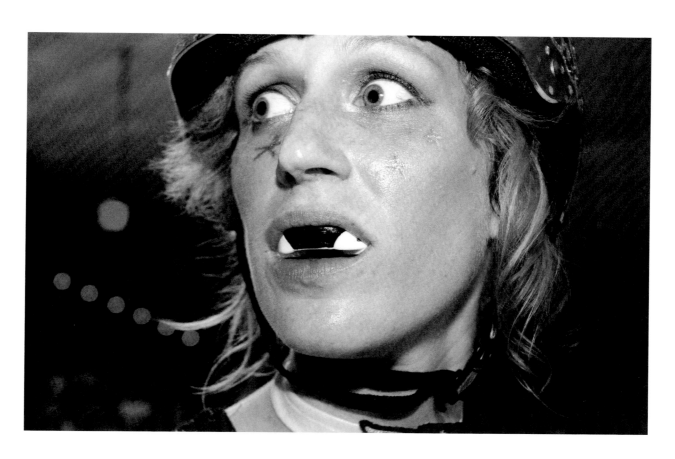

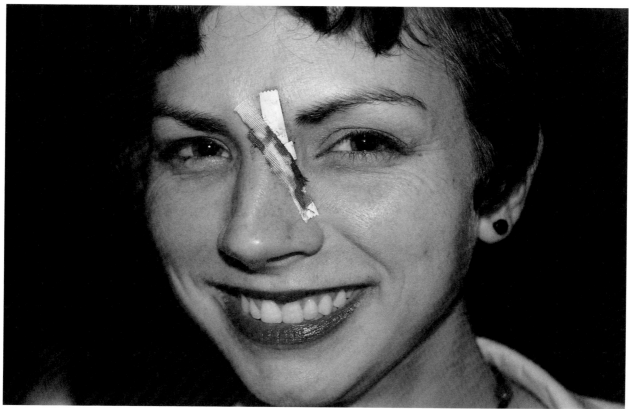

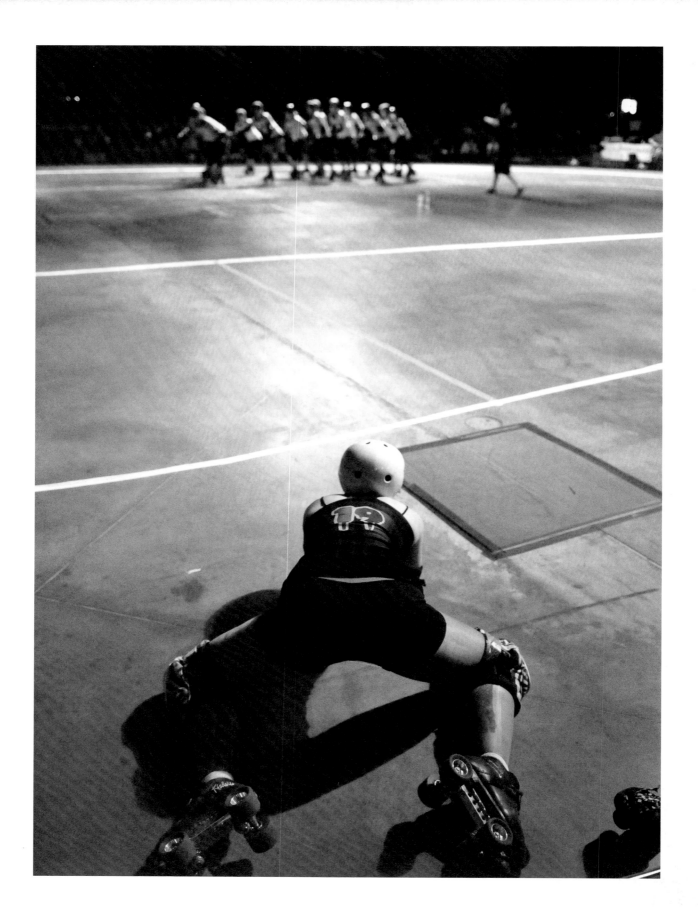

FOR THE SKATERS, BY THE SKATERS.

Stretch Austin, 2011

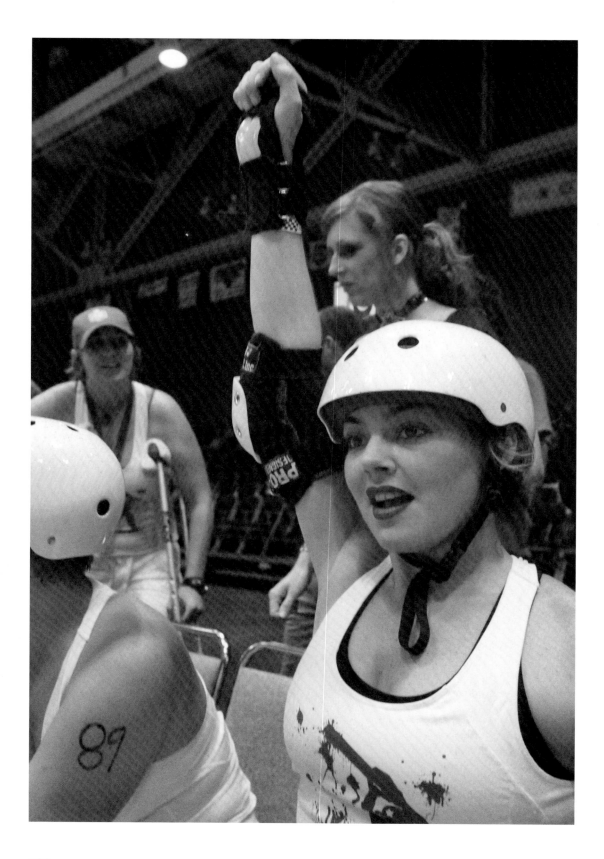

Barbarella Nationals, Austin, 2007

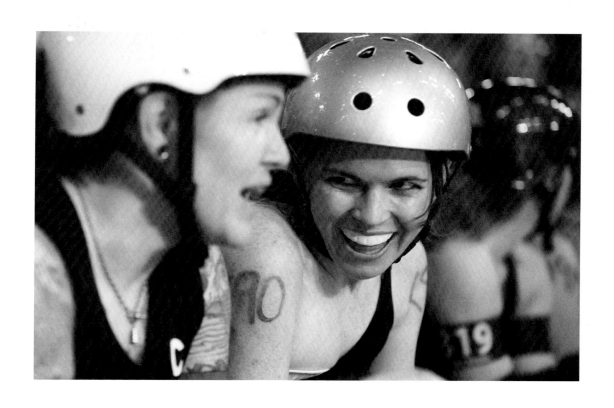

ABOVE: **Kat A Killzem & Acute Angel** Austin, 2011; FOLLOWING SPREAD: **Takeover** Austin, 2005

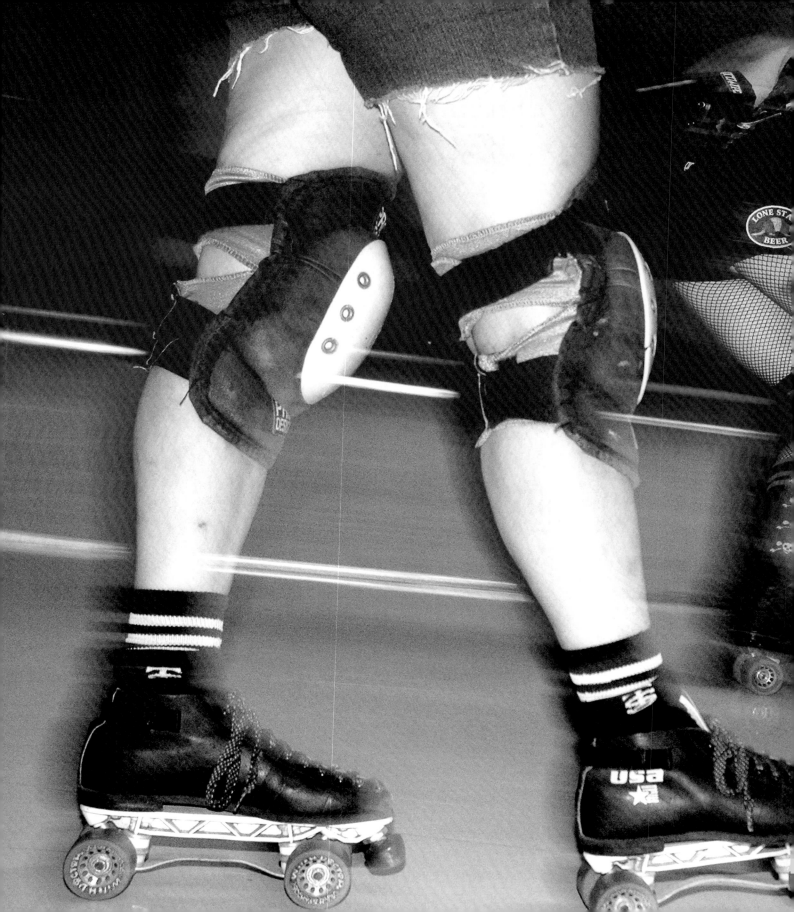

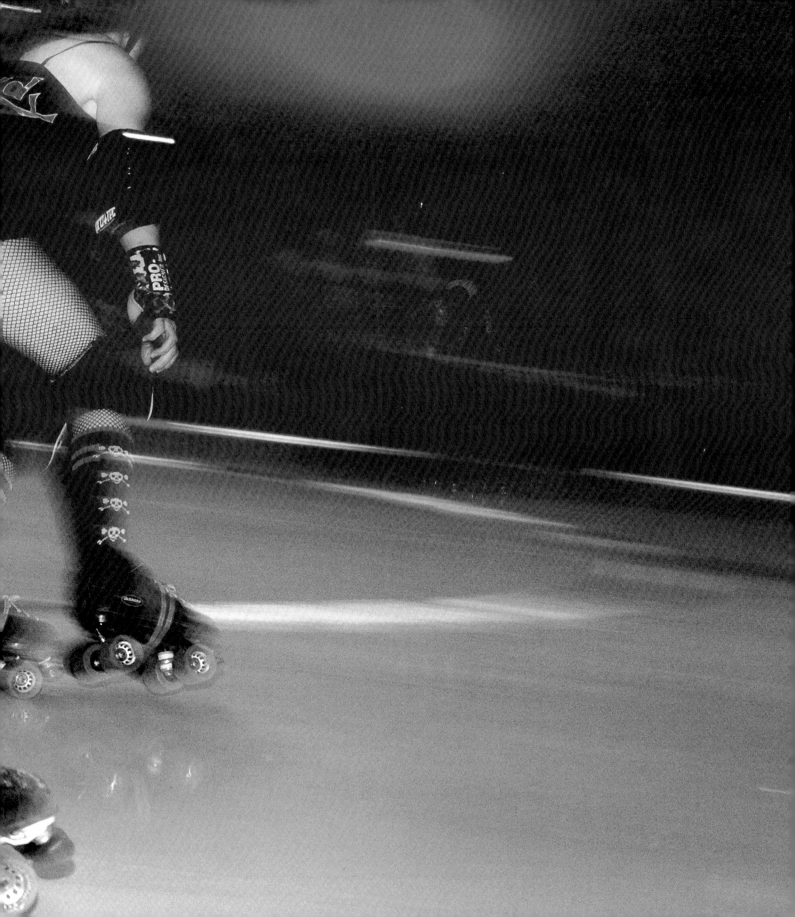

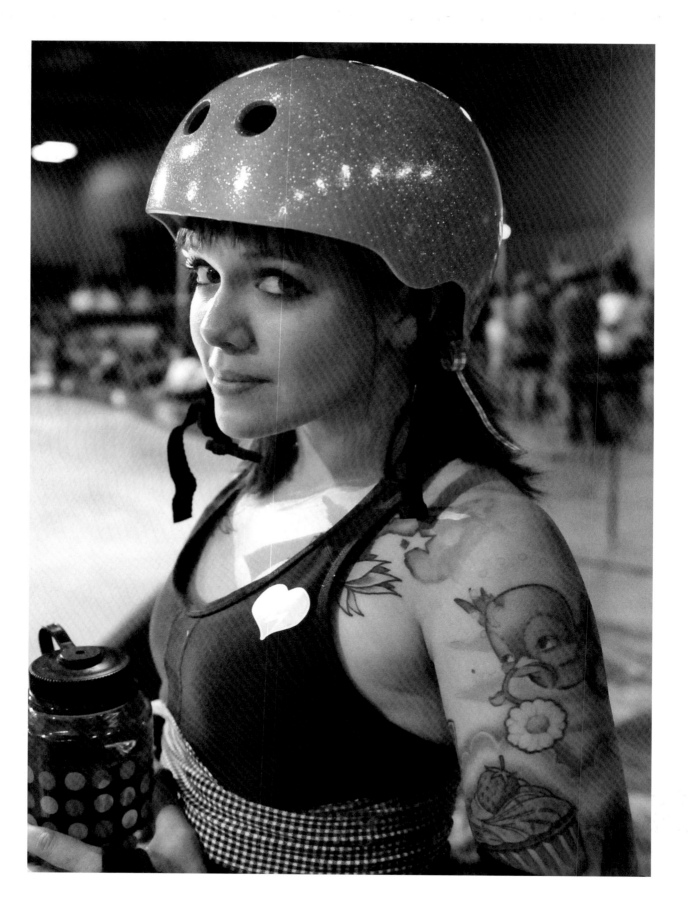

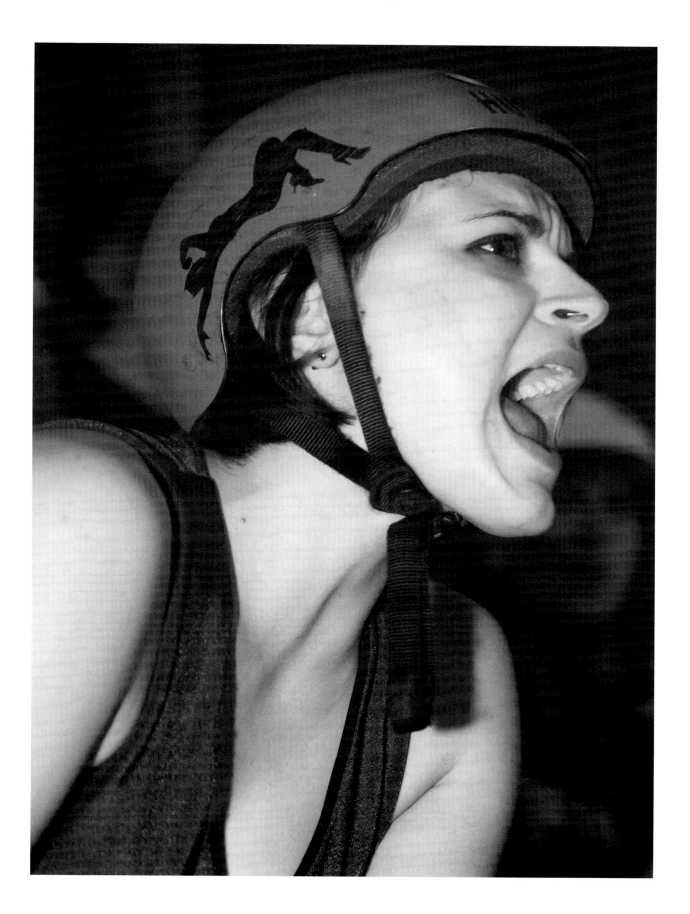

PREVIOUS SPREAD: (Left to Right) **Big Nasty** Austin, 2011; **Spawn of Terror** Austin, 2008; OPPOSITE: **Cat Tastrophe vs. Muffin Tumble** Austin, 2008

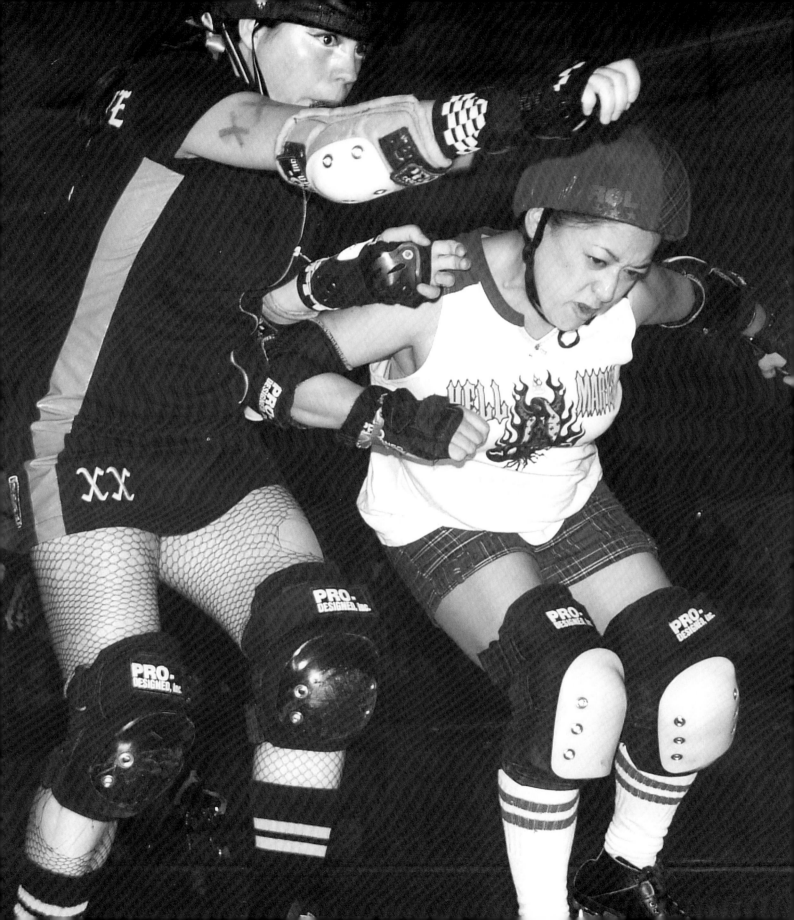

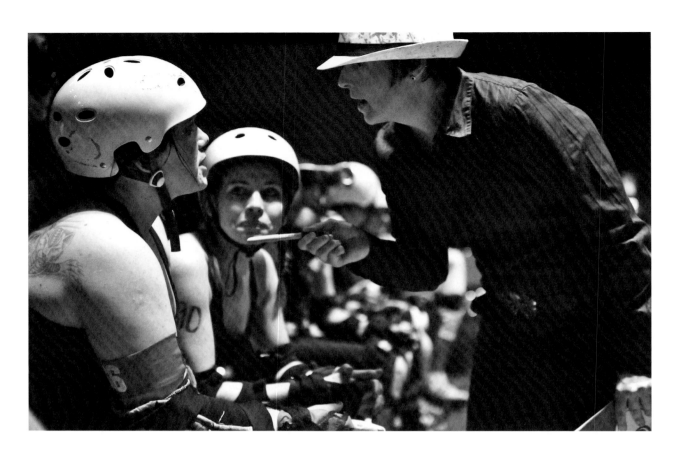

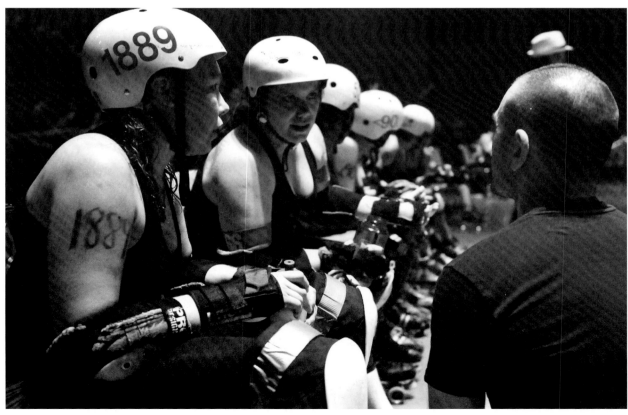

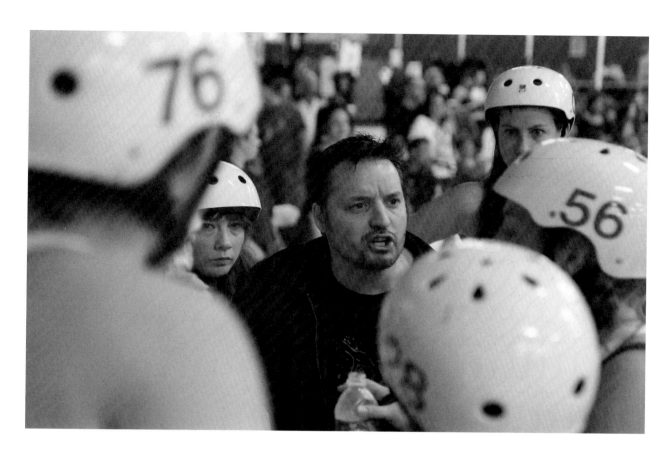

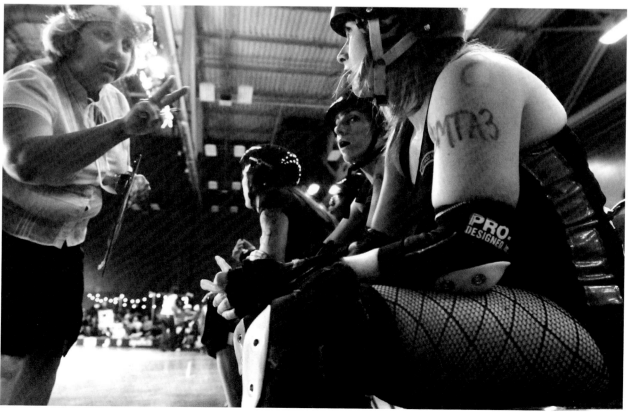

PREVIOUS SPREAD: (Clockwise From Top Left) **Coach Kelly** Austin, 2011; **Coach Phil** Tucson, 2008;
Hydra Austin, 2011; **Johnny Roast Beef** Austin, 2001; ABOVE: **Big Tom** Austin, 2011

Kiss My Ass Austin, 2005

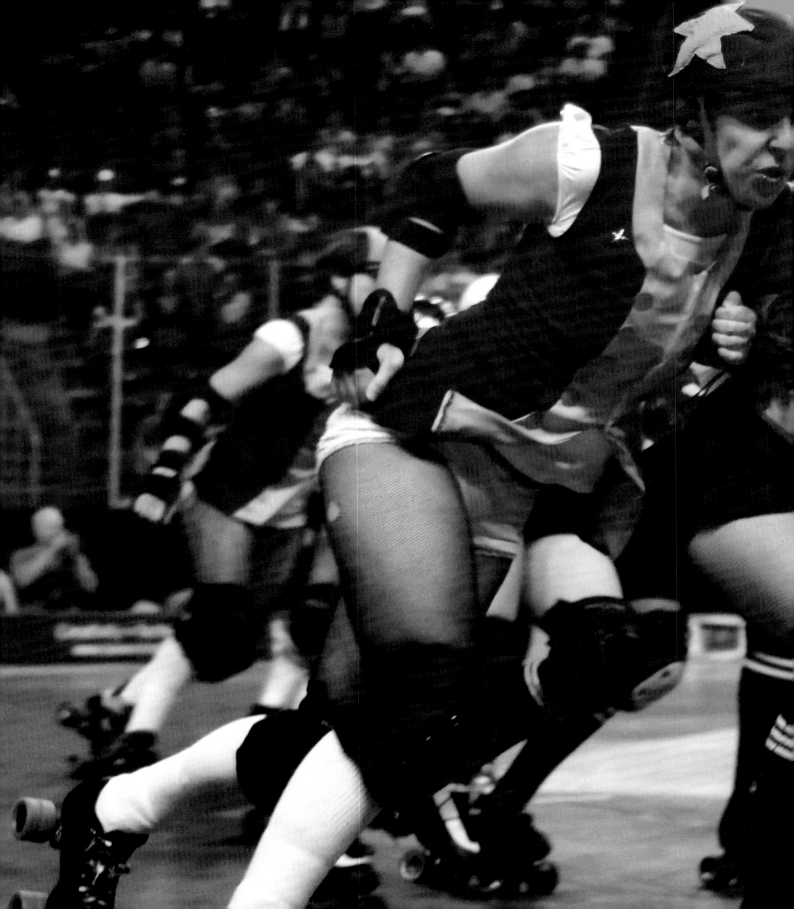

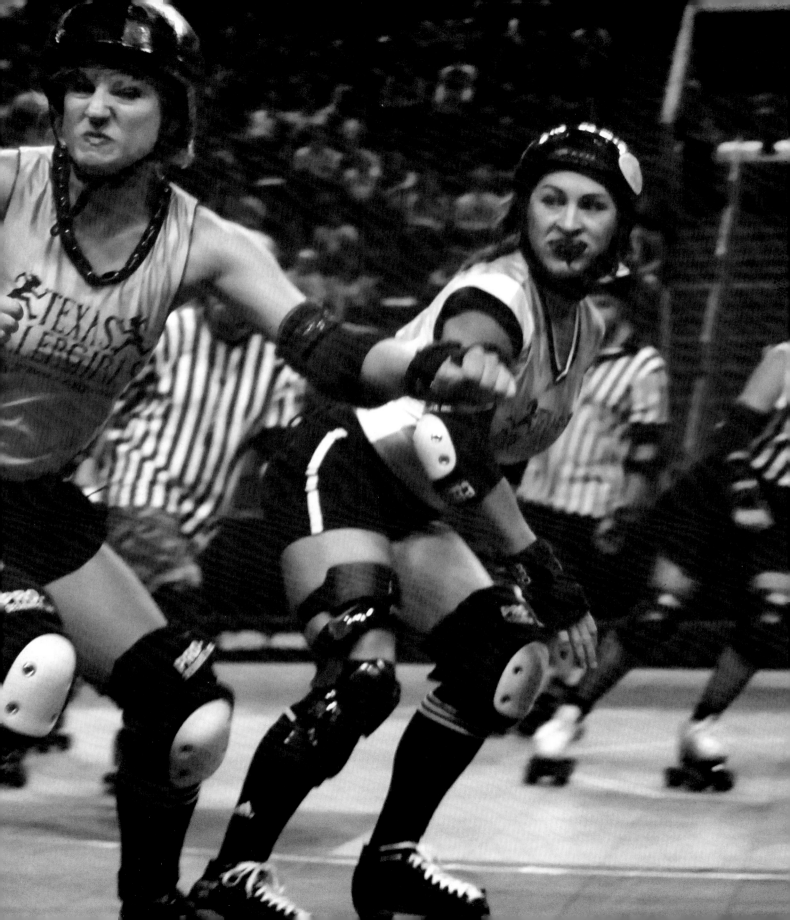

DERBY HAS HELPED ME TO BE MORE OUTSPOKEN AND STAND UP FOR MYSELF.

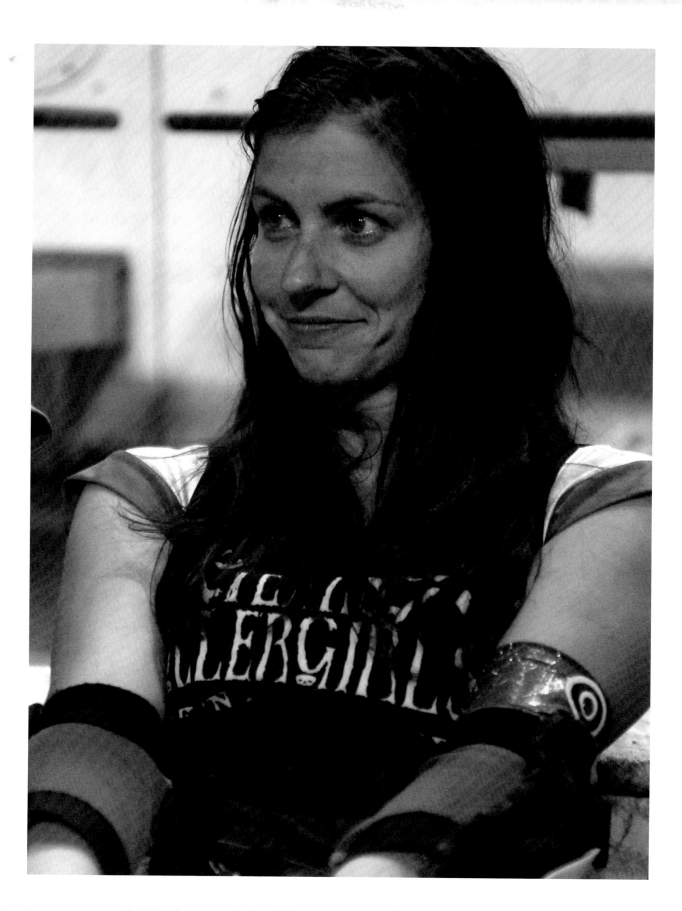

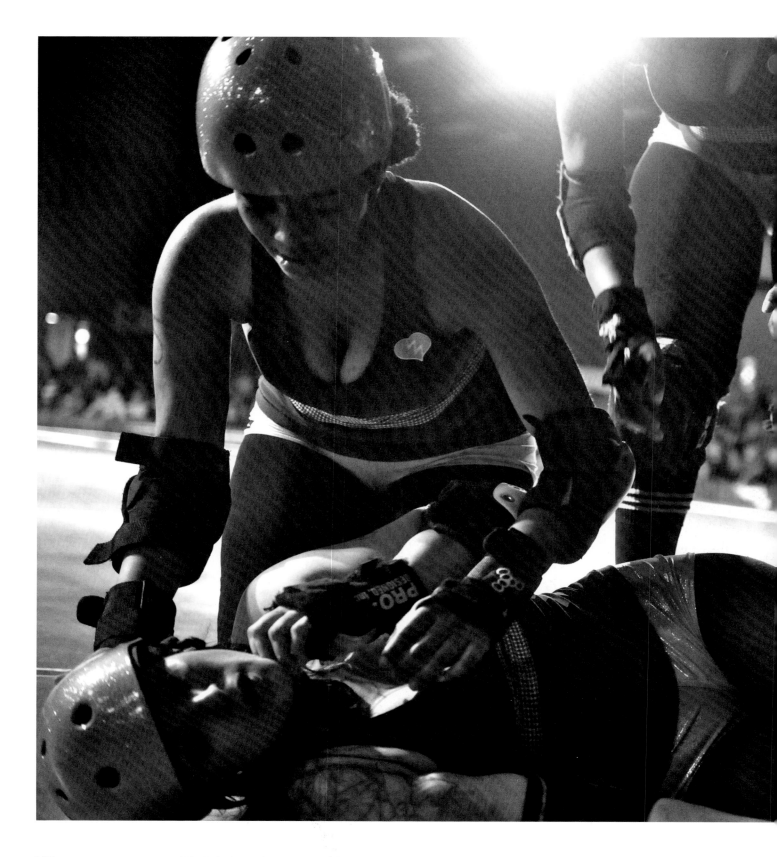

ABOVE: **Ruby Wring & Rita Menweep** Austin, 2011; FOLLOWING SPREAD: **Track** Austin, 2012

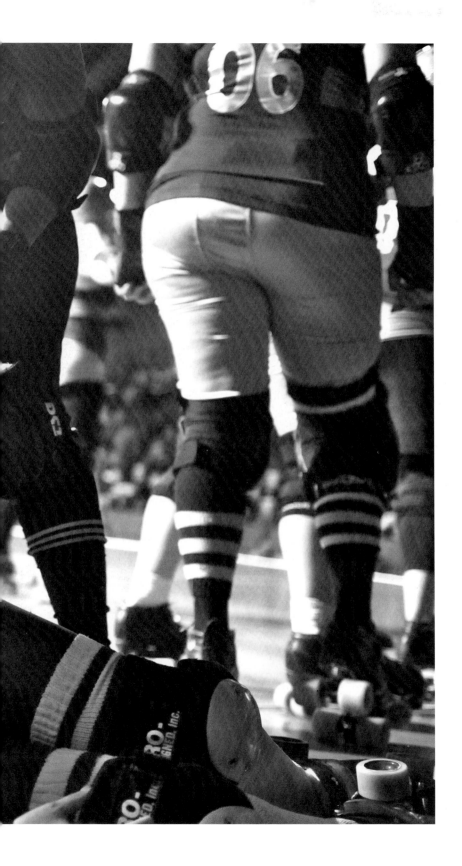

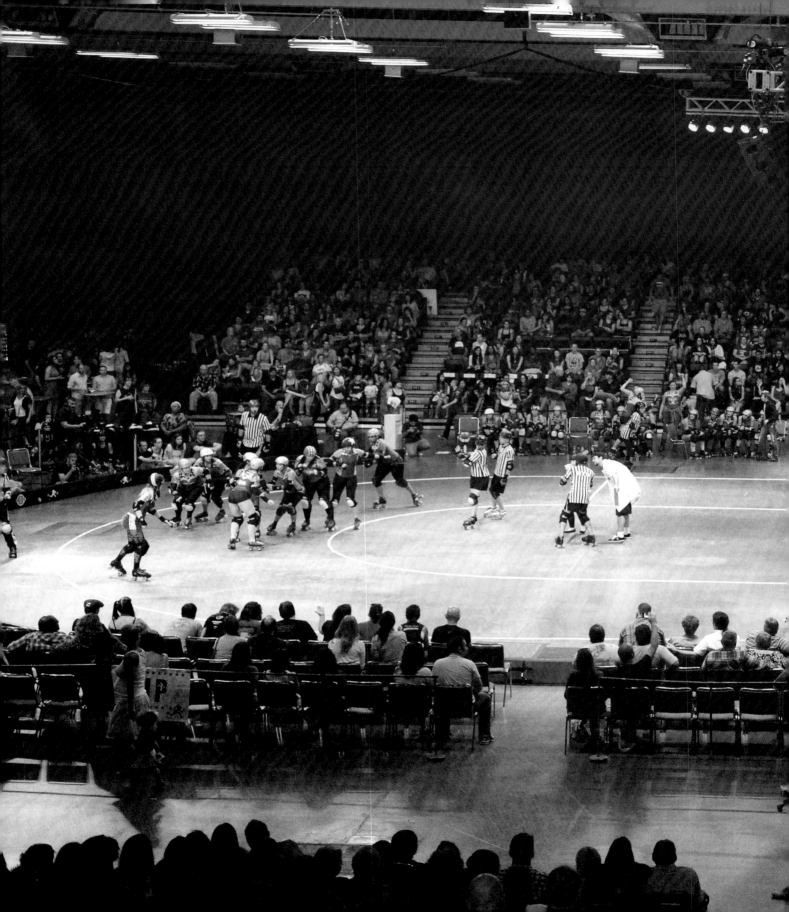

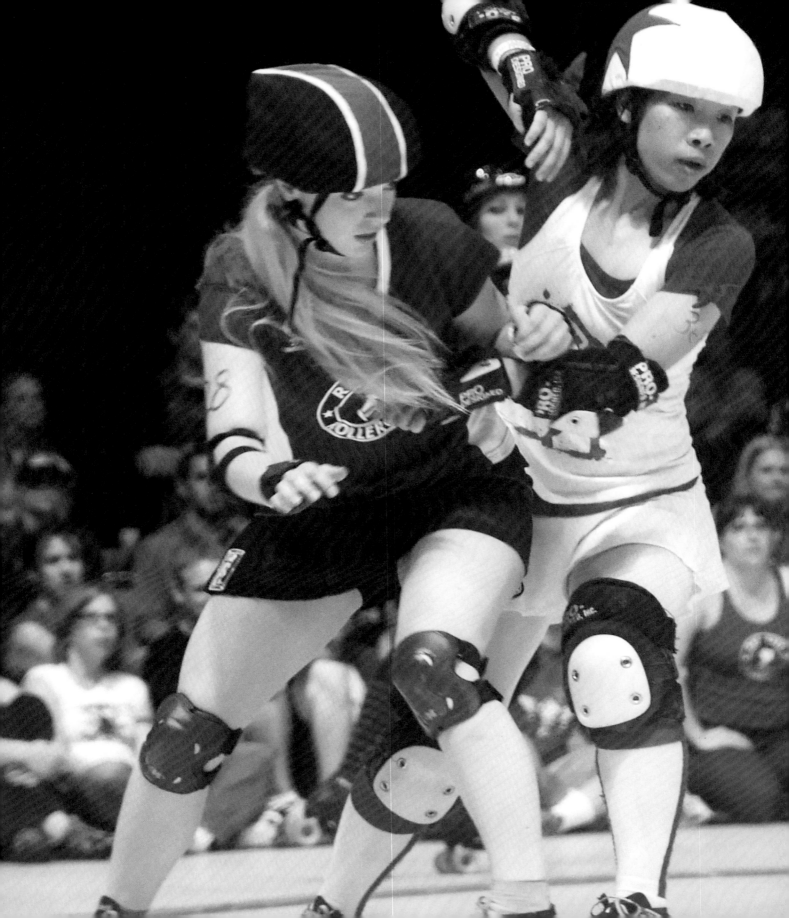

Rice Rocket vs. Rat City Nationals, Austin, 2007

159

Texecutioners Mascot Austin, 2011

Little Hell Mary Fan Austin, 2006

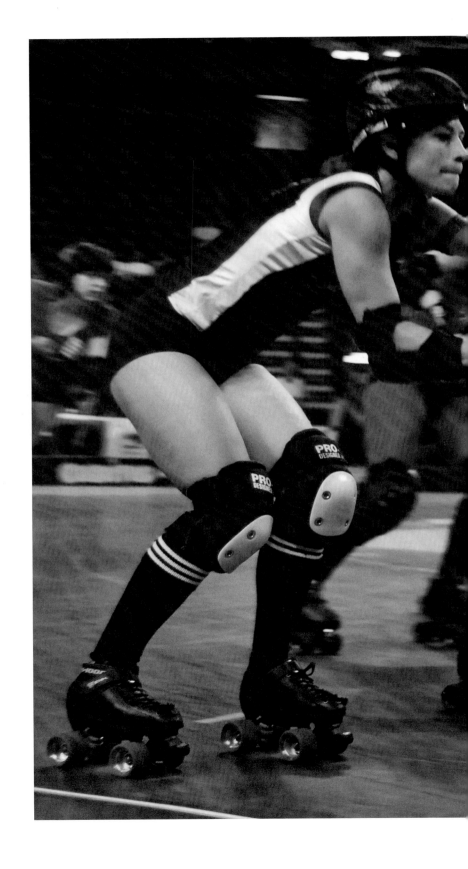

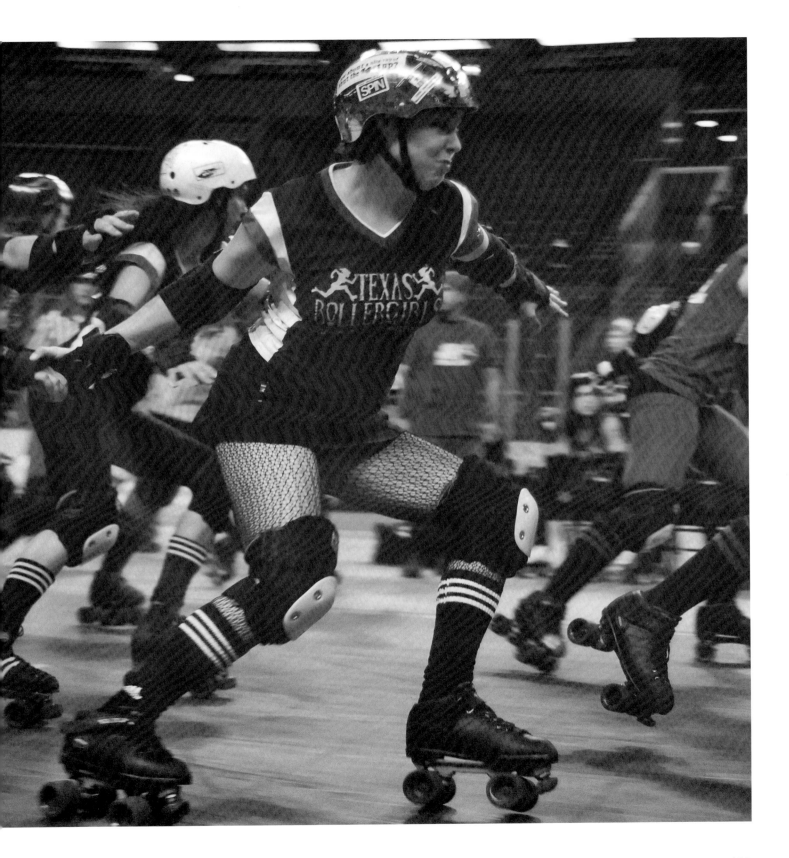

Barbarella Slings Bloody Mary Seattle, 2006

Shank Nationals, Philadelphia, 2009

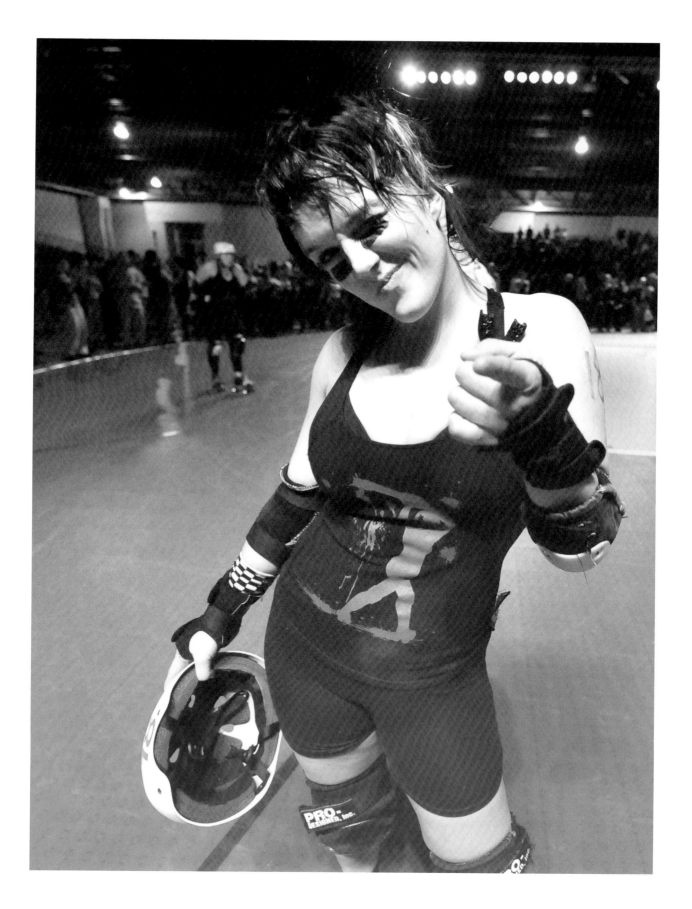

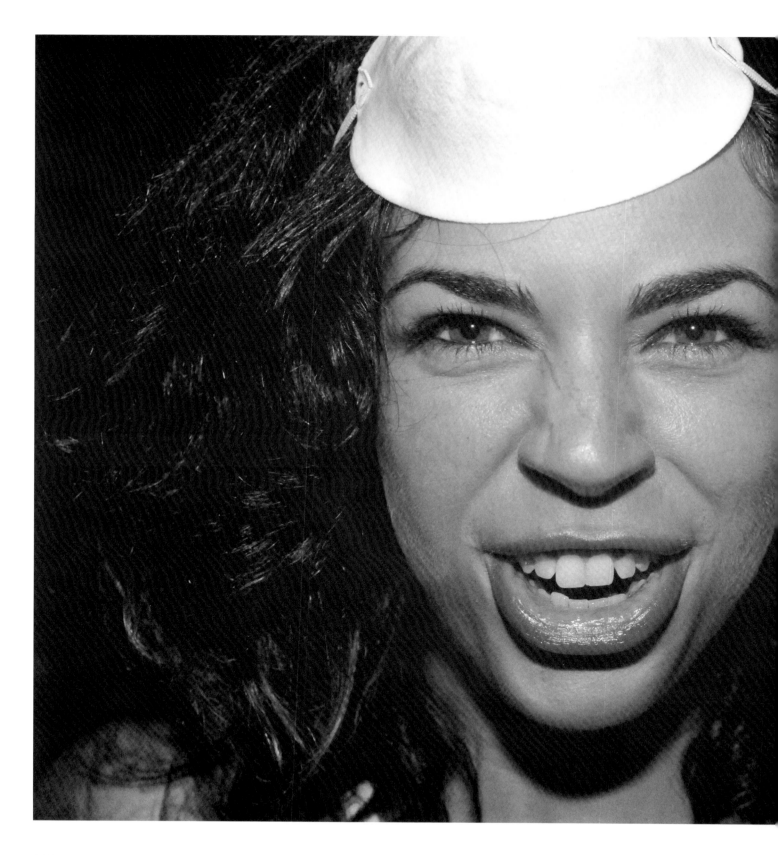

Buckshot Betsy Austin, 2006

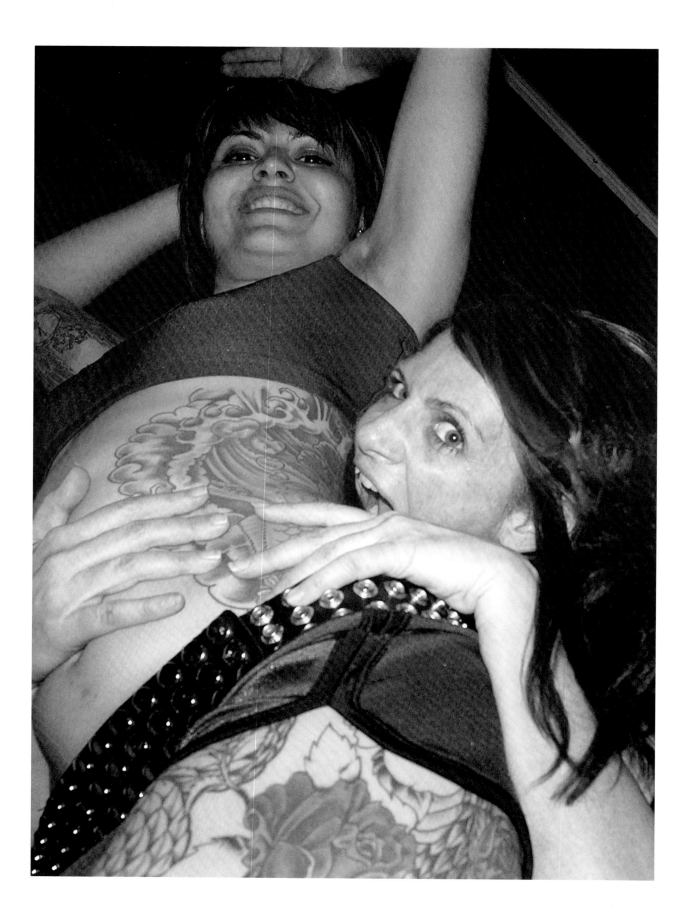

OPPOSITE: **Rosie Cheeks & Electra Blu** Austin, 2005;
FOLLOWING SPREAD: (Clockwise From Top Left)
Hell Marys & Notorious D.I.E. Austin, 2014; **Vicious Van GoGo Retires** Austin, 2009;
Smarty Pants, Notorious D.I.E. & Me Shove You Long Time Austin, 2014;
Vicious Van GoGo & Desi Cration Nationals, Philadelphia, 2009

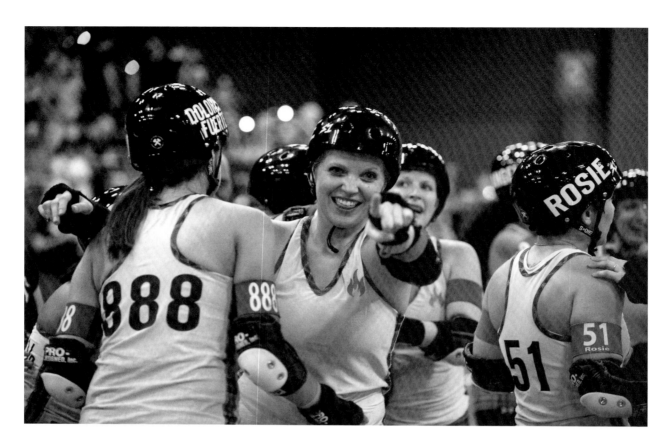

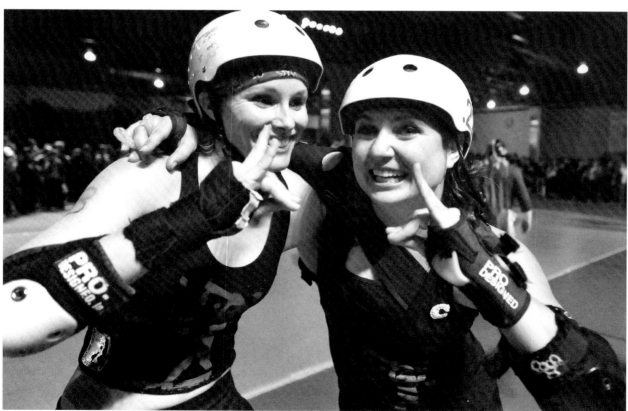

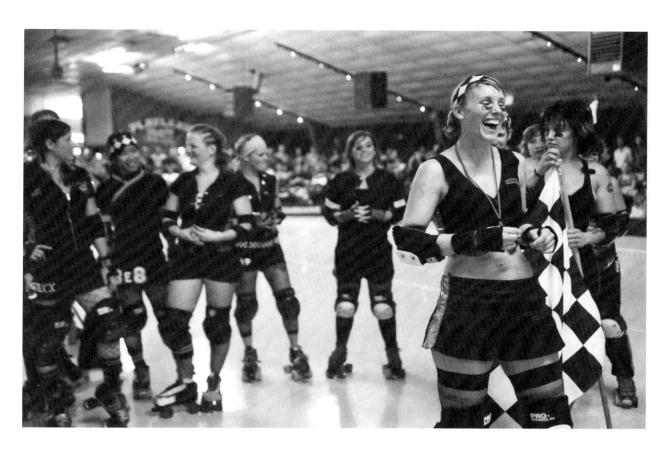

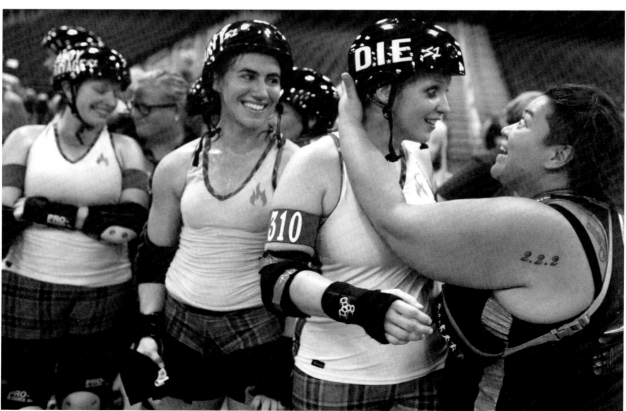

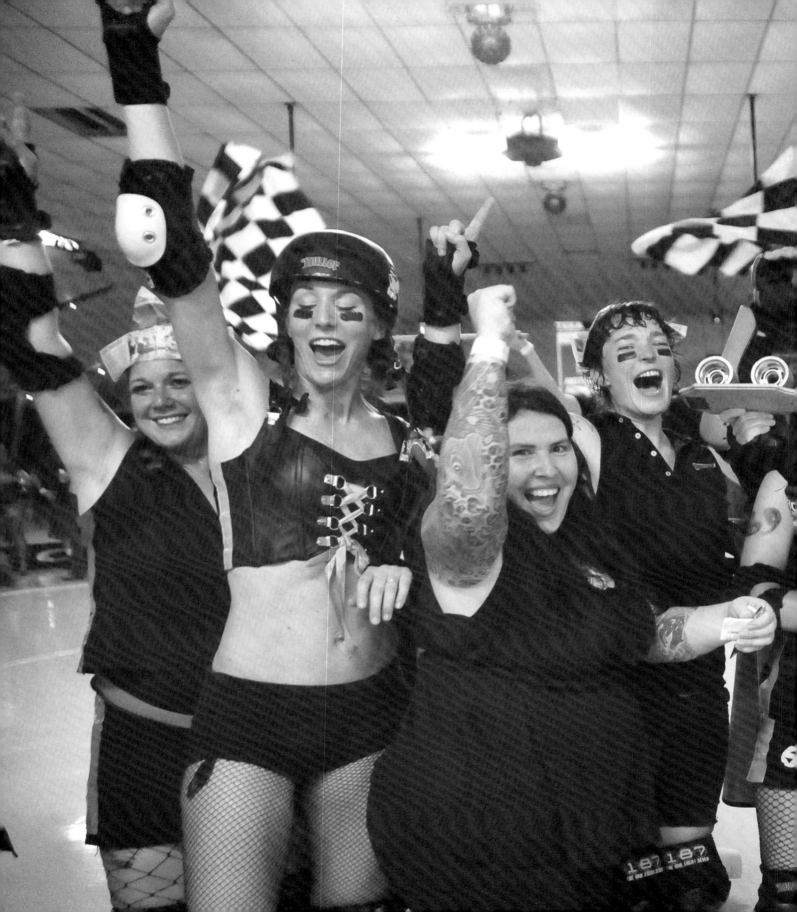

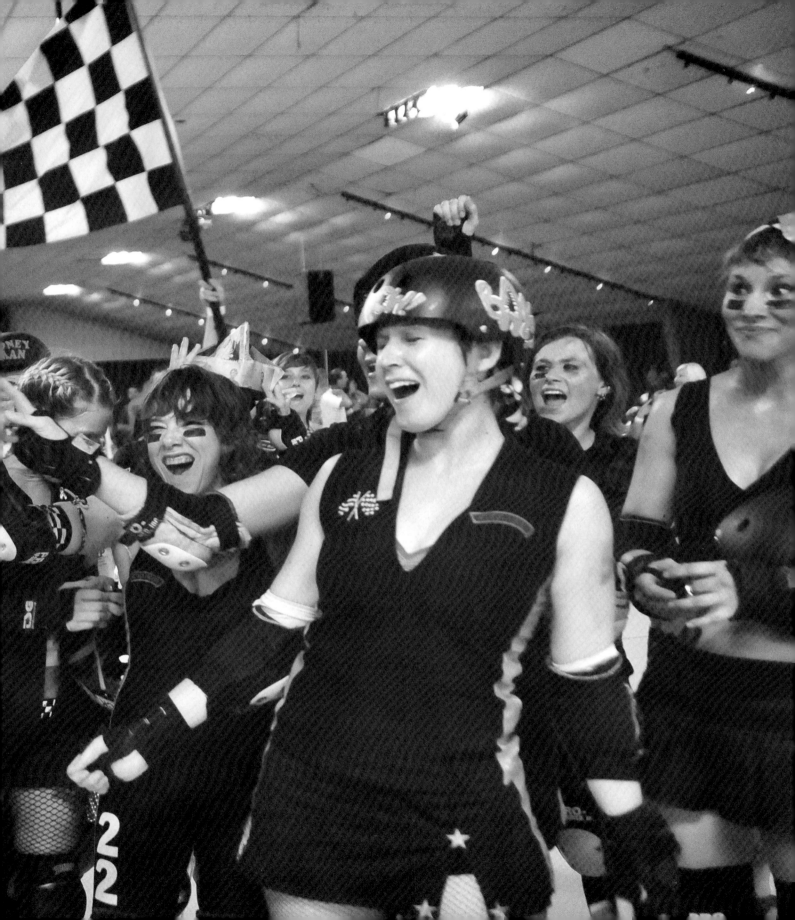

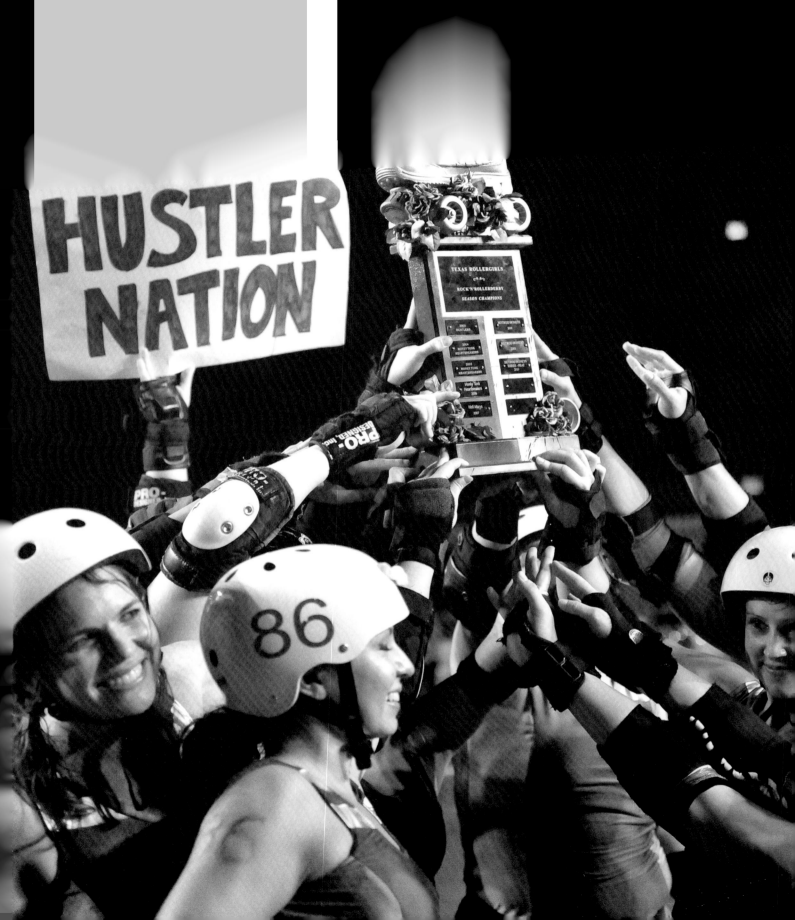

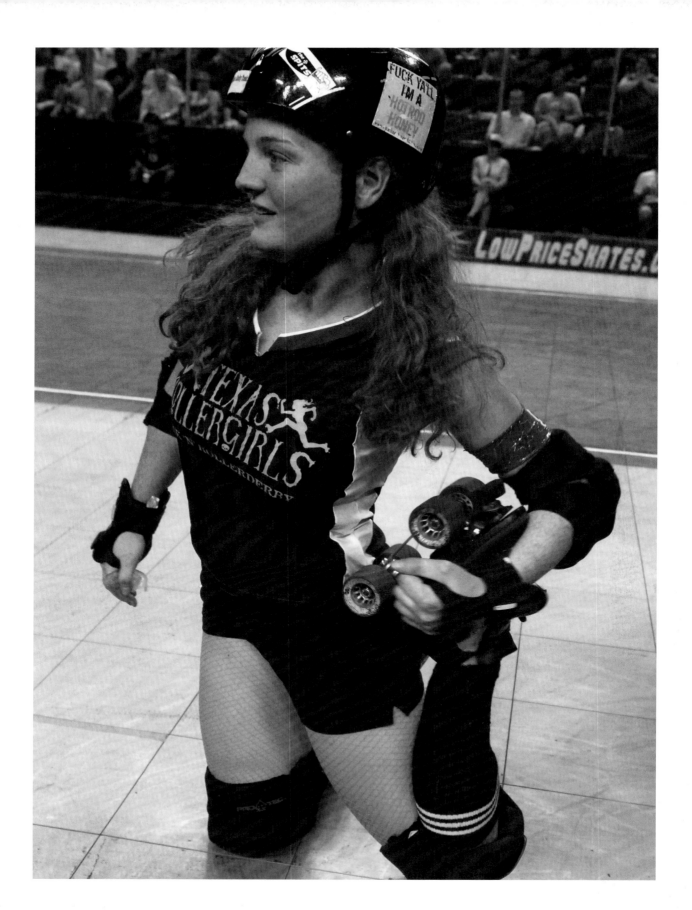

EVERY MINUTE OF EVERY DAY, ROLLER DERBY IS ON MY MIND.

Lucille Brawl Seattle, 2006

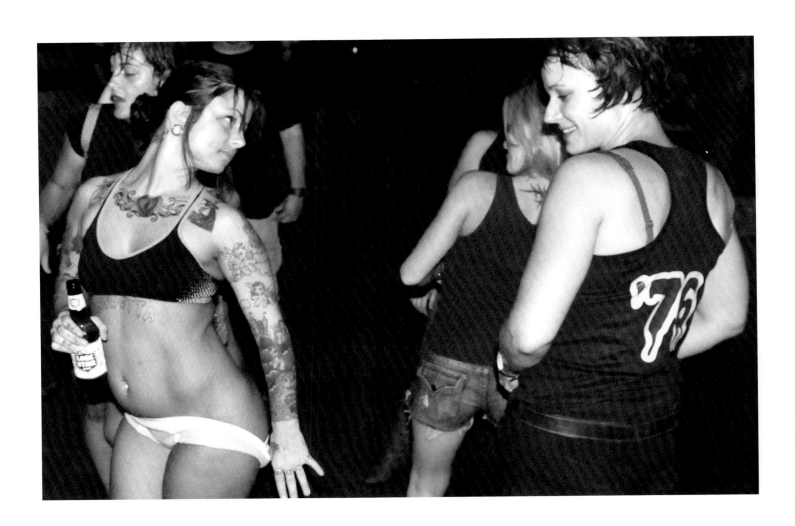

Curvette Checks Out Competition Austin, 2010

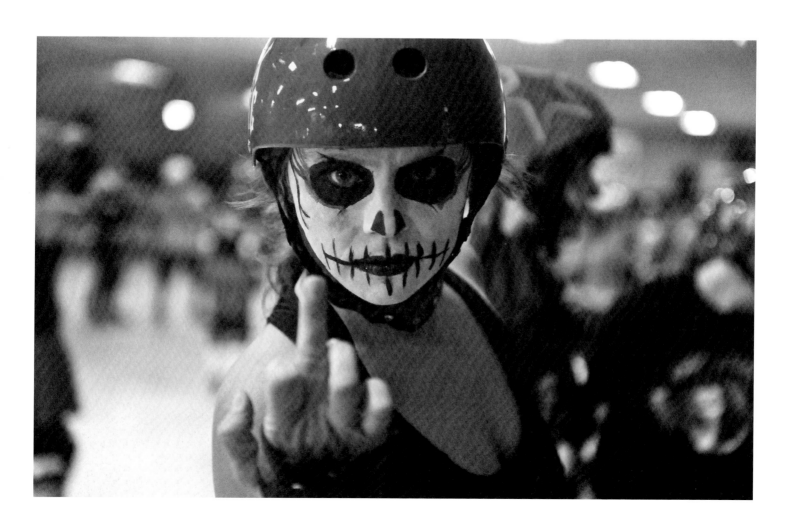

Tomax Blade Austin, 2010

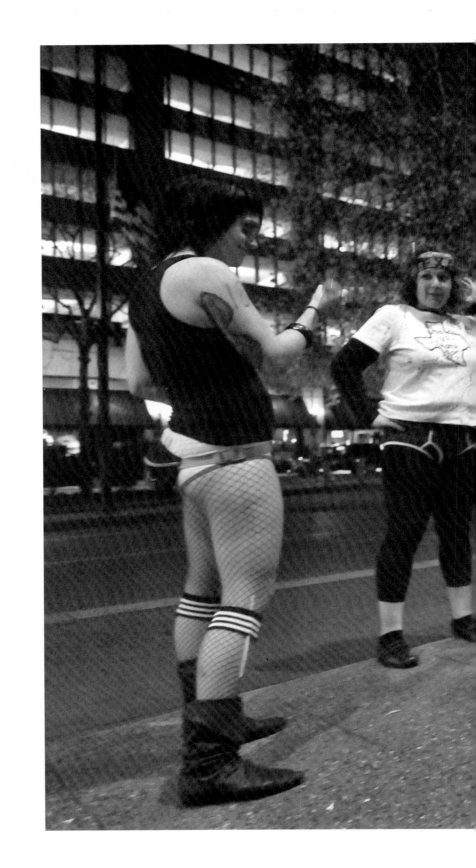

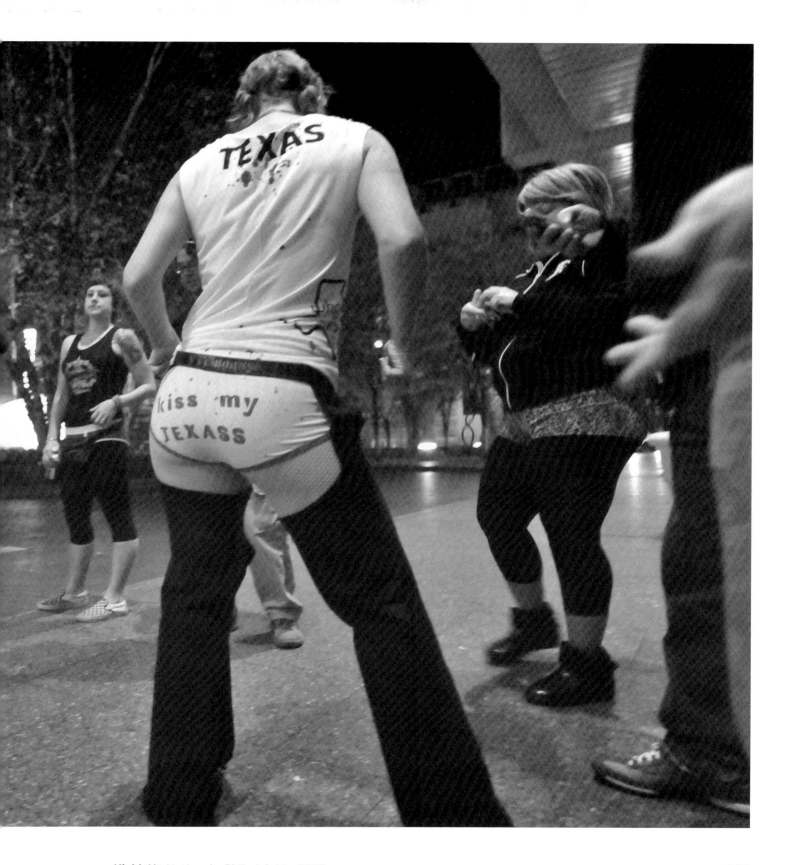

Kickin' It Nationals, Philadelphia, 2009

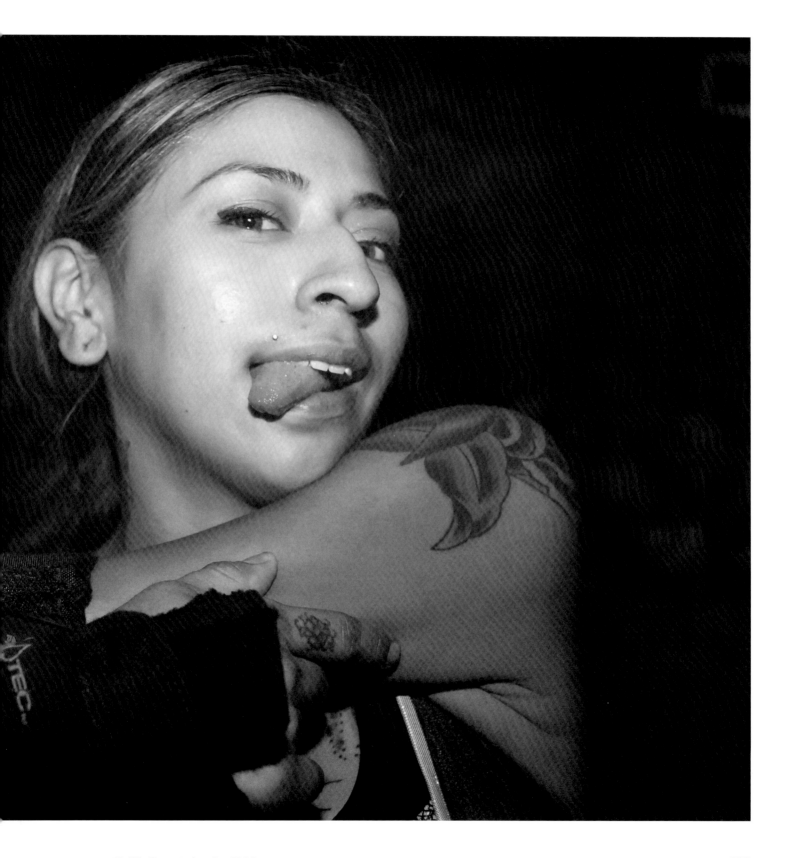

Rollin Sweet Austin, 2006

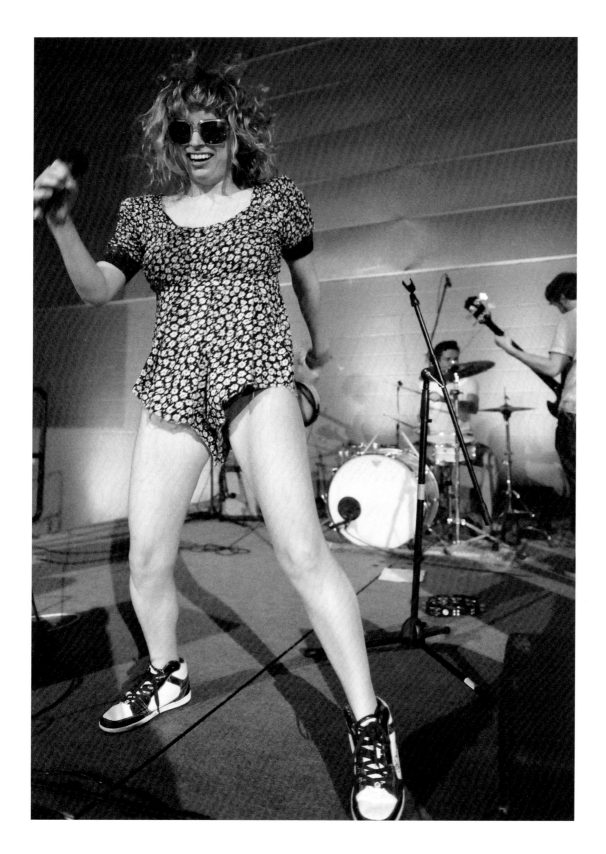

A Giant Dog Austin, 2011

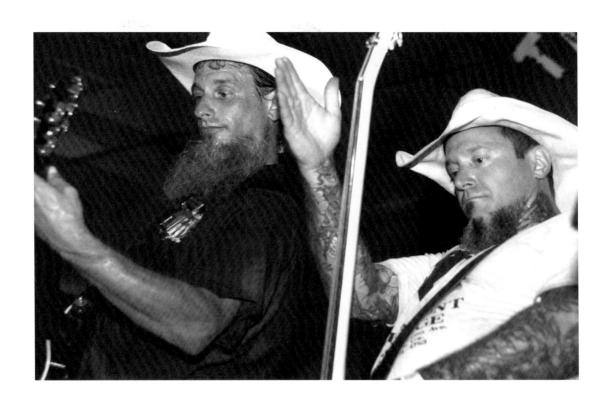

ABOVE: **Honky** Austin, 2006; FOLLOWING SPREAD: **Bucky on Bar** Austin, 2005

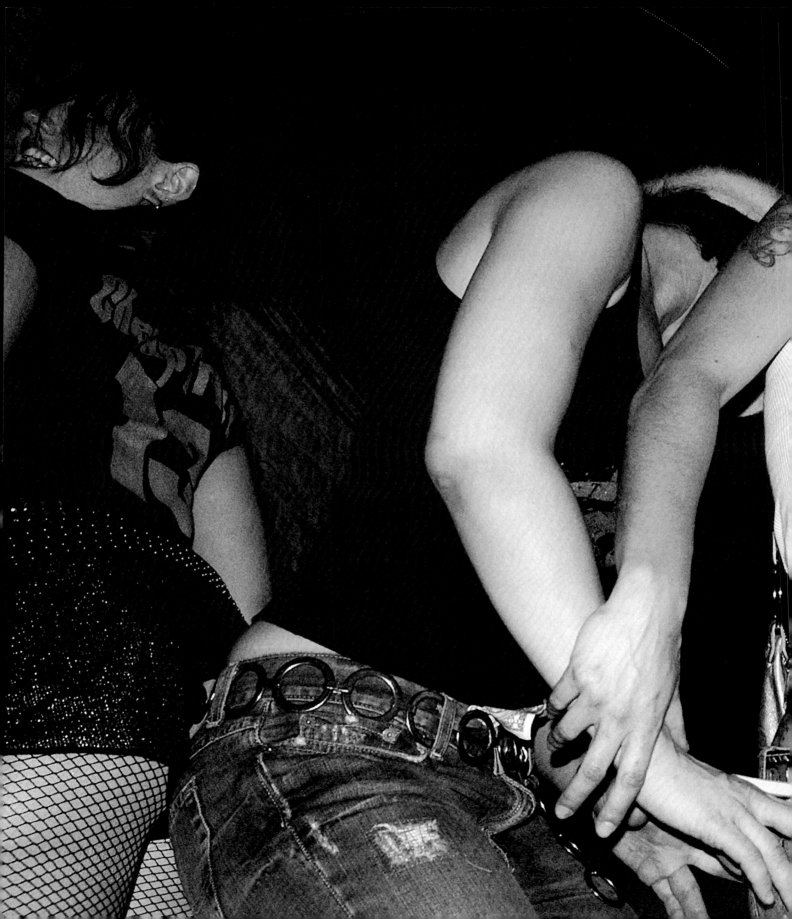

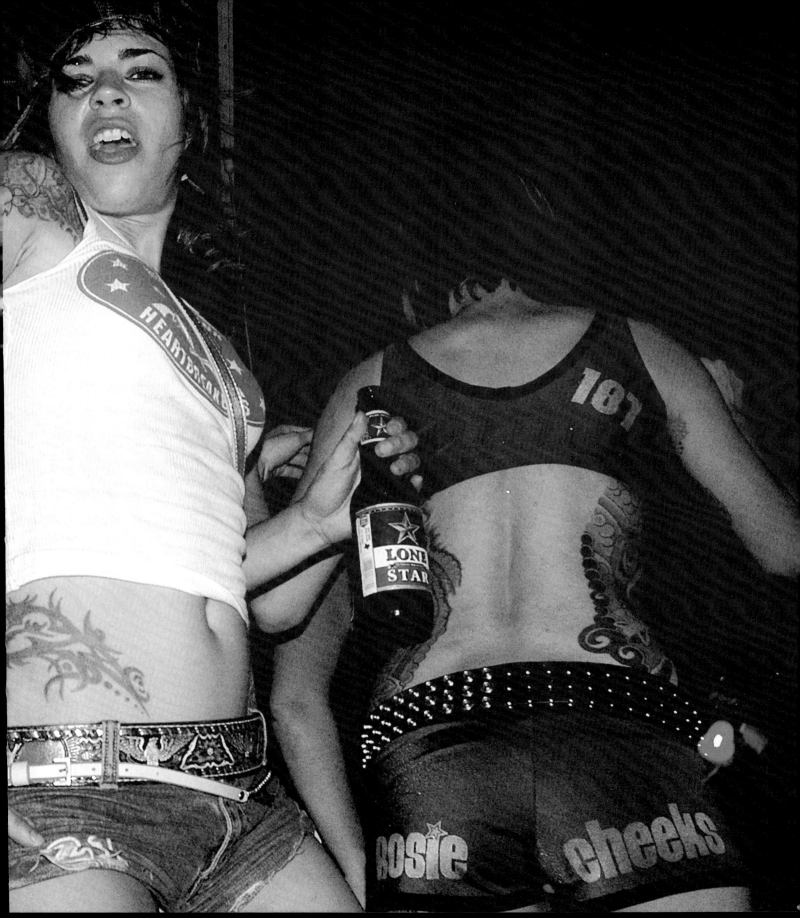

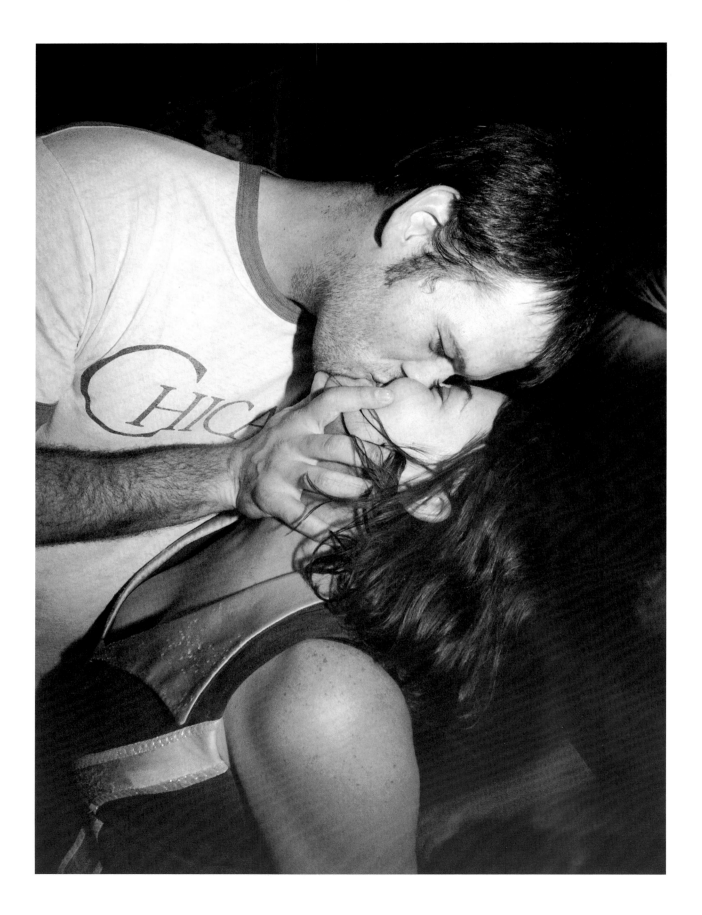

OPPOSITE: **Barbarella & Joe** Austin, 2005;
FOLLOWING SPREAD: (Clockwise From Top Left)
Olivia Shootin' John & Cat Tastrophe Nationals, Portland, 2008
Pixie Tourette, Rebellika & Loose Tooth Lulu Austin, 2005; **Rice Rocket** Nationals, Portland, 2008;
Sic Shooter, Cheap Trixie, Hissy Fit, Belle Star, Derringer & Lady Stardust Austin, 2006

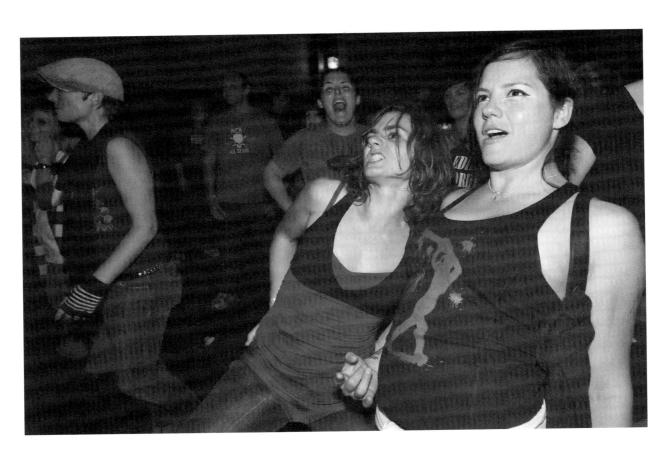

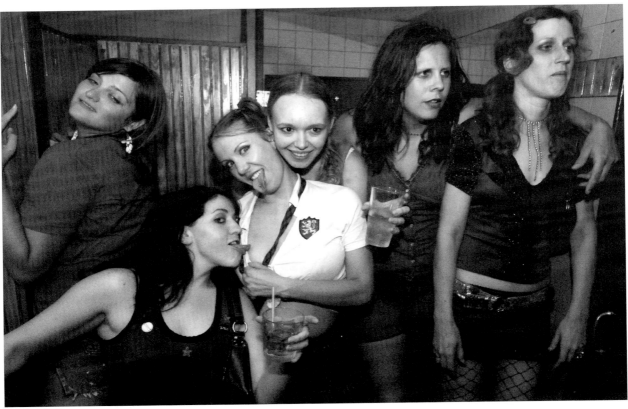

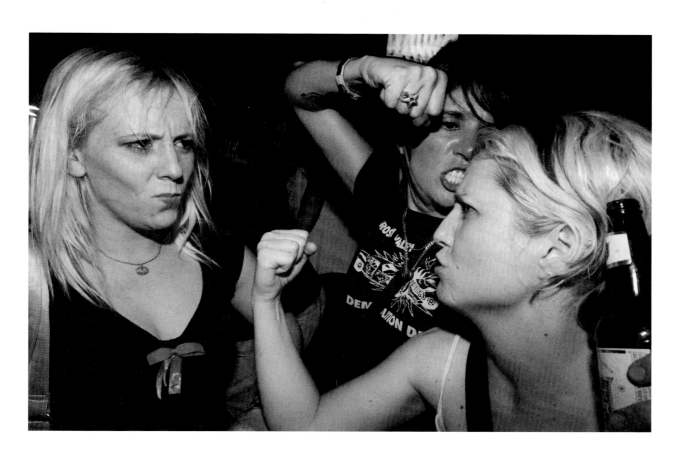

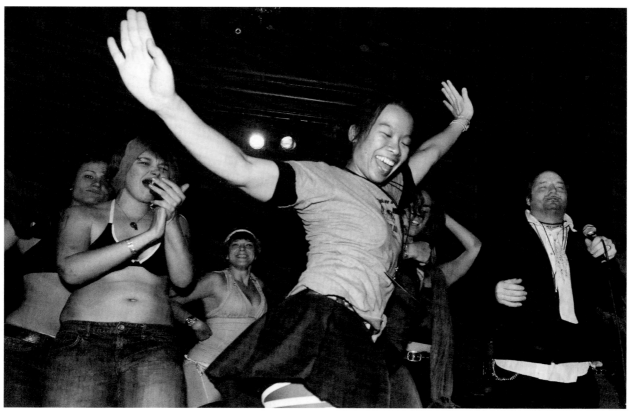

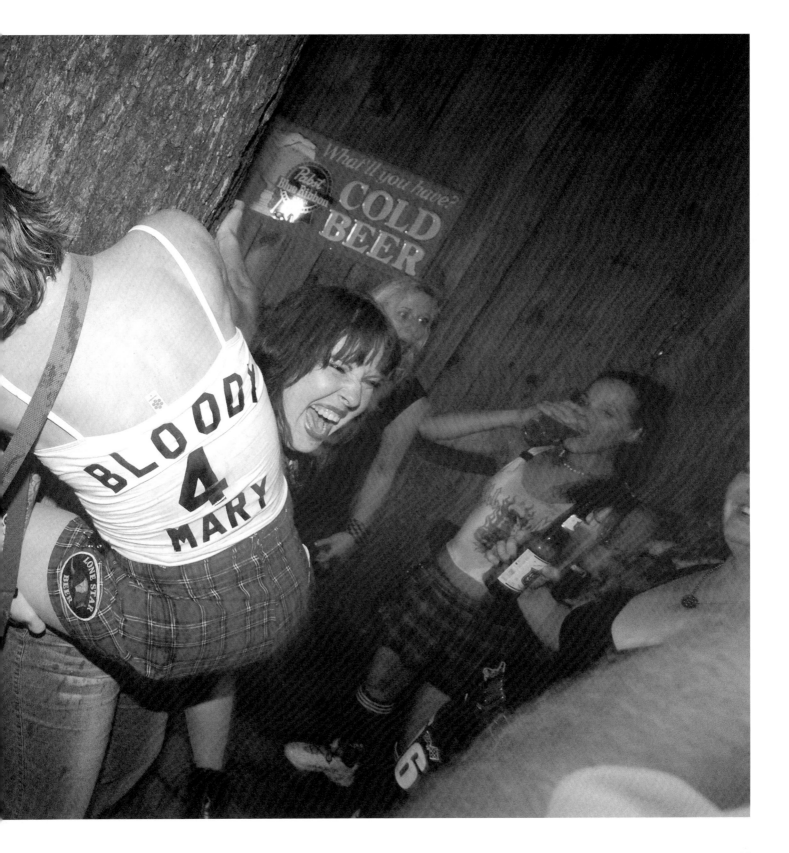

Bloody Mary Crushes Dagger Deb Austin, 2005

ONCE A ROLLERGIRL, ALWAYS A ROLLERGIRL.

Cat Tastrophe & Morphine Austin, 2008

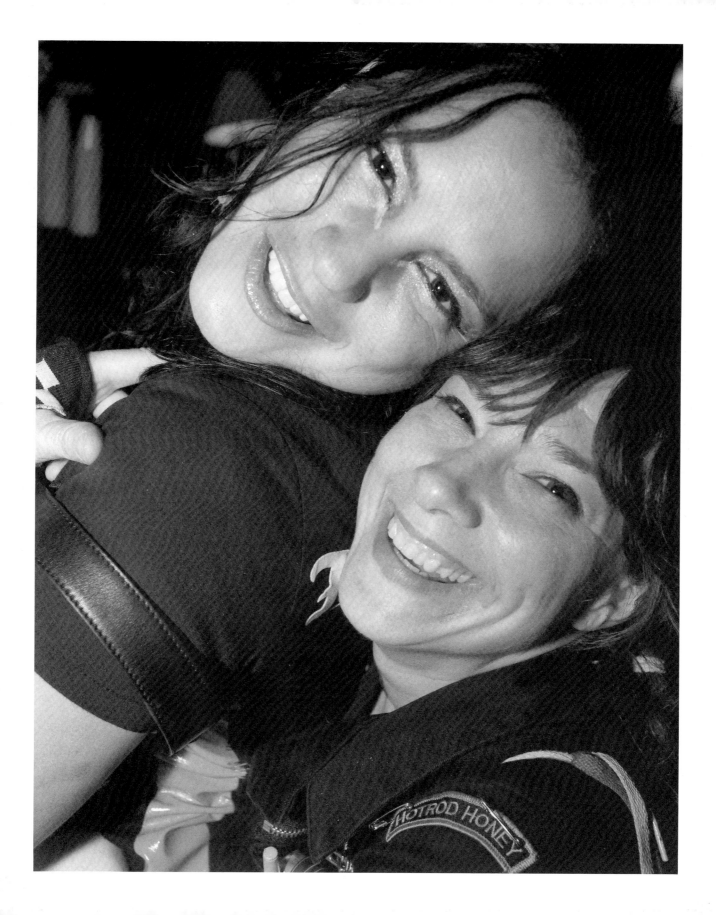

Have Skates, Will Travel Seattle, 2006

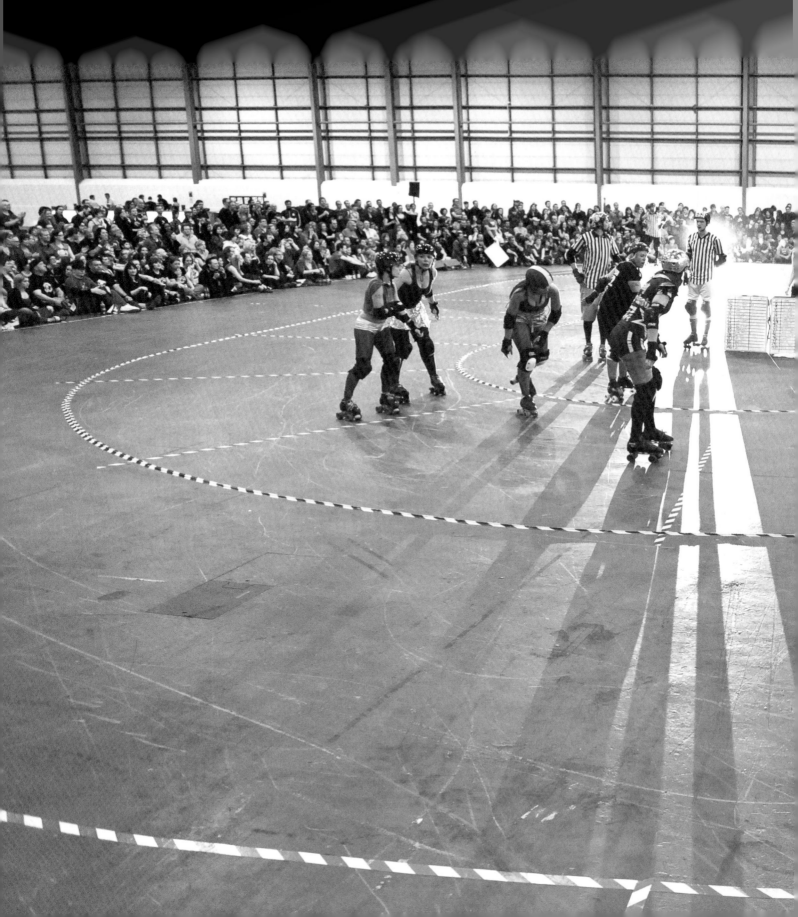

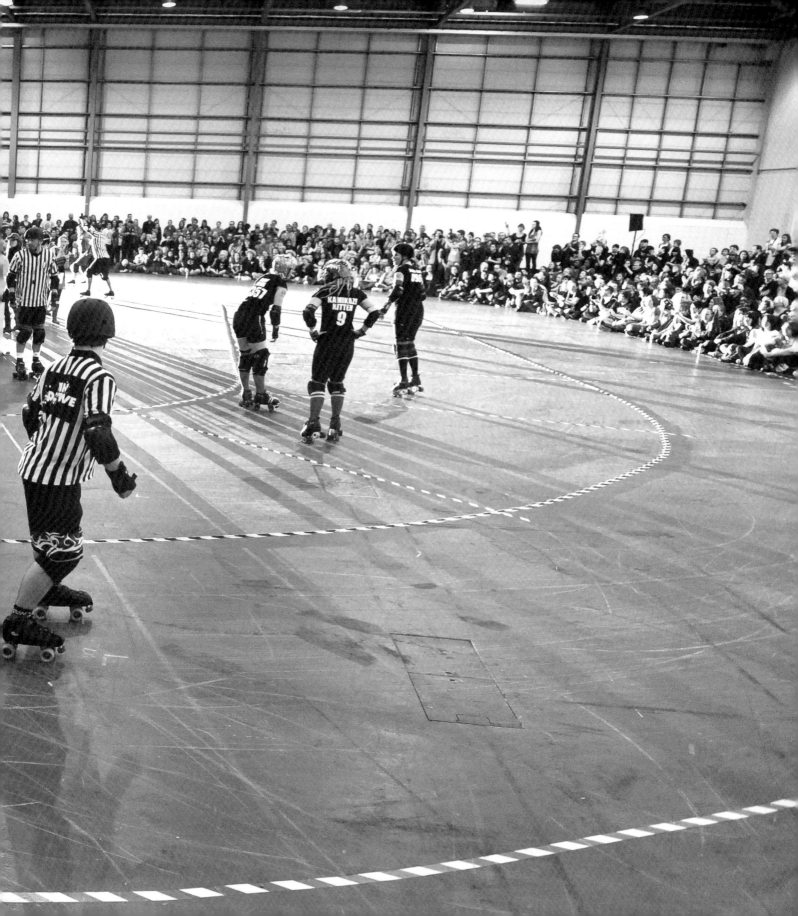

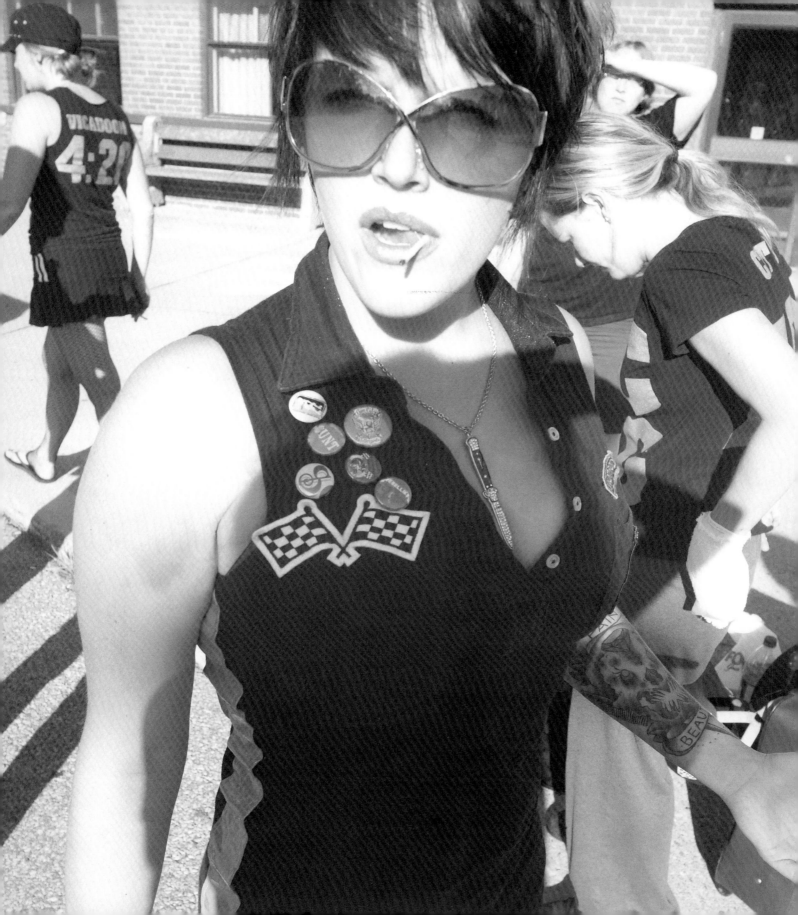

PREVIOUS SPREAD: **Hustlers vs. London Rollergirls** London, 2010;
OPPOSITE: **Shank** Hamilton, Canada 2008

201

Texecutioners Head to Tucson Somewhere Over Texas, 2008

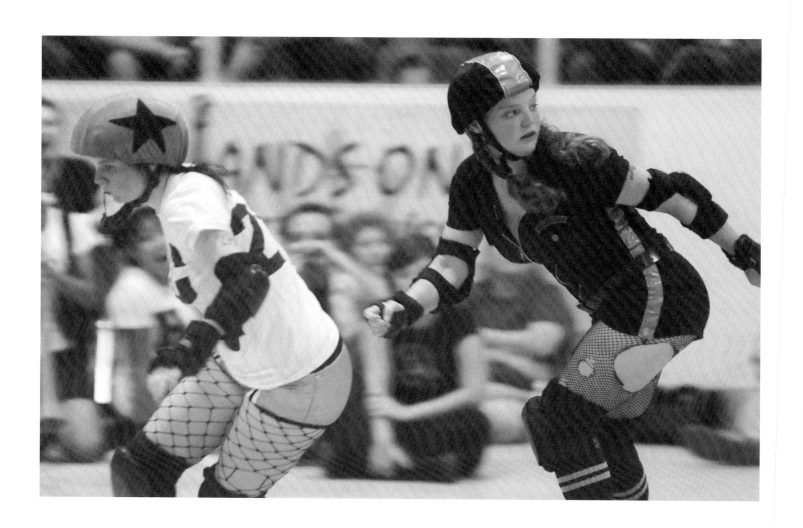

Lucille Brawl Hamilton, Canada, 2008

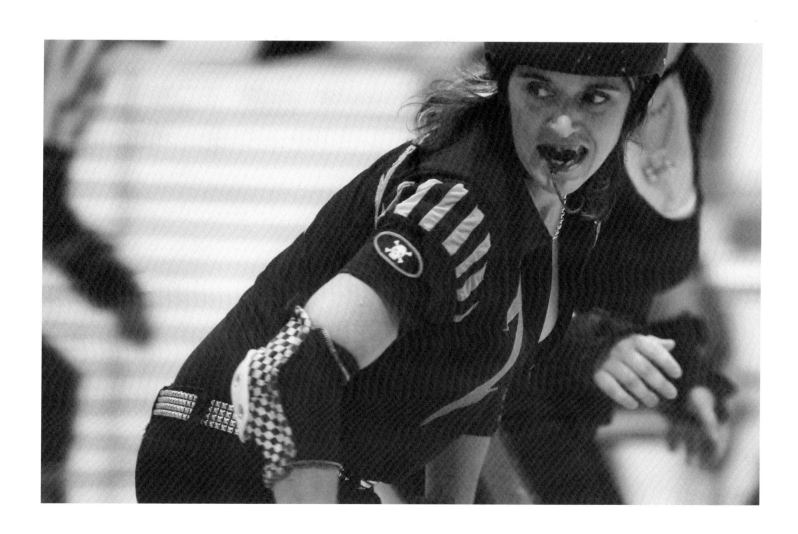

Rebellika Hamilton, Canada, 2008

OPPOSITE: **Shank & Radio Active** Hamilton, Canada, 2008;
FOLLOWING SPREAD: **Ref. Johnny Roast Beef meets with
Hammer City Rollers & Hotrod Honeys** Hamilton, Canada, 2008

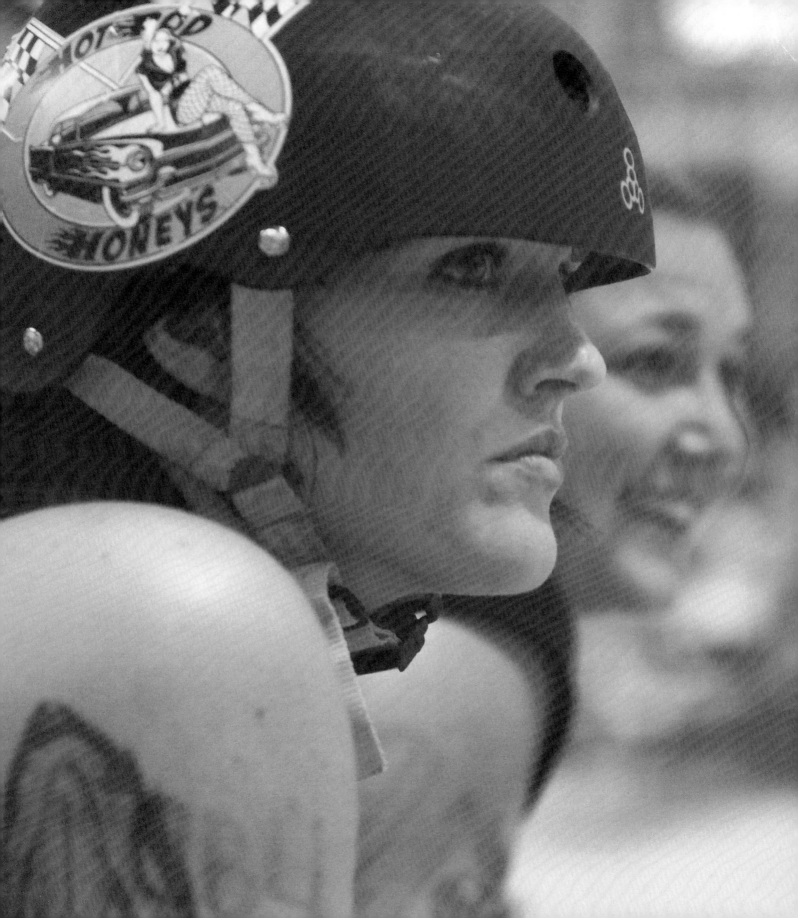

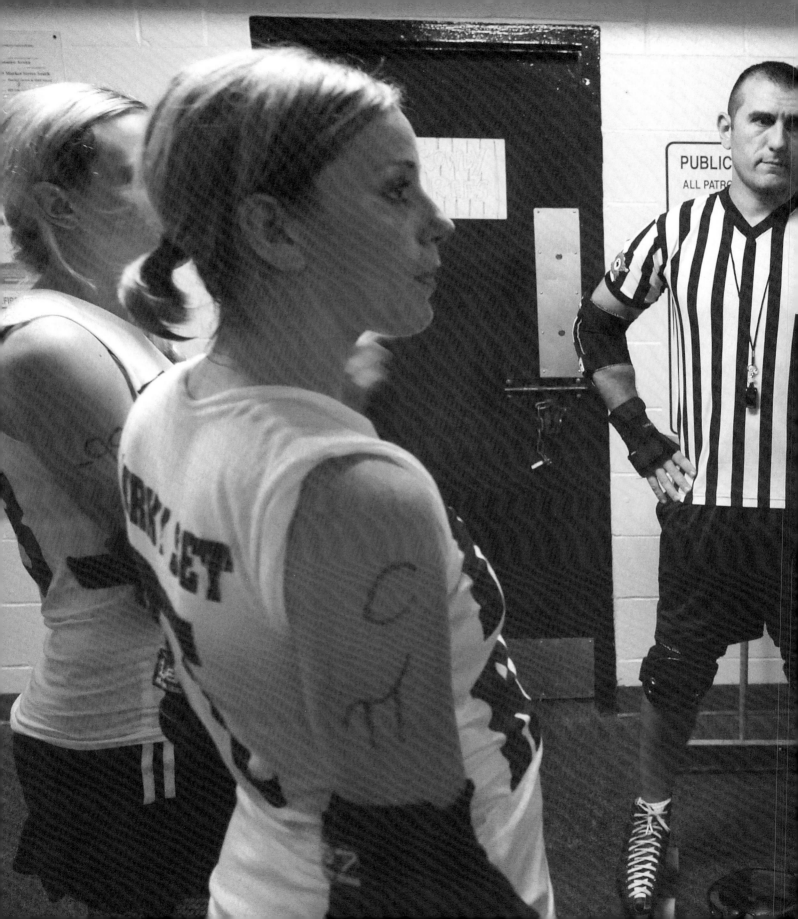

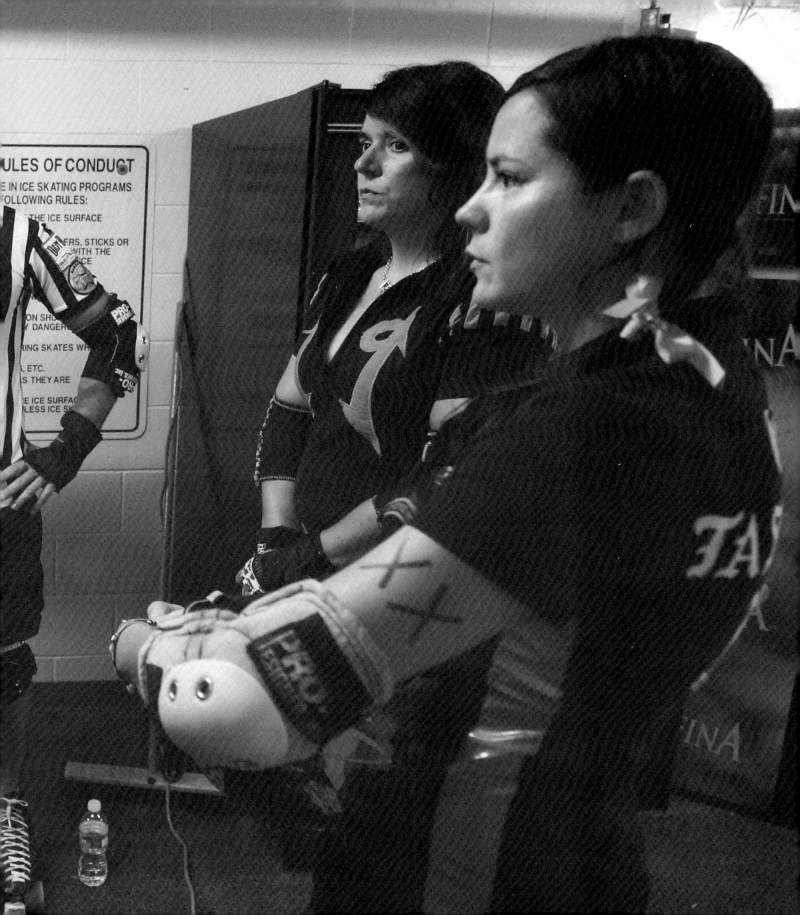

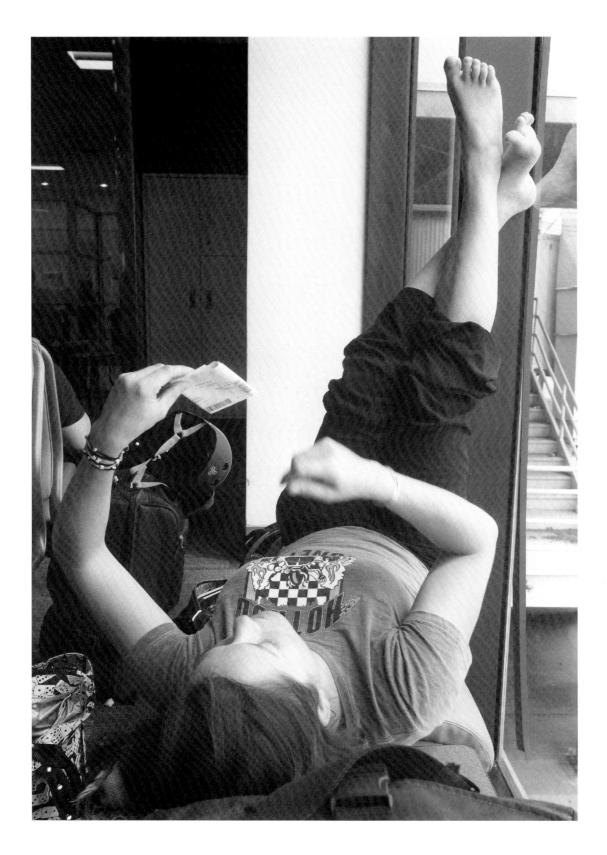

Cat Tastrophe Before Flight Austin, 2008

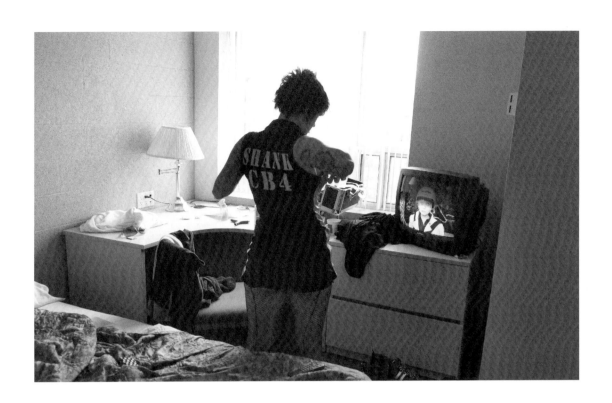

Shank Gets Ready Hamilton, Canada, 2008

Molotov M. Pale Rides Tube to Street Skate London, 2010

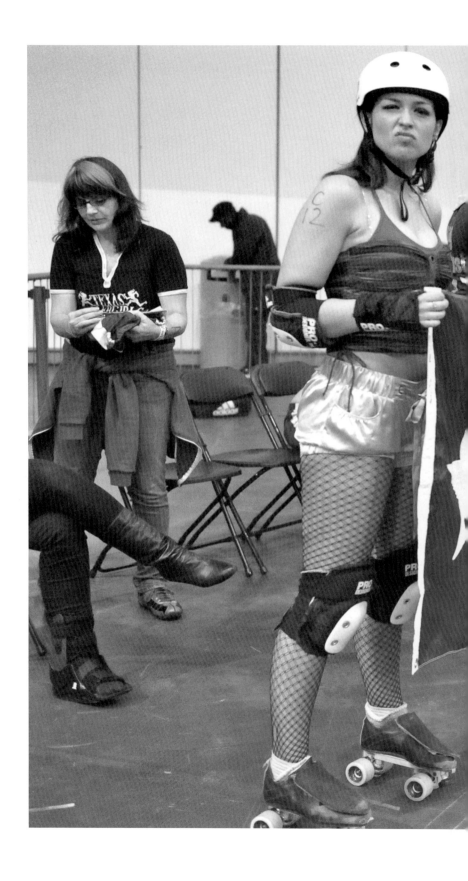

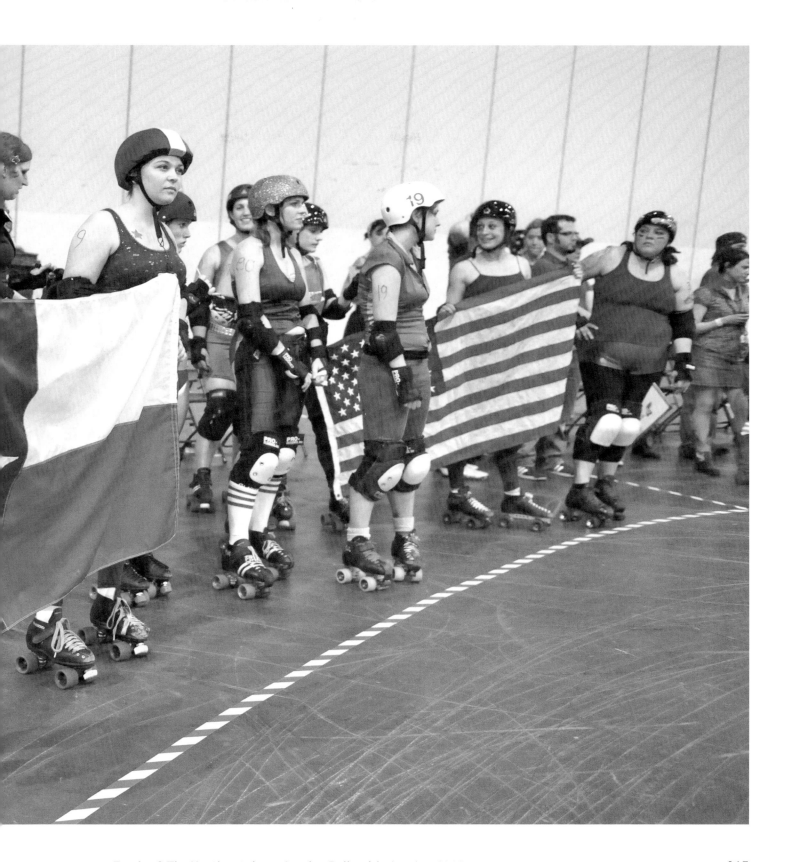

Fearlys & The Hustlers take on London Rollergirls London, 2010

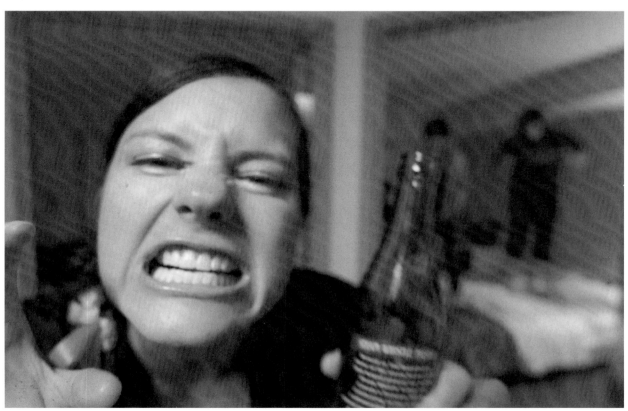

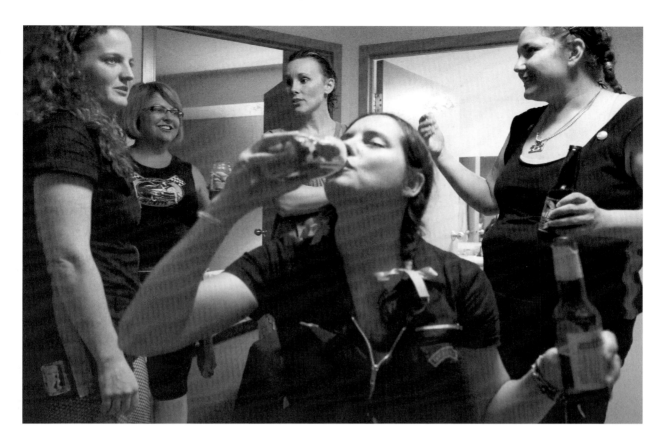

ALWAYS LEAVE 'EM WANTING MORE!

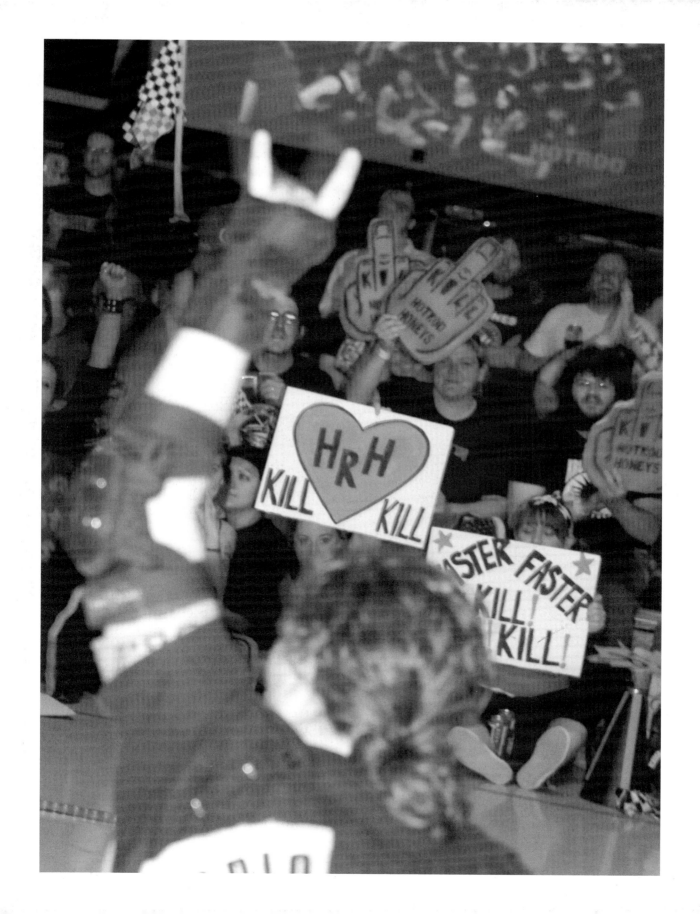

AFTERWORD
BY DENNIS DARLING

I find writing an afterword or, in this particular case, an "after-photo" a challenging task. A photobook's foreword section is generally devoted to presenting the history, background, and context for the images that will follow. Important work. Because it sets the stage, the foreword is, of course, forward–positioned squarely in the footlights before the curtain rises on the main event.

The afterword waits back stage and appears only after the curtain has fallen and folks are shuffling toward the exit. Relegated to the last few pages of a book and often adjacent to the sleep-inducing acknowledgements, it attracts little attention. However, the afterword has an important job to do as well. Its mission is to shed light, of the non-lime variety, on how the particular work came into being. Its small presence is devoted to the basic nuts and bolts details that brought the work to fruition, in Felicia Graham's instance, how she approached this Roller Girls project.

When I look at Graham's roller derby photo series, I look at it through the prism of my own experience as a documentary photographer and photo instructor. I recognize several fundamental qualities in Felicia's photo work that underpin many a compelling documentary project. A couple things, in particular, stand out.

I'm not sure what initially attracted Graham to the roller derby. However, I suspect it was the basic kindling that ignites many long form documentary projects. It is a trait that, try as I may, I have been unable to teach. It is curiosity. Being curious is the first ingredient of the complex amalgam of storytelling essentials. It's what propels photographic work out of the ranks of the ordi-

nary. You photograph best when you photograph what interests you. A healthy curiosity is just interest turned nosey. Graham obviously had more than a passing interest in the derby and it shows. She is curious enough to record the unseen, the hard to see, and the little-known, curious enough to make a long-term commitment.

An old saying asserts, "things made with time, time respects." Once Graham's curiosity was whet, she had the good sense to realize that the project would require ample time for discovery. Her series on roller derby girls was made during an eleven-year period, a considerable amount of time on any photographer's calendar. Seldom is a photographer afforded the luxury of this excessive block of time to complete a project. That is, unless it is a self-inflicted endeavor, which the roller derby project was in Graham's case. Thus, inoculated from the tyranny of a deadline, Felicia was able to take time to learn from and explore the subculture of these wheeled female warriors. Looking at her images, it is apparent she spent her time wisely: sharpening her photo skills as needed while honing her visual sensibilities. The result is an engaging look at a peculiar sport, resurrected from America's early twentieth century and given, as if it needed one, a new twist.

The handmaiden of time is experience. It is difficult to gain experience without the nurture of time. Louis Pasture, the famous scientist known for his radical discoveries, most of which are now considered scientific bedrock, once summed up his success saying, "chance favors the prepared mind." A prepared mind is cultivated with both time and experience. In documentary photography, the subject usually dictates how much of each

is needed. One satisfaction for the photographer, when doing documentary work, is to make pictures that appear as if taken by pure chance, but knowing that they are able to make the image at will, on a regular basis, because of their experience. The well-known French photographer Henri Cartier-Bresson labeled this sweet-spot of time as capturing "The Decisive Moment". Felicia Graham's roller derby portfolio is chock-full of what looks like lucky encounters. However, there are far too many to simply credit good luck, too many "decisive moments."

Graham readily concedes she had no previous familiarity photographing sports. "I had to learn to shoot action, something I had little experience doing, and I not only had to learn to photograph fast movement but had to learn about the sport itself. I confess that for the first year I just came and shot picture after picture. I knew nothing about the game, including how the teams even scored."

After the first season, Graham had mastered the essentials but was still having trouble with producing satisfying images. She says, "I started out shooting in color. I was attracted by the derby girl's uniforms but I soon found I really didn't have enough light to shoot "good" color or, for that matter, capture motion as I desired. The images just seemed average." After some soul-searching Graham decided, based on her experience from the first year, to change course and basically begin anew. She recalls, "It wasn't until I started shooting black and white film that things began to fall into place for me." Graham received an additional boost when she first brought the B&W prints back to the derby girls. "They loved them," she said grinning. The die was cast. Shooting positions had been scouted, personal connections made,

and poor light conquered. She was ready for "chance" to favor her.

From the thousands of photographs made, Graham selected seven hundred for possible inclusion in this book. Working with Pentagram designers, her initial edit was narrowed down to what is contained between these covers but selecting the finals for the book was not the first editing she had done of the images. The strength of many of Graham's photographs comes from her awareness that composing a photograph is not only an additive process but a subtractive one, as well. Editing was accomplished in the camera, not on the computer after the fact. As with most photography, documentary or otherwise, it is not only important to know what is needed within the frame but what is not. Editing in the camera is a discipline that many photographers fail to appreciate. However, it is a tool that needs no special equipment, just the mindfulness that less is usually more. When viewing Graham's images, there is little question of why a photograph was made or where you should be looking. That which draws your eye away from the photo's intent has been purged. Left ringside.

If you have made it to this page, in all probability, you have already experienced Graham's photographs. Hopefully you will return to the book many times and will be rewarded by something newly-revealed on each visit. I am of the opinion that time will also respect this body of work and that future generations will not only be favorably disposed at this insider's view of the élan and temerity of these wheeled hellions but will also appreciate the endeavor of one woman who spent more than a decade recording their feisty frays.

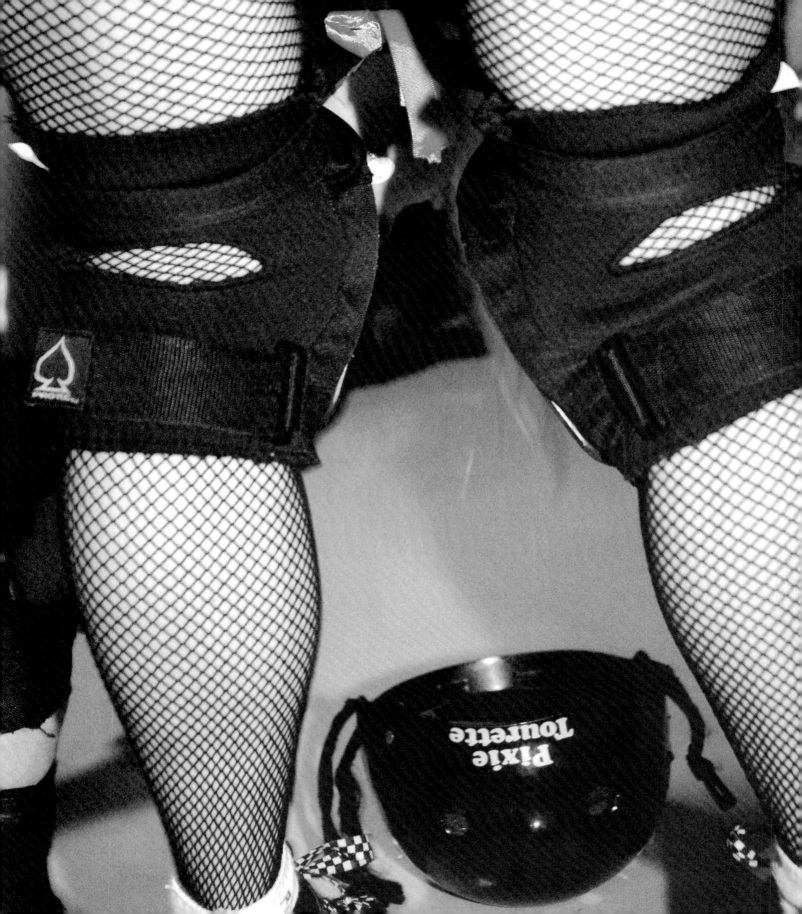

OPPOSITE: **Pixie Tourette** Austin, 2005

Houston-born photographer Felicia Graham discovered her love of photography at an early age, but it was not until her senior year of college, in Atlanta, Georgia, that she started getting serious about her work. Her camera has been her trusted tool to express her vision of the world since 1997. She returned to Texas in 2003, eventually earning a master's degree in journalism from the University of Texas at Austin.

Graham has photographed subjects around the country ranging from rock stars and juke joints to weddings and roller derbies. Today she works on music documentaries, commercial still photography, movie productions, and other projects, and she continues to pursue her passion for the art of photography.